The study of
education and art

Also by Dick Field
Change in Art Education

The study of education and art

Edited by

Dick Field

Institute of Education,
University of London

and

John Newick

Institute of Education,
University of London

Routledge & Kegan Paul
London and Boston

First published in 1973
by Routledge & Kegan Paul Ltd
Broadway House, 68–74 Carter Lane
London EC4V 5EL and
9 Park Street,
Boston, Mass. 02108, U.S.A.

Printed in Great Britain by
Ebenezer Baylis and Son Ltd
The Trinity Press, Worcester, and London

ISBN 0 7100 7648 7 (c)

ISBN 0 7100 7775 0 (p)

Library of Congress Catalog Card No. 73-83074

Contents

Foreword

I agreed to write a Foreword to this book even before I had read it. In departments of education, as in secondary schools, there has long been a tendency for the specialists to 'get on with their own work' and not to realize that neighbouring colleagues might have a good deal to say that would be of interest and importance for their own specialist thinking. Here was one of our departments at the London Institute of Education producing a collective volume on Education and Art from staff members who have been teaching Art from the point of view of various basic educational disciplines. This seemed to me a first-rate idea.

Now that I have read the book I still think so, though to carry out the task has proved more difficult than perhaps anyone realized. Art is concerned with experiences that are not in straight antipathy to the cognitive side of our life, as some of the contributors to this book rightly say; but it is a world of experience in which the cognitive is less dominant than in some other subjects of study. Yet essays like those that follow are almost bound to use a cognitive mode of discourse, rather than one of insights more or less poetically or at least symbolically expressed. The reader may feel that some of the contributors are struggling with these formulations couched in a cognitive mode. The wonder of the rainbow is not there (that was not the purpose of the book perhaps) but the clear finality of Apollonius is not always there either.

One of the contributions that seems to me to be completely in focus (and to be written with clarity and the best kind of simplicity) is that of Professor Arnaud Reid. But even he uses a concept, that of 'the aesthetic experience', that worries me. Indeed this is implicit throughout the book. The argument is that the aesthetic experience is a necessary part of a good education and that it is to

this, whether through making works of 'art' or through active spectator's enjoyment of them, that we are to introduce the young. But what is this aesthetic experience?

One could use the phrase as a handy label for all those experiences that come through works of art and that in one way or another are felt to be valuable. It would be a superficial definition, relating only to the formal origin of the perpetuation of the experience, but at least convenient. Professor Reid, however, rejects this. He insists that we can have aesthetic experiences from 'real life', from a landscape, the cleaving of the air by the wing of a bird, and an almost infinite variety of things. All right. But then what is specific about an 'aesthetic' experience?

Nothing, it would seem to me. It cannot be Beauty. That, as many people have pointed out, is too narrow as well as too vague. (What about the gargoyles of Notre Dame?) It cannot be the Expressive; for what of the value or lack of value of what is expressed? If we abandon the matter-of-fact distinction that aesthetic experiences are those that, to use the current jargon, are mediated through works of art, we have to say that there is no distinctive kind of experience that we can call aesthetic. The experiences in, or (from the spectator's point of view) of, a work of art are not different in kind from those we have in real life. (I do not mean, of course, that the sunset in Turner's painting 'was' the sunset his friend and representationist critic saw.) They are simply lifted from the ruck of things and given a greater intensity and a more enduring power through the artist's vision and his command of the medium he has chosen to use. A man is less well educated than he might have been if he has not entered, as with help and encouragement he could, into this enhanced life. And he must understand that this is not just a matter of giving oneself to an experience. It is that, but it is also a selecting and refining thing, in which the imagination and the critical faculties work not against one another but hand in hand; and this is something, not in which one can be merely instructed, but which one indeed does learn.

To understand how this happens, or fails to happen, implies some psychological understanding, some cultural and historical and even anthropological knowledge, and of course enough philosophical analysis to get reasonably clear about the terms one is using. And one needs to know a great deal about people, whether children, youngsters or adults. This book is an attempt to present the reader

with some of these varied considerations. The result admittedly is not a single picture dominated by a sense of composition. (That in any case would have been wrong; it would have been stultifying to seek to impose a unity where none as yet can be said to exist.) It is rather a collage, with a variety of things put on the paper, and an active effort required by the reader to make his own synthesis if he can.

So, if a layman's view is worth anything, I would like to commend this book. There will be few readers who will not gain from reading its various contributions—if only a realization of the necessary and important complexities of the subject.

LIONEL ELVIN
Formerly Director, University of London Institute of Education

Preface

This book is addressed to all *students of art education*—to students and their teachers in the departments of educational and teaching studies of universities, polytechnics and colleges; and to teachers in schools.

It is a study-book, comprising seven new Articles, with an Introduction and the transcription of a Symposium. The issues raised in the book as a whole invite further study through participation in the arts and through discussion.

1 Introduction:
the study of education and art*

Dick Field and John Newick

I

The phrase *the study of art education* comes easily to the lips, but the content of such study appears to be tantalizingly elusive and tantalizingly mutable. We have purposely avoided the merging of *education* and *art* into a single concept in the title of this book as an open invitation to consider what happens when they are seen in juxtaposition. We should first ask: can the concept of 'education' and the concept of 'art' coexist?

Marshak in this volume claims that by promoting flexible cognitive and perceptual styles, the arts are man's only defence against psychological rigidity; for Marshak it is just these flexible styles which education works consistently to ossify. This view appears to be in sharp contrast to that held by Perry for whom the experience of fine art is an essential element in the education of the person; it is the hallmark of non-instrumental, cognitive development. For Perry, without the fine arts it is impossible to conceive of 'education' in any real sense; for Marshak, educational establishment can be no more than an expression of conventional order and conventional belief.

Whether these two views of education and art are really conflicting is an open question. It is perhaps a peculiarly Western notion to assume that the aesthetic dimensions of experience are endemic to a special kind of elitist education, rather than phenomena which are essential to the fabric of culture as a whole, embodying compressed meanings which are both emotive and normative.

* The authors wish to thank John White who read the first draft of this Introduction and made valuable suggestions.

While Perry and Marshak appear to be working at the perimeter of this area of inquiry, other writers in this volume take up other positions. Gordon (1972) sees the arts as the only means open to man to break 'the seal that locks him fast into his inner world', and as the primary means to cultural cohesion. Reid focuses on aesthetic experience, both as a field of philosophical study and as an educative function which rests on active involvement with the inherent, non-propositional qualities of works of art. Rouve, in an associated but distinct view, picks out existential involvement and 'unpremeditated response' to art as the basis for structuring cognitions and for the formation of evaluative propositions. Newick posits the study of art education primarily as an inquiry into the context of participation in the arts, while Field seeks to give firm structure to the study by exploring the historical and contemporary relationships between art in society and art in educational institutions.

Such then are some of the angles from which the authors tilt at the study of education and art. The topics of the articles have emerged over the last few years as areas of interest to the authors, all of whom teach, or have recently taught, in the Institute of Education of the University of London, and most of whom are concerned with teaching in the Art Department. The book is a series of forays; nevertheless, since the authors have generally cast their nets widely, the topics in themselves generate—as we have found in the Institute—discussions of other equally important issues. We hope that the articles as presented here may be of use to others in a similar way, and we invite readers to associate and to contrast the focal angles of the articles and to come to their own conclusions about the nature of the study of education and art.

2

The relationship between the function of education and the function of art is clearly complex; in consequence our first sight of 'art education' is of a fluctuating field of study which is characterized by human action and involvement and whose dimensions and priorities are in constant change. Part, indeed the major part, of its variability arises from the changing concept of education and the changing concept of art. Furthermore, part of the complexity of the field of art education rests on the degree to which it is conceded, or

denied, that art in institutionalized education is integral with art in the public sense. It looks at first glance as though change in public art is followed by change in art education (although one might have expected the opposite); indeed, it is an open question whether one conceives of the Bauhaus as a response to twentieth-century art forms or as an educational institution in which artist-teachers developed new forms of public art.

What form, then, should the relationship between education and art take at the present time? Of course, art education has often been in a state of flux. At some times and in some cultures, education and art may appear to present a cohesive whole; at other times and in other places they may appear incompatible or to work in contrary directions. It is clear that the connection between the respective functions of education and art can never be simple.

Art education *as a study* is defined by the objectives it sets for itself *as a function*. If, for example, fine perceptual differentiation is seen as an educational priority, then specific areas of the psychology of perception become a part of the *content* of the study of art education; if the objective is seen to be the exploration and support of the ineffable and the mystical, the studies of pre-logical thought and of philosophical and cultural attitudes to mystical experience become relevant; if the objectives are social cohesion and the fostering of the popular culture, then the sociology of meaning in urban societies becomes immediately pertinent (see Newick's article in this volume).

The field of study is, then, inevitably variable. Shifts—some temporal and some specific to cultures and sub-cultures—become *in themselves* an essential part of the content of the study of art education; it must contain the study of change.

A further reason for the elusive boundaries of art education as a study seems to be located in man's passion to explain his experiences of art. This may be predominantly a Western phenomenon. In the event, man is drawn into a range of investigations which extend into almost unlimited regions: his desire to understand himself leads him to examine the nature of these experiences—to justify them philosophically, to explain them psychologically, to survey them sociologically and to relate them culturally. No wonder that in any complex society the net spreads more and more widely and with finer and finer mesh, and associated studies achieve a new, but shifting relevance.

3

Students of art education—and in this category the editors of this book place themselves—are therefore faced with the necessity to come to terms with the elusive and shifting nature of their field of study. Is there no way in which this study can be structured? There is, and it rests, as it were, beneath the hand, in the unique, intrinsic quality of the *experience of art*; indeed, this has long been accepted tacitly as the basis for such study. It is the purpose of this Introduction to remind us of the recurring need to evaluate this assumption.

The experience to which we refer is not only the experience of the maker of the arts; it is also located in the complementary responses of the onlooking or listening participant (see Dewey, 1934). Indeed, the degree to which it has become accessible to individuals is not to be estimated exclusively or conclusively in the quality of their performance as makers. For some individuals the experience of art may be developed more efficiently in their receptivity to the arts of others than through their own art-making behaviours. The experience of art is naturally available to all human beings; it is not elitist. But in its nature it cannot be willed: therefore it cannot be acquired expediently in order to qualify as a student of art education.

In claiming that the experience of art is at the heart of the study of art education we are thinking of a quality of experience which is fundamentally aesthetic (see Phenix, 1964 and Barkan, 1970). This experience shades into other kinds of human experience but in the process of merging its experiential nature is inviolable. It is a 'natural' experience yet it is sometimes undervalued; it is available to everyone although it is not necessarily availed *of*; it is always potent yet its potential can remain unexplored.

The experience of art is peculiar and unique since the artist 'thinks in qualities' (Ecker, 1966), in 'direct apprehensions of sensory experience' (Eisner, 1971). Because this is so, the analysis of aesthetic experience can go only so far; an essential part of the content of the study of art education must be participation in the experience of art.

Individual experiences may vary all the way from the merest intimation to something rounded and immediately recognizable. The process of grasping and defining the nature of the experience may therefore be longer for some of us, shorter for others. Further-

more, the degree of significance of the experience of art will vary from one experience to another; hence the need for recurring (but not necessarily continuous) opportunities to encounter this experience.

It is sometimes claimed that the experience of art can be reinforced by the participant becoming sensitive to the *nature* of this experience. Sensitivity to its nature may strengthen recall of the experience itself, and may help to alert us to the possibility of the emergence from recurring experience of patterns in our own responses. These patterns do not necessarily leap into sight and may vary from one occasion to another. The way such patterns may or may not relate to the experience of others would clearly be an important concern for the art educator. Conversely, others may claim that the experience of art itself—independent of our cognizance of its nature and internal rhythms—is of such a kind that the insight it generates leads to greater intuitive comprehension of which the participant is scarcely conscious (see Marshak).

There is one more point to be made here: in the experience of art we have the means to a unique mode of insight into perception, imagination and other mental processes involved in art participation —insight which enables us to accommodate psychological theory in our mental constructs of experience (see Bannister, 1966). Such insight is a means of study for all students of art education, whether they are concerned directly with the art encounters of others or whether they engage in specialized, theoretical studies— for example, the sociology of aesthetics or the study of art syllabuses of the late nineteenth century.

4

We have so far discussed the experience of art as a means of structuring the study of art education. We shall now suggest that the experience of art is the base from which to assess the relevance of contributory studies—studies which are inevitably extrinsic to the experience.

In this matter the art experience is, we submit, the only touchstone we have: the criterion for estimating the worthwhileness of contributory studies would be the manner in and extent to which they enhance our experience of art (see Barkan, 1970). Consequently one would at times embrace some aspects of such studies as insightful, at other times reject them as temporarily misleading. But

ultimately the validity of all must be referred back to the art experience.

There is a particular sense in which the experience of art can be justified as the touchstone: this resides in the fact that the aesthetic experience provides an element of constancy in a situation of change. We may judge this from the fact that currently in the West we seem able to respond to an apparently unlimited range of visual imagery; our eclecticism recognizes no limits.

5

We have now considered two distinct readings of the function of the art experience in the study of art education: we have claimed that not only does this experience give cohesion and body to the study, but that it becomes the measure by which we can gauge the relevance of knowledge extrinsic to the experience itself. Now we come to a consideration of the cultivation of this experience as an educational objective.

Art—indeed, education in the arts—as an enterprise is founded upon two separate premises: one, that it is possible to create situations in which others have access to the experience of art; and two, that the untutored experience of individuals may be intensified and made more significant when they learn to achieve certain behaviours; to recognize these experiences in themselves; to develop attitudes and attention which promote their occurrence; and to understand these experiences both as personal to themselves and as communion with others.

It may be argued that the self-imposed task of attempting to enrich the art experience of others is both unnecessary and hazardous: unnecessary because the aesthetic response is not the privilege of the few but the possession of the many; hazardous because the delicate mechanisms of genuine response may easily be overlaid and destroyed by the attempt to encourage it by means external to itself. The question poses itself: is the intention, endemic to the enterprise of education in the arts, to enrich the art experience of others inevitably negated by the heuristic nature of art? Even supposing it is possible and necessary to enrich the art experience of others, the question then needs to be asked: is the experience of art the only legitimate and necessary objective for art education? Is the art experience really instrumental in the

achievement of extrinsic social aims? Is it even conceivable that the experience of art is inherently subversive and a spur to the extension of social and cultural mores in unpredictable ways? These are fundamental questions which all students of art education must face.

6

Within the field of art education are a number of apparently intractable issues—intractable since their origins are either inherent in the nature of art or lie deep within the structure of society. It is our purpose here merely to adumbrate the most prominent since a study of them reveals facets of the nature of art education itself.

All elements which contribute to society are subject to a certain paradox: that they at one and the same time shape society and are shaped by it. Yet perhaps the arts can claim to be different in the sense that they are the principal means by which society learns to know itself. Trilling (1965, 40) points to the agreement, ever growing in assertiveness, 'that art yields more truth than any other intellectual activity'. The artist records not only the commonplace facets and notions of his society, but also its deepest aspirations, hopes and fears. He records these so that he may himself apprehend and comprehend them: but they speak also to his fellow-men of themselves. The artist often enough tells us what we do not say; what he has to say he has seen through the eyes of his—and our— society: in truth, so to speak, shaped twice—by the eye of the artist and by the eye of society. He who works with the arts, therefore, is working at the frontiers of man's knowledge of himself; inevitably, the student of art education is a student of society and the sociologist becomes a student of art. For an expansion of these ideas, see Gordon's article.

It is in the light of this overriding paradox that we have to approach the study of art education; and the first question that now arises is that of its location. This will not only depend on the exact mix of elements from art and elements from education appropriate to the current culture pattern, but also on the source and nature of the criteria used by art education. From whence does art education draw its criteria? Some must certainly come from within the field, as a product of integration; but others must equally certainly be

drawn separately from art and from education. In respect of these we have to say that there is no surety that criteria drawn from art and from education will support one another: they may sometimes be contra-indicatory. Here is an ambiguity central to the nature of art education which in turn affects the location of its study.

When we turn more directly to participation in the arts we are faced with the need to assess our *attitudes* on the one hand to the experience of participation and, on the other hand, to the artefact itself. While some teachers have felt that the arts in education are to be justified in terms of developmental potential, with no necessary condition that this should be reflected in the aesthetic quality of the artefact, others have felt that the product, however ephemeral, is the only measure of the significance of the mental processes involved. For many teachers of the arts in the West the claims for attention from 'process' and 'product' appear to be an unresolved conflict— even a dilemma. How is this conflict to be resolved? The first question to be faced is whether it is, in fact, a matter of choice between alternatives. It may be rather a matter of coming to terms with this apparent dichotomy as a necessary and recurring element in the genesis of the art object.

In recent years this question has moved outside art in education to become, in the West, an issue for the professional artist. The assumption that the artist has an obligation stoically to exclude traces of personal struggle and to achieve a performance from which others may derive enrichment is now rivalled by the assertion that the artist can justify his activity in the form of behaviour involved, and that he no longer has the need to demonstrate the validity of his contribution to society in the quality of the emergent forms; these forms, he argues, are not the most significant part of the pheno-menon. At the extreme, the product of the phenomenon is entirely 'conceptual' and internalized, with no accompanying physical event which can be sensed by others.

It is, however, possible that in the West it has been too lightly assumed that the icons of a culture may be forged without prudent respect for the ritualistic implications for their makers. To suppose, on the one hand, that there is no necessary connection between the quality of the artist's experience and the quality of his product or, on the other hand, to conceive of the 'superhuman' power of the artist as confirmation of the intimate relation between his thought process and his works, may both distort the situation.

Another such apparently intractable issue lies in the claim sometimes made that the art of children and of the untutored should be accepted as 'modest' and personal, yet different in essence from 'full-blown', public art. In an interesting counter-proposal Burgess in the Symposium at the end of this volume takes the example of poetry which he sees as 'continuous with the more modest kinds of usage of language'. This continuum, we suggest, is not a *track* for the sequential performances of individuals but a mental construct which legitimizes the action and response of individuals over a wide spectrum of personal and cultural meanings. The continuum which Burgess has in mind is not, it seems, characterized by ontological differences; it is not a hierarchy of aesthetic achievement, but a spectrum of meanings. For an account of changing historical views on this issue, see Field's article.

We should need, then, to recognize that what is regarded as 'modest' and what is regarded as 'full-blown' are cultural decisions which appear to bear little or no relation to the appearance of the artefacts. The situation can exist where the 'modest' communicates in a public sense, while the 'full-blown' remains culturally inert.

The concept of 'modest' in this discussion is conceptually close to the emotive, unpremeditated responses to art which Rouve in her article sets out to validate as the foundation for discriminating judgments of the aesthetic. In a similar vein Margaret Bryant (1972) claims that popular, 'leisure-pursuit history—even amid romantic trappings' is characterized by elements which 'seem to be aesthetic and historical' and which establish 'exhilarating contrasts with the present, nourishing both the intellect and imagination'. Bryant claims that popular, leisure-pursuit history is not different in kind from academic history. If this is so, we suggest that what may be needed in education in the arts is an overt recognition that the 'modest' and the 'popular' can carry experiences which characterize a *total* art experience. When this recognition is not freely given, 'education' in the arts may unwittingly destroy just those qualities on which cognitive and feeling states are built. Indeed, it may be argued that the descriptions 'modest' and 'full-blown' become redundant in association with the experience of art.

When we examine the relationship among the arts we find a number of contentious and sometimes puzzling issues to engage the attention of the student of art education. One such issue may be set out as follows. Common to all the arts is the aesthetic

experience; yet this experience finds embodiment in different forms. This presupposes that we have a *concept* of this experience in the abstract, disembodied from the form in which it is expressed in the various arts. Yet in practice it is often maintained that our experience of art must derive from an embodiment in an art form (see Reid, 1969). If this is so, then the meaning of imagery in the arts must depend upon our apprehension of the particular form in which it is embodied. This seems to indicate that, for the conceptual artist, the concept is the form.

In the relationship among the arts lie some of the most difficult questions that face the art educator. Normally the practitioner or spectator cares not a whit for these questions; they tend only to assume importance either in an inquiry into the relationship among the arts, or when integration in the arts in the curriculum is being considered.

The most fundamental questions must be: what exactly are the similarities among the arts, what the differences? Growing from these questions are the complementary ones: how may we define the boundaries between the arts and how firm are they? Indeed, is it any longer possible to draw such boundaries at all?

An intriguing question relates to the criteria for originality: how is the concept of originality transformed by the degree of flexibility in a score, used by a performing musician or by a painter, but composed by someone else? Such a score might be at any point on a continuum, one end of which would be in the form of instructions leading to a preconceived production; while at the other extreme would be cues for making an unpredicted work. Perhaps this last point has to be of special interest to teachers of the arts.

Apparently intractable issues inherent in society, in art and in education—only a few of which we have lightly touched on here—are often treated in greater depth in the articles and are discussed in the Symposium. The reader will no doubt identify further issues and will wish to argue them out. He will often find that such argument takes him to the very heart of the study of art education.

7

It is not only the *study* of art education which is subtle and complex; the teaching of the arts is correspondingly perplexing. The claim has been made in this Introduction that in the study of art education

the experience of art provides the criterion by which to decide the relevance of contributory studies. By the same token it may be claimed that the experience of art is the criterion by which to define culturally relevant curricula in the arts.

When the arts in education are seen as a means towards behavioural changes in individuals and in society at large—changes which are extrinsic to the experience of art itself—then 'goals of art education cannot be determined without reference to the populations to be educated' (Eisner, 1972, 4). Although such an education through the arts may be characterized by the merit of cultural and even personal relevance, it may not be axiomatic that it would necessarily meet the criterion of *significance*; it may have the merit of aptness and even usefulness, but it may lack the drive of the pupil's commitment. One may indeed doubt whether relevance can ever determine significance. But the converse may be true; if one asks if significance can determine relevance, the situation is transformed from a theoretic into a dynamic issue. When viewed in this way the 'essentialist position' which claims that 'the most valuable contribution that art can make to human experience is that which is directly related to its particular characteristics' (Eisner, 1972, 5)—characteristics which are inherent and unique— the *significance* of this experience becomes the measure by which relevance is assessed.

There is little doubt that objectives for art education which are extrinsic to the art experience are justifiable in personal and social terms; but if these objectives were to violate the significance of art to the participant, such objectives would be called into question. This conclusion comes close to that of Eisner (1972, 9) when he writes:

> Although these various (extrinsic) justifications are appropriate under certain circumstances, they do not, it seems to me, provide a sufficiently solid base for the field of art education. ... The visual arts deal with an aspect of human consciousness that no other field touches on: the aesthetic contemplation of visual form. ... In short, we can learn the justification of art in education by examining the functions of art in human experience. We can ask, *What does art do?* To answer this question we need to turn directly to works of art themselves.

In the Symposium an attempt was made to answer the question, 'Is it necessary to make art in order to teach art?' Supposing it is

thought to be 'desirable' (and there was considerable support for this view), is the making of art *sufficient* preparation? It would seem to be important for everyone preparing to teach the arts to contemplate this question. In colleges of teacher-education practical involvement by students is implicitly understood to be preparation to involve others in the *making* of art; whereas discourse about the arts—history, criticism and description—is implicitly taken to be preparation to involve others in *response to* the arts. Rarely is it explicitly understood that both kinds of participation could provide insight into teaching for both kinds of involvement.

There may be individual teachers and students in the arts with exceptional endowment to achieve access, vicariously, to the experience of art in other people, not simply in their response to the artefacts made by others, but in discussion with them, through autobiographical writings, through television and film explorations of the artist's procedures and attitudes. Research is needed to discover the extent to which this exceptional endowment is related to personality and to environmental opportunity. Certainly the opportunity to explore the attitudes of others to their creative involvement is considerable in the West at the present time, but only rarely is this opportunity fully recognized as an important source of insight in teacher-education programmes.

There is, however, an important point to be made in conclusion. Personal involvement in the arts, as maker and as onlooking and listening participant, is valid for the act of teaching only to the extent to which it provides *generalized* insight. There is always the danger that insight may remain too egocentric and too eccentric, and so distort the teaching function. By the same token our experience of art may limit our *study* of art education—unless we develop the capacity for empathy and the *will* to seek greater communion with others. It is here, ultimately, that 'discursive language ... is quite unequal to such a task'. In the light of this we may do well to examine Gordon's claim (1972) that through the arts man 'has discovered a language which least distorts the original message ...'

References

Bannister, D. (1966), 'A theory of personality' in Foss, B. M. (ed.), *New Horizons in Psychology*, Harmondsworth: Penguin.

Barkan, Manuel, Chapman, Laura H. and Kern, J. (1970), *Guidelines: Curriculum Development for Aesthetic Education*, Ohio: Central Midwestern Regional Educational Laboratory Inc. (CEMREL).

Bryant, Margaret (1972), article on the teaching of history, *The Times Educational Supplement*, 47, 24 March.

Dewey, John (1934), *Art as Experience*, New York: Putnam.

Ecker, David (1966), 'The artistic process as qualitative problem-solving' in Eisner, E. and Ecker, D. (eds), *Reading in Art Education*, Waltham, Mass.: Blaisdell.

Eisner, Elliot (1971), 'Media, expression and the arts' in *Studies in Art Education*, vol. 13, no. 1, Fall, National Art Education Association.

Eisner, Elliot (1972), *Educating Artistic Vision*, London: Collier-Macmillan and New York: Macmillan.

Gordon, Rosemary (1972), 'A very private world' in Sheehan, Peter (ed.), *Function and Nature of Imagery*, New York: Academic Press.

Phenix, Philip H. (1964), *Realms of Meaning—a philosophy of the curriculum for general education*, New York: McGraw-Hill.

Reid, Louis Arnaud (1969), *Meaning in the Arts*, London: Allen & Unwin and New York: Humanities Press.

Trilling, Lionel (1965), *Beyond Culture: Essays on Literature and Learning*, Harmondsworth: Penguin Books, in association with Secker & Warburg (London).

2 Art: mistress and servant of man and his culture

Rosemary Gordon

Introduction

From the very dawn of his existence man has made art. From the very dawn of his existence man has played, has doodled and has decorated his body and his artefacts. Before he had learned to domesticate animals or to ensure his food supply by the cultivation of plants, and long, long before he had invented the wheel or primitive pottery or mining or smelting, man had developed a pictorial art, vital and excellent in both style and execution as we have discovered in the caves of Altamira in Spain, Lascaux in France and in Africa. Though naked, in danger from many animals stronger or taller or faster than himself, and struggling for his livelihood in a world which his physical changes had rendered less munificent, primitive man nevertheless spent time, energy and inventiveness on what is not, on the face of it, a primary and material necessity.

Our daily experience through introspection or through encounters with others tends to confirm that there is in man a fundamental need to make forms—visual, verbal, musical, or kinaesthetic—through which to express feelings, experiences, thoughts and beliefs. Indeed, for the sake of the chance to make—or to experience—meaningful forms a man is prepared to sacrifice a great deal; and for its sake many have proved themselves willing to suffer all the discomforts of doubt, anxiety and isolation.

I have often felt surprise that all this evidence of man's age-old aesthetic sense and his seeming compulsion to make art should have affected so little the general thinking about the nature of man or the understanding of his basic needs and basic goals. It is true that Jung (1960a, written in 1937) was early on in this century so impressed by it that he suggested that creativeness is in fact one of

the five primary instincts in man. But the general climate of opinion was not yet ready to accept this view. The sciences of man took little account of it until the recent emergence of the humanistic psychologists, like Maslow, McClelland and many others. This trend has in fact avalanched into a spate of 'creativity' experts, theorists and testers. It is slowly becoming part of our *Zeitgeist*; disappointment, despair and disgust with the effects of science and technology on the quality of man's life are no doubt playing their part.

Though most men experience the urge to express themselves and to make forms, only a few can be described as 'artists', as having made 'art'. The difference, which I suggest exists between on the one hand the form-making and form-seeking person and on the other the inspired artist, may become clearer towards the end of the article. All I would like to say at this point is that some of the differences seem to rest on the artist's superior endowment of specialized sensori-motor skills, on his unusually extended range of imagination and empathy, and perhaps on his being possessed by a particularly imperious need to find meaning.

Before I embark on a discussion of the psychological and the social influences on artists and art forms I need to describe some of my reflections concerning the nature of 'art' and the nature of 'beauty'. These two phenomena—art and beauty—are frequently identified and confused with one another; and indeed there are many critics and art historians who believe that neither can exist without the other. This then leads them to claim that everything that is beautiful is art and, more importantly, that there can be no work of art which is not beautiful. Though frequently closely linked, such complete identification is questionable; for instance, a 'work of art' essentially refers to an artefact, to a man-made object; yet the quality of beauty is frequently discerned and ascribed to nature and to natural objects. What is more, a sense of what is beautiful is not altogether absolute and universal but is much conditioned by social, cultural and personal factors—even though, as I will suggest later on, there may exist some basic formal relationships of shapes, composition and rhythm which evoke in most men an aesthetic experience. Again, a work of art is not always, or necessarily, 'beautiful'. The primary purpose of a particular work, for instance, may be to provoke a particular emotional reaction or to shock the observer out of an old mode into a new mode of awareness and

understanding; in order to achieve this the artist might quite deliberately flaunt some existing aesthetic convention.

We, in the West in the twentieth century, know only too well that many works of art, which had at first been greeted with thunderous accusations of 'ugliness', have after a time come to be accepted as powerful and impressive and perhaps even beautiful. The works of Henry Moore and Picasso are cases in point.

The 'aesthetic', the 'beautiful', I would suggest, addresses itself primarily to our senses; these produce an experience of satisfaction when a harmony of formal relations is present. Yet though aesthetic experience is primarily sensuous, it can also be affected by emotions and interests: the beauty of the countryside, for instance, of mountains, lakes and the star-splattered night sky was really only rediscovered and 'seen' by the Romantics of the late eighteenth and the nineteenth centuries.

Herbert Read (1943, 23) has suggested that artistic activity can be divided into three stages: the first two—perception of the material qualities (sounds, colours, gestures, etc.) and the arrangements of these material qualities into pleasing shapes and patterns—comprise the aesthetic ingredients, while the third stage—when the arrangement of the perceptual pattern is made to correspond and to express states of emotion and feeling—is the stage of art-making proper. This analysis of art-making into an aesthetic and an expressive stage seems to me to be valuable, so long as this distinction is recognized as relative rather than absolute. For, just as the aesthetic experience can be affected by emotions, so the effect of the expressive, the third stage, must depend, to some extent at least, on the aesthetic sense finding some minimal satisfaction. The distinction between the aesthetic and the expressive aspects of art will also be relevant later on in this article when I try to trace some of the social and psychological factors which play a part in the making and the appreciating of art. When I speak of art I may not necessarily confine myself to the visual arts only, but may in fact refer to other art forms like literature, music, dance and drama. Admittedly the historic evidence of man's compulsive art-making rests predominantly on the visual arts; for the visual artist, when he had used such relatively indestructible material as caves, stones, metals or pottery, had been able to confide his work to posterity; he had thus stolen a march on the makers of literature, music and dance long before the art of writing came to rescue the latter from

oblivion. But in individual development also the plastic arts seem to attract the attention of child and child observer sooner than do the other art forms. Maybe this is in part due to the general importance of primacy of vision in man, though I suspect also that it occurs because we can translate visual experiences into verbal and conceptual forms more easily than any of the other sensations. Clearly auditory and kinaesthetic experiences occur in the infant at least as early as visual ones and may serve equally well as channels of expression. Yet, while the study of child 'art' already has a long and respectable history, the study of child movement and child music is only just beginning to get off the ground.

1 Psychological forces

This article rests essentially on my belief that a man is shaped by a combination of psychological, social and cultural-historical forces and that, as a consequence, the making of art—this, to him, most meaningful activity—cannot help but reflect these multiple influences and pressures. Thus art can serve—in fact has served—to express and to give form to concerns and conflicts a man may feel in relation either to himself or to his social group; it may question, confirm or reinforce existing links and beliefs, or it may make manifest personal experiences or explore potential moral values.

It may be helpful if I introduce the description of those psychological factors involved in the making of art by summarizing what I regard as some of the basic needs that power man's will-to-form and impel him to make art. I believe that there are four major groups of such needs, all interrelated and intertwined with each other:

first is man's need to clothe his internal images in forms existing outside himself;

second, and closely related to the first, is his need to relate as much as possible of what goes on inside himself to the outer world; art is for him, then, a sort of bridge between what is inside and what is outside;

third is his constant, and, I believe, everlasting need to make sense of death, of life and of his place in the universe;

fourth is his need to communicate with others and also to commune with them, that is to achieve moments when he can shed awareness of his separateness and share with others some significant and possibly ineffable experience.

Perception

Turning now to the description of the various psychological mechanisms, I shall start with perception. To take this first is really quite logical. For all art is sensuous form and depends on the artist's capacity to relate to sensuous form; he does this, of course, through his sensory equipment. It is in his will-to-form, in the valuing of his senses and in his fascination with the sensuous world around him that the artist differs so essentially from the mystic whom he often resembles in many other respects. For both mystic and artist seek with particular passion for meaning, for order and for unity behind the discontinuities, diversities and disjointedness of the world of appearances. And both seem endowed with an unusual capacity to look at the world again and again with innocent eyes, as if they saw it for the first time; and so they open themselves to the experience of wonder and awe. But while the mystic in his desire for passivity and fusion with the All tends to reject the body, sensations and the sensuous, the artist is driven and compelled to 'endure the ordeal of return' (Blake) and to seek again and again to fashion forms that might express his experience. Far from trying to sacrifice body to spirit, the artist battles to relate them, to unite them one to the other. The perceptual processes are thus of particular importance to him, for they relate him to the world and they enable him to furnish the world.

Perception is one of the psychological processes which has lent itself to much experimental study in the psychologist's laboratory. In consequence there is a vast literature on the subject and several divergent theories. Briefly, the traditional idea that perception is a passive receptor mechanism which functions much like a camera has had to be abandoned. Instead (Arnheim, 1966, 33):

> far from being merely passive registrations, perceptions are creative acts of grasping structure even beyond the mere grouping and selecting parts. What happens in perception is similar to what at a higher psychological level is described as understanding or insight. Perceiving is abstracting in that it represents individual cases through configurations of general categories.

In other words sensori stimuli are automatically organized so that, for instance:

(i) a grouping of disparate parts results which makes for
 (a) the simplest available structure
 (b) a recognizable, familiar and nameable configuration;
(ii) size and shape of objects perceived is 'seen' to be closer to their actual shape and size than to the retinal image received when viewed from a distance;
(iii) expectation, need, interest and emotion, all affect perception directly.

The perceptual process itself thus demonstrates the mind's tendency to make figures and shapes, to close or gloss over apparently irrelevant gaps and to produce the best possible interpretation of the given sensori data. Consequently what matters in perception is not just acuity but conditions which facilitate reaction, in other words, recognition. Indeed, an owl which *sees* a mouse but fails to *perceive* it, will starve.

The arguments concerning the perceptual process are nowadays no longer concerned with whether perception is an actively organizing or a passively receptive process. Arguments are now merely about which factors are likely to distort what is perceived and by how much.

What is important in all this is the growing awareness that we can never see the world just as it is, but that the way we see the world is determined by a combination of its actual qualities plus the information, expectation, needs and wishes of the percipient.

Imagery

Intimately linked up with the process of perception is the phenomenon of imagery. An image can be defined as the perception of sensory data like forms, colours, sounds, smells, movements, objects, etc. in the absence of an actual external stimulus which could have caused such perception. This does not mean that such external stimuli have never been present in the past, nor that an image is independent of such past experience. But it does mean that at the time when the image occurs no such stimulus is present.

Clearly imagery is one of the most important influences which affect the organizing principles of perception. But while on the one hand they help to structure the multiplicity of stimuli which throng upon the organism they are also responsible for many of the perceptual distortions.

Imagery seems to be a universal phenomenon in man and possibly also in animals. The work of ethologists and their observations regarding the innate release mechanism suggest that there exists in most animals something in the nature of an image which functions like a trigger of instinctual responses when an appropriate stimulus presents itself. In the case of man imagery enables him to classify and to abstract, and to relate his present perceptions to past experience. This then aids the process of learning and adaptation; it also helps man bear present frustrations for the sake of future satisfactions.

Apart from seeming to be universal, imagery is also most pervasive in the psyche of man. It is secretly ever-present and enfolds him like a mantle. But this makes introspection difficult and we are therefore rarely aware that our perception of the world comes to us filtered through this diffracting medium.

There are a great many variables that characterize imagery and this differentiates one person's image world from that of another. Quite apart from the content, there is the difference in predominant sense mode—visual, auditory, kinaesthetic, etc.; there is the difference in degree of rigidity and flexibility, in degree of voluntary control, of faintness or sharpness of image and probably very many more await to be discovered. The existence of such differing image worlds, perhaps precisely because they easily elude introspection, can cause difficulties in communication between people and arouse suspicions of obstinacy or refusal to listen or understand. On the other hand their very variability enriches each one of us.

Images, unlike thoughts, cannot be validated socially, for there is no way in which we can communicate them directly to one another. Discursive thought and language are quite unequal to such a task.

However, through the forms of art man has found a way of breaking the seal that locks him fast into that part of his inner world. Through the arts he has discovered a language which least distorts the original message and which is as closely as possible analogous to the essential nature and quality of the original message.

Here then, so I believe, lies one of the strongest impulsions for art-making. Because of the privacy of the image world on the one hand, and the need to communicate and to validate his inner world on the other, man, I believe, has made art and will continue to make art. Furthermore, though art may be the most adequate way of giving substance to images, it can never do it perfectly. Art-makers

rarely fail to experience disappointment, which may verge on despair, when a work has been completed. For it never is, and perhaps never can be, the exact match of the internal image with all its qualities and characteristics. This discrepancy between image and art work ensures that there cannot be a final, a definitive work of art.

It is perhaps worth considering here the connection between 'image' and 'imagination'. Many writers tend to use these two terms interchangeably, as if they had the same meaning. Clearly there is a direct etymological link; yet they do refer to different processes. An image is a representation of a sensuous and individual experience, and I regard it as the raw material of imagination. Imagination is a dramatization of images, images which have been assembled together and 'produced', so that they tell a story which has emotional rather than cognitive urgency. Thus the image in relation to imagination is like a still picture in relation to a moving film. Such interdependence clearly makes imagination in the absence of images quite unthinkable.

Symbolization

For the student of art education the study of images leads on directly to the study of symbols and the process of symbolization, for images and symbols are intimately connected. Herbert Read (1964, 25) for example, writing in 1952, described the symbol as 'an image plus its mental associations' and he has defined it further (1960) as 'a throwing together of tangible, visible objects either with each other or with some immaterial or abstract notion'. Read quotes Cézanne as saying that 'I paint in order to realize my sensations'; he suggests that this remark illustrates the essential nature of art, which has to do with an objective symbol being made for a feeling or emotion. The philosopher Cassirer (1953), in 1944, also ascribes to the symbol the function of transforming a sense image into a metaphor image, while Susanne Langer (1941) suggests that in a metaphor the image of the literal meaning acts as the symbol for the figurative meaning; and both Langer and Cassirer describe man as a symbol-making animal. Most modern thinkers seem therefore to believe that imagery is the essential material out of which symbols are made.

Symbolization implies the experience of links between disparate

and distinct entities which then enable man to concern himself with individual and separate objects as well as with universals, that is to say it enables him to concern himself with facts as well as meanings. Lévi-Strauss (1963), the anthropologist, is also very aware of this function of the symbol as a bridge between two different levels of experience when he defines symbols as 'meaningful equivalents of things meant, which belong to another order of reality'.

When one discusses perception and imagery one really discusses mental contents, the furniture of the mind, as it were. But what is finally really important is the use made of these contents and the attitudes adopted towards them. Perception and imagery are like the figures written on a cheque. Only the signature can transform these figures into more than ink-marks on a piece of paper. Not all images are symbols; we may delight in their presence and wish for no more. But when we regard them as tokens of a different reality, when, like Blake, we 'see a world in a grain of sand', then the process of imaging has been extended into a symbolic experience. This use of perceiving and imaging is most frequent and most complete in the act of making art. For, in the words of Arnheim (1966, 12), 'art is the most powerful reminder that man cannot live by bread alone' even though many try to 'ignore the message by treating art as a set of pleasant stimuli'. As I have suggested earlier in this article, the artist—like the mystic, of whom Jung (1963, 375) has said that he is alone in bringing creativity into religion—is driven to his work by a passionate need to find meaning and to span the gulf between the world of sensation and the world of dreams.

The capacity to symbolize, that is, to experience simultaneously the known and the unknown, the concrete and the abstract, the I and the Not-I has a history, a developmental pattern which can be either furthered or obstructed. Nowadays many psychodynamically orientated psychologists would describe the evolution in the individual of the symbolic function as follows:

There is an original state of experience—variously named 'the oceanic state' (Freud), 'the original self' (Jung, Fordham), 'the primitive ego' (Fenichel), 'the ego-cosmic phase' (Federn), 'the primal psycho-physiological self' (Jacobsen), 'the true self' (Winnicott)—when there is as yet little differentiation and little experience of boundaries, of inside-outside, I and Not-I. Then, as result of a growing need for independence, separateness and uniqueness, a certain amount of differentiation occurs, so that the

individual recognizes himself as a separate entity; but only when the major psychic institutions—such as Id, Ego and Super-ego in Freud's schema, and Ego, Shadow and Self in Jung's schema— have been established and consolidated can the symbolic function, the 'as if' attitude, as Jung has called it, develop. The emergence of the symbolic function is then a sign that the stage has been reached when the individual makes attempts to re-relate to one another his need for the personal and unique and his need for containment, togetherness, union and meaning.

The ancestors of the symbolic function are first of all direct experience, the sensations. Then develops an intermediate stage which Segal (1957) has described as 'symbolic equivalence', when there is the tendency for two or more separate objects or activities to be thought of in such a way that the reality of one of them is denied, so that it becomes quite identified with the other. When finally symbolization is achieved, the 'as-if' attitude, then recognition of the similarity of objects coexists with awareness of and respect for their separateness.

Much misunderstanding occurs when the term 'symbol' is applied to some particular content of the mind—be it experienced as existing without or within the person—irrespective of whether or not it is accompanied by the symbolic attitude. Surely it is the intrinsic quality of a symbol that it conveys meaning; in other words that it deals not only with the sensory qualities of an object presented, but with its relations, beyond itself, to other objects and experiences. Accusations of such confusion can be levied justifiably at a clinician like Jung, when (writing in the thirties) he strays from his own premise concerning the symbolic attitude and instead identifies the archetypal *image* with a *symbol* (1960b, 402): 'but beside that (the intellect) there is a thinking in primordial images, in symbols which are older than the historic man'; or (1958a, 89): 'a study of the natural symbols of the unconscious . . .'. It can also be levied at those art historians who confine themselves to a formalistic view of art, when they consider art as primarily an aesthetic experience; they are probably tempted to this view of art in an unconscious effort to fend off art's wider and potentially more disquieting qualities.

But we must also remember that between the sensation and the symbol lies the sign. This is indeed a very important issue and it divides Freud's concept of art from Jung's concept of art very

sharply. The difference between symbol and sign has been most tersely described by Weizsacker, quoted by Read (1960, 36): 'A sign which cannot be made superfluous simply by pointing to the object we shall call a symbol.' Freud failed to make this difference between symbol and sign. For Jung the difference was so crucial that it led him to propose that works of art fall into two distinct groups: those which are in the visionary and those which are in the psychological mode. Art in the visionary mode, he claimed, is informed essentially by truly symbolic forms and contents; but art in the psychological mode derives primarily from the personal interests, preoccupations and neurotic conflicts of the artist. He believed that when Freud interpreted art-forms as sublimations of unconscious urges and phantasies, that is as socially acceptable 'symptoms', he concerned himself with art in the psychological mode only. Whether the actual work of art warranted it or not, Jung did not deny the existence or the value of such works, but he questioned whether they could ever be considered as great art. Great art, he wrote in 1922 (Jung, 1966, 71), tended to be in the visionary mode: 'The special significance of a true work of art resides in the fact that it has escaped from the limitations of the personal and has soared beyond the personal concerns of the creator.'

The distinction between sign and symbol meets, I think, Arnheim's criticism (1966, 217) that the symbol, as conceptualized by Freud, lies only on the horizontal axis which connects the symbol to the referent and thus leaves out of account the vertical axis which alone can indicate that symbol and referent belong to different levels of abstractness. Arnheim cites as an example a piece of pottery and the maternal womb: both belong to the genus 'container', but they are distinguished in that one is made of clay and the other of flesh and blood. This makes their logical position homologous and reversible. But the psychoanalyst who considers the vase to be a symbol of the womb makes the association one-sided and subordinates the one to the other. The two objects are thus really dealt with in terms of symbolic equation rather than symbolization, and a *necessary* connection is ignored in favour of a merely *possible* one. Surely only an examination of the actual attitude brought to bear on the relationship between these two objects can discover whether in any particular instance they stand to one another on a horizontal axis which could also make them

signs of one another—or else on a vertical one, in which case their relationship would be 'symbolic'.

Returning to the psychological origins of the symbolic function in the individual: one of the most important contributions to our understanding of its development and its relevance to art and to the other creative activities, which I feel must be mentioned here, is Winnicott's concept of the 'transitional object'. In his paper 'The location of cultural experience' (1967), Winnicott himself shows to what wider use this concept can be put. It may well prove to be a bridge connecting the inner world of phantasy to the outer world of culture. Already in 1953 Winnicott wrote as follows (1958, 230):

> It is usual to refer to 'reality testing' and to make a clear distinction between apperception and perception. I am here staking a claim for an intermediate state between a baby's inability and his growing ability to recognize and to accept reality. I am therefore studying the substance of *illusion*, that which is allowed to the infant, and which in adult life is inherent in art and religion, and yet becomes the hallmark of madness when an adult puts too powerful a claim on the credulity of others, forcing them to acknowledge a sharing of illusion that is not their own. We can share a respect of *illusory experience*, and if we wish we may collect together and form a group on the basis of the similarity of our illusory experiences. This is a natural root of grouping among human beings.

In the child's attachment to a 'transitional object'—a teddy bear, a blanket, a sucking vest or whatever—and in his claim to own and to possess it, Winnicott recognizes the earliest expression of man's creative drive, of his symbolizing capacity and of his concern with meaning and with the question 'What is life all about?' For the transitional object is both given and created, and is the child's first attempt to reconcile reality and phantasy, inner world and outer world. The importance of this object, Winnicott insists, is not its symbolic value but the fact of its actuality, and so it demonstrates the potential positive quality of a paradox, when it is accepted. In this reconciliation of reality and phantasy lies the foundation of what he has called the 'third area' or 'the area of experience', which then becomes the source of play, imagination, culture, religion and art.

Profiting from this imaginative linking of man's most sophisticated pursuits with one of his earliest ones, Winnicott makes some challenging comments about culture itself. He proposes, for instance, that culture is the result of the interplay between originality and inventiveness on the one hand and of the acceptance of tradition on the other; it therefore represents a creative integration of man's need for separateness and uniqueness and his need for fusion and the experience of belonging. Extrapolating from this model he then suggests that a plagiarist—committing the unforgivable sin in the cultural field—is someone who cannot relinquish enough the state of fusion and identification and so he walks around in other people's clothes, despairing of ever being able to have or to make his own; while that artist who isolates himself and denies the relevance and value of all tradition is really also in a state of fusion and identification, but in his case it is with the Great Maker Himself; this prevents him then from emerging out of the state of primitive omnipotence. Neither, therefore, have come to terms with the reality of either the external world or their own personal existence.

The importance of the discovery of the 'area of experience' lies in the fact that we can now locate that psychic area where sensuous experience meets imaginative invention, where cognitive activities are brought into relationship with emotional activities and where the need for order and meaning finds expression in the discovery or creation of forms that embody experience. Winnicott makes clear why playing is such a crucially important forerunner of creative work when he points out the link between the emergence of play activity and the development of the area of experience. He also suggests that playing is characterized by a 'near-withdrawal state akin to the concentration of older children and adults', that it happens in a space-time continuum 'when instinctual arousal is not excessive' and that it consists in the 'manipulation of external phenomena in the service of the dream'. And he believes (1971, 51–2) that there is a 'direct development from transitional phenomena to playing, and from playing to shared playing, and from this to cultural experiences'.

The importance and seriousness of playing have for a long time been underestimated. Yet in my therapeutic work I am left in no doubt that a person who cannot play, whose perfectionism, obsessional defences and fear of criticism do not allow him to play, is

banned from the joy of making and creating and is crippled in his capacity to feel truly alive. Already long ago some students of man had recognized this. 'The creative activity of imagination,' wrote Jung (1954, 46) in 1931, 'frees man from his bondage to the "nothing but" and raises him to the status of one who plays. As Schiller says, man is completely human only when he is at play.'

Creativeness

A word needs to be said here about the creative process itself. It has so often in recent years been defined in terms of novelty or originality while criteria of value or meaningfulness have tended to be passed over. This unbalance in the definition of creativeness has really led to a good deal of confusion both in the evaluation of works of art and also in the very construction of the so-called 'creativity tests', where quantity and fluency of association have often quite displaced consideration of relevance or realism in the answers given to the test questions.

As regards the creative process itself, the study of biographies, autobiographies, etc. has led us to believe that there are four main and distinct stages: two of them—the initial, the preparatory stage and the last, the stage of critical testing—do demand the activity of consciousness, of the ego functions. But the other two—the stage of incubation, which Stephen Spender, the poet, has described as the experience of 'muddled suspense', and the stage of illumination, when the state of 'creative emptiness' is suddenly filled by an answer 'as if by the grace of God'—depend on the capacity to become passive and receptive and to set aside conscious ego activity. Kekulé, the discoverer of the benzene ring, admonished his colleagues as follows, showing a most sensitive understanding of this necessary interaction of conscious and unconscious activity in creative work: 'Let us learn to dream, gentlemen—then perhaps we shall find the truth. But let us beware of publishing our dreams before they have been put to the proof by the waking understanding' (attributed to Kekulé).

Exposure to the impact of both conscious and unconscious processes demands of the individual that he be able to tolerate both doubt, tension, anxiety, excitement, and fascination on the one hand, and effort, perseverance and possible disappointment on the other. And it seems to me a possible hypothesis that what

distinguishes a neurotic use of conflict from a creative use of conflict is the absence in the latter of resentment at discomfort and suffering.

Archetypes and the self

Before I conclude this part of my article I must briefly outline three concepts in Jung's work as I will have to refer to them further on.

The first is his concept of the *archetype*. This is really a metapsychological model to account for the recurrence and apparent universality in man of certain experiences and images, the archetypal images. Jung has defined the archetype as the psychic representation of the biological-instinctual drives. In other words, archetypal images are the instinct's perceptual constituents which help release instinctual activity in relation to the appropriate external objects. They form, as he puts it, writing in 1942 (elsewhere, 1958b, 149 notes), the 'structural dominants of the psyche in general' and 'may be compared to the invisible presence of the crystal lattice in a saturated solution'. Jung has been concerned primarily with archetypal images of persons and processes. Students of art and the aesthetic impulses may, however, need to extend this concept so that the archetypal images come to be recognized as being concerned not only with subject matters—persons and processes—but also with formal elements and structures.

The second concept I need to outline here is Jung's structural model in which he divides the psyche into two dialectically related areas—the *ego* and the *self*. This model of an ego and a self helps us to perceive the permanent state of tension between the internal demands for separateness and for union, between the drive towards differentiation and the drive towards non-differentiation. While the ego is conceived as being primarily concerned with identity, boundary and personal achievement, the concept of the self has been developed to account for the experience of symbols of completeness and totality, for the feelings which Freud has described as 'oceanic' and for that living awareness which transcends one's personal self and reaches out to what Iris Murdoch has called the 'un-self'.

The third concept, the concept of *individuation*, refers to that process which links—or re-links—the institution of the ego to that of the self. Individuation aims at the achievement of a synthesis of

some of the aspects of both the conscious and the unconscious processes and phantasies, and points towards a final, unknowable, transcendental centre. It leads a person to the experience not only of his own individual uniqueness, but also of that which transcends him both within himself and without; it thus provides conscious awareness of the life of the non-ego.

2 Social and cultural forces

Having discussed, all too briefly, some of the psychological processes which seem to me to be intimately related to the making of art, I want to turn now to some reflections about art in terms of the links that bind it into the structure of the various forms of society. In doing so I will inevitably have to question some of our own implicit notions about the artist and about the nature and the purpose of art.

Fine art and applied art

The distinction, for instance, between 'fine arts' and 'applied or useful arts' is, even in Europe, of relatively recent origin. It seems to date back to the beginnings of the Renaissance in the fifteenth century. Such a distinction does not exist in so-called primitive societies, where art works have a distinct function in the religious and social life of the group, or in their socially defined inter-personal relationships. But such societies usually make a difference between sacred and secular art. This may not be conceptualized or verbalized by them, but it is certainly quite apparent if one examines their rules and taboos which apply to the making and the handling of sacred art in contrast to the greater freedom and permissiveness they allow in the making of secular art. Jean Gimpel in his provocative book *Contre l'art et l'artiste* (1968) accuses post-Renaissance society of introducing, almost inadvertently, an attitude of religious worship in relation to the 'fine arts'. This may be a very valid observation. But his explanation in terms of the primacy and the pressures of the cash economy may not really be sufficient. For the modern distinction between fine art and craft art could be a continuation and a translation into the modern idiom of the age-old and apparently universal opposition between sacred and secular art, fine art fitting itself neatly into the niche vacated by sacred art. Thus

though the themes have become secular, the attitudes remain stubbornly 'religious'. Again, though our aesthetic sensibility coincides so often with the aesthetic sensibility of a quite alien people, yet the way this is expressed frequently differs: while Western man tends to describe his experience as a response to the 'beautiful', the 'simpler' man often ascribes it to the work's 'power', its 'magical efficacy' or its devotion-inspiring quality.

An African tribe: the Dan

Let me take as an illustrative example the Dan, an African tribe investigated and described by Vandenhoute in 1945 and discussed more recently in 1957 by A. Gerbrands (1971, 366–82). This tribe, living on the Ivory Coast, has such a vast array of art objects, serving all sorts of social purposes and ranging over a whole scale of sacred and secular activities, that a description of them here may give an idea of the use of art objects in some African cultures.

First and most important is the making of masks. The mask is believed to be the most direct representative of a supernatural being. According to the ideas of the Dan and their various sub-tribes, there exists a unique, omnipotent and anthropomorphous Supreme Being, Zlan, who has created everything that exists. But this Supreme Being is so exalted and so far removed that mortal man needs the intercession of the ancestors, whose spirit had, at death, entered the supernatural sphere. However, even the ancestors cannot be approached directly, but only by means of the masks and then only if the approach has been initiated by the highest spiritual functionary, the 'go-master' or 'go-priest'. In other words there is a ladder with five rungs in the spiritual hierarchy of the Dan. It starts with man and then moves on to 'go-master', mask, ancestor and finally Zlan. The mask is the crucial mediator between human and divine.

There seems to be no special procedure of selection of the sculptor of masks, and many factors like family tradition, talent or personal choice can play their part. However, being a sculptor is amongst the Dan a vocation, not a profession, for there is no economic reward. The 'sculptor' therefore carries on with his normal occupation, which means farming for most of them, though amongst the related tribes, like the Gere and the Wobe, the sculptor is often also the medicine man, a combination that occurs frequently

in other parts of the world. But even when there is no economic reward, the sculptor tends to enjoy considerable social prestige; this can make him become rather self-important and overbearing for he may feel that he has been specially chosen by the Supreme Powers, Zlan, or more likely the ancestors.

As the mask is invested with such great power, even the tools, with which it is made, are sacred and capable of influencing not only the success of the work but also the health of the artist.

While making the mask the sculptor always works alone, in isolation, carefully guarded against being seen by either women or non-initiates. And he must abstain from sexual intercourse even before he begins his work. Yet many of the artists confessed that the sight of a beautiful face or of a handsome man or woman had at times impressed them so much that they had felt drawn to retire into solitude in order to make a mask—though the mask was in no sense a portrait of what had inspired them. The sight of beauty had simply sparked off their need to create, to make form.

The taboo on sexual or any other contact with women when a man is engaged in creative work is very widespread indeed. This is really very interesting because these simple societies institutionalize and so give social sanction to a mode of reaction which students of modern art have often interpreted as a sign of sickness and abnormality, and as a proof of Freud's belief that the artist is a neurotic who has escaped from his neurosis through art. And yet famous remarks like Balzac's that 'A woman with whom one sleeps is a novel one does not write' or Charles Baudouin's conclusion that 'the moment a sexual desire is satisfied the aesthetic equilibrium is upset' seem to reveal an intuitive rediscovery of the complex interrelationship between sexuality and artistic creation which man had early on recognized and accepted.

The Dan also believe that in order to please the ancestors a mask must be 'as beautiful as possible' (Gerbrands, 380). These people recognize that whether a mask approaches such an ideal or not, necessarily depends on the capability of the artist, who is thus very aware of his responsibility. The criteria for beauty seem indeed to parallel some of our own. Both Himmelheber and later Vandenhoute discovered this when they compared their personal assessment of the aesthetic qualities of a mask with those of the 'connoisseurs' among the Dan. It appears that symmetry, balance, rhythm and harmony are quite consciously striven after by the Dan artist who

2*

will examine critically and from all sorts of angles the sculpture as it grows under his hand. Thus, though the principal function is a socio-religious one, aesthetic considerations nevertheless play a most important part. This adds to the evidence that the need for 'good' form is part of the aesthetic impulse in man which seeks expression whenever it can.

It is probably the promptings of this aesthetic impulse which the sculptor feels as so particularly tiring and arduous and which demands that 'his heart and head must always be *thinking*' while he works; but this same impulse also provides him with 'pure joy' when he successfully completes a work.

Not all the masks of the Dan tribe are in the service of Zlan and the ancestors. Many exist for specific activities like dancing, singing or begging; in other words they can also be associated with entertainment and other secular activities. The fact that the same mask can gain or lose rank—in terms of its role and function—suggests that form and function are not always or completely correlated.

Apart from the masks there are very many other objects made or decorated by artists: carved stools on which the boys sit during their ritual circumcision; 'dancing spoons' which the eldest wife uses during the dance which celebrates the return of her son from the initiation hut; and ordinary serving spoons; dancing staffs and staffs of office; birds to decorate the gables on houses; clubs, neck rests, musical instruments, wooden sandals; and any of the things used daily for more or less practical purposes or amusement can stimulate the artist's wish to exercise his skill.

Analysis of man's 'environment'

A discussion of the role of art and the artist in society must be accompanied by a quick scanning of the various facets of the 'environment' in which a man has his existence and which, in the absence of any other experience, tends to be accepted as 'natural' and 'universal'. This environment, which affects man, but is also affected by man, consists of four main categories:

(i) *The physical environment* The geographical and climatic conditions in which a man lives inevitably affect the way in which he can satisfy his biological needs for food, shelter and clothing. They affect also his perception of himself both in terms of the other

creatures with whom he has to share his world, and in terms of his perception of the 'space' within which he sees himself. Thus the world of a man living in a tropical forest must have a very different dimension from the world of the man in the wide open desert or by the wide open but living and moving sea; and to the inhabitant of a fertile plain or valley the world may seem more friendly and generous than it does to him who wrests a meagre sustenance close to the capricious but imposing heights of mountains.

(ii) *The skills and artefacts* A man also lives in a world fashioned to a greater or smaller extent by the knowledge accumulated by his people and his forebears, knowledge of skills and technical processes and knowledge about his world and how it works. Concomitant with this are, of course, the various artefacts, the man-made objects and tools—caves, huts, houses, means of transport, goods, etc.—which he may come to take for granted and which he may think of as little different from the natural objects around him.

(iii) *Social organization* Infinitely variable and infinitely complex may be the social environment, of which an individual is really simultaneously creator, carrier and creature. This consists of the organization, interrelationship and interdependence of the various social groupings which are formed in response to man's various biological, emotional, social and ideational needs. They themselves, by virtue of the way in which they satisfy—or fail to satisfy—these needs, tend to create new needs and new personality organizations; and these, in their turn, may call into being new social groupings and new social institutions. Thus there exists a complex dialectic between individual and social organization.

The kinds of groups which I have in mind as making a particularly important impact on each individual are, of course, first of all the *nuclear family*, consisting of a mother, father and siblings. This unit is clearly directly concerned with man's primary needs and appetites for food, protection and sexual relationships. Most frequently the members of the nuclear family have a joint home, though this is not necessarily so in the various polygamous societies. The nuclear family is related by links, clearly demarcated by specific rights, duties and etiquettes to the *extended family* of grandparents, uncles, aunts and cousins. This extended family group may be composed of the relatives belonging either to father's

family or to mother's or to both, and some or all of them may or may not share a common home with the members of the nuclear family. The links to the extended family can also be stretched further to comprise a whole *clan*, a whole *tribe* or even a cluster of tribes making up a *nation*. The members may thus feel that their unity is based on family ties—be they real or symbolic—though other common interests may, explicitly or implicitly, hold them together, such as common property, economic or strategic considerations, a joint language or adherence to a common system of beliefs.

Overlapping, more or less completely, with the extended family, the clan or the tribe, are the *neighbourhood groups*—the street, the village, the district, the town, the county and the country. And there are sometimes *age groups* which may or may not be sharply delineated from one another in terms of privileges, responsibilities and achievements. Other groups are based on skill, craft and profession. I am here thinking of the medieval guilds or the modern trade unions and professional societies. The skills, crafts and professions may either result from or be at the root of *social class*. Social class essentially involves a hierarchical social order and a differential distribution of power which may be based on wealth, on inheritance or acquisition, on conquest or the possession of special powers—of personality, of talent, of magical spells or of whatever is rare or valued in the society. Government, law-making and law-enforcing may also be carried out by a particular sub-group in the society based either on individual personality, on skill, on age or on class.

The character and the patterning of these various social groups make up the structure of a society. Its customs, conventions and etiquette might be described as the cement of that structure, for they implement and symbolize the relationships between the individuals and so translate social structure into personal experience.

(iv) *The supra-personal environment* Finally a man's 'environment' comprises the whole cluster of ideational conceptions and experiences—the moral values, the myths and legends, the magical techniques, the religious beliefs, the cosmological constructions—and, of course, the art forms and expressions. These may all either conflict with each other or cohere together more or less completely. And some of them, or all of them, may be safeguarded by social

institutions with their priests, shamans, magicians and the partici-
patory rites involving all or only a selected few of the community.

As we have seen in the case of the Dan, the artist's skill can be
enlisted or evoked by any of these various social groups and in
relation to any of their social functions and purposes. In the case
of the practical artefacts—the ploughs, the hammers, the axes, the
dwellings, the wheels, etc.—their purpose and function are relatively
clear and unambiguous; they can therefore be made to work whether
the artist has contributed to their manufacture or not—although he
may be tempted to express even there his aesthetic needs, by adding
to them decorative motifs or by fashioning them in forms that are as
sensuously pleasing as possible without interfering with their
efficient functioning.

Of course some of the artefacts themselves come to play a role
in the social organizations—as status symbols, for instance, or as
emblems signifying identifications, as objects of joy and amusement,
or as gifts variously expressing submission or domination, loyalty,
achievement or reward. In that case the artist may well be called
upon in order to help make them more imposing by making them
more beautiful.

However, it is also made clear by looking at the artist amongst the
Dan that his role and his involvement are most essential and most
serious in those activities that are concerned with man's relationship
to the supra-personal and supernatural world. Here he assumes
crucial importance, for he alone can 'embody' the invisible, the
abstract and so provide a community with shared forms and shared
images. For, as the Dan say, without a mask no contact is possible
with the ancestors and without this contact the community would
be doomed. And because the forms themselves evoke distinct
moods and emotional feelings they help persons to shed their
separate and individual reactions and to share instead in a joint
emotional experience.

The basis upon which rest the religious, spiritual and myth-
making institutions is man's need to *know*: to know his origins, to
know 'why' he and his group have come into the world, and to
know his place in the world. There is also his need to make order
out of his many and contradictory wishes, hopes and fears; his
need to surrender his separateness and to feel himself fused and
united with something that transcends him. But above all is his
need to know what comes after death; for no man can escape

awareness that life is temporary, that it has a beginning and will have an end. All these are questions to which there can be no rational answer. Intellect, knowledge, skill and technology can help man discover how things are made and how they work. But they are of no avail when he wants to ask *why*. And yet, so it would seem, few people can be content with answers to the *how*, most are impelled to ask the *why*, and to seek out the meaning and purpose of it all.

Only the artist's particular ease of access to imagery and imagination, his personal need to give form to feelings and visions, and his capacity to evoke symbolic experiences can respond to these needs and provide for them.

The social functions of art

But to step back once more and take a cooler look: Desmond Morris (1964) has suggested that art has served society in three main ways, depending on the society's priority of needs at any particular stage in its development. First, paleolithic man, for instance, living in caves and depending for his survival on hunting most likely used the artist's skill for the purpose of sympathetic magic. The primitive hunter might well have thought that if the artist could imagine a successful hunting scene and then create it as an image outside and external to himself, then perhaps his own wish could also result in an externalized object—the slain prey. The use of art in the service of sympathetic magic must have continued for a very long time, and so, I believe, it has never really quite ceased to have this role. Only the goals which we wish to create 'magically' have become less concrete and material. Even nowadays, when a work moves us deeply and creates in us images and feelings in ways that we cannot altogether analyse and comprehend, we still speak of its 'magic', its 'wondrous power', its 'awesomeness'.

Belief in the efficacy of sympathetic magic may furthermore have been underpinned by actual results, for modern psychological knowledge has helped us understand, through research on learning, attention, creativity and the study of the precepts of the Zen masters (Herrigel, 1953) that it is intense though semi-focused attention which enables man to use his skills as effectively as possible. Art works and prayer may in fact help to create the very conditions for such intense, semi-focused attention.

Second, society has used art as a means of passing on actual skills

from one generation to the next (one need only think of the famous 'lion hunt' from the Palace of Ashurbanipal); it has also used art in order to preserve through it a record of important events and so build up its 'history'. Just like the individual, so society also needs to ensure its continuation; it does this by 'implanting' in each of its members—and so across time—its knowledge, skills, beliefs and history. Before man had invented writing much of this 'implanting' was of necessity entrusted to the visual as well as the oral arts. But even after the invention of writing, as this skill usually remained confined to a privileged few in any society, the transmission of the social heritage, its lore and tradition, continued, as before, to be passed on through the arts. For instance, the numerous paintings of the 'stages of the cross' to be found in so many churches, had most likely not only a worshipful but also an educational function. Indeed, even today, the growing use of 'visual aids' suggests that the word cannot always easily replace the picture.

It is, however, Morris's third use of art which is particularly interesting, for here he postulates an inherent aesthetic need in man, which man in fact shares with the animals. One may indeed wonder why, for instance, the cave paintings of Altamira or of Lascaux, which are hidden deep inside the bowels of the caves, should have been made so well, why they should even now give us such real aesthetic satisfaction though their purpose has been primarily magical. Even the early flints and stone axes are not only well wrought, they are also wrought well; they are pleasing to touch and sight. The Dan assertion that the ancestors are better pleased—and therefore more readily cajoled—with a beautiful mask rather than with an ugly one is surely a good example of the projection of man's own aesthetic impulses, in this case on to the ancestors.

On the basis of the work by Ruesch, who used two species of monkeys and two species of birds in a series of preference tests, and of his own work with chimpanzees, Desmond Morris has suggested that there may be some basic factors which appeal to the eye and that certain formal characteristics are pretty universally preferred. The factors which he has singled out are: steadiness, symmetry, repetition and rhythm. Thus Congo, his most talented chimp artist, showed a preference for regular rather than irregular patterns. He had the impulse to fill empty space, but to confine this to the space within a frame; to balance a central figure by an off-set figure; to enjoy rhythmic repetitions, and to consider his picture finished when

it had reached what Morris himself experienced as optimum heterogeneity. The ape never developed to a stage when he would attempt to make a representational image, and Morris postulates that when representational imagery develops in the human being, the purely aesthetic needs give way—or at least become adulterated —by the representational needs, or, as I would suggest, by the symbolizing needs. For even the early cave painter, through his abundant use of stylization, seems really to have striven not so much after verisimilitude, but after the impression of 'vitality, vividness and emotive power' (Read, 1936). Rhoda Kellogg (1969), who has collected and classified more than 200,000 spontaneous drawings by children between the ages of two and eight from many different countries, found that they tended to go through a regular progression, beginning with the scribble, then moving on to diagrams, then combines, then aggregates, arriving at an elementary representation of the human figure at about four years old. Herbert Read (1943, 186 *et seq.*) described how a teacher had encouraged young adolescent schoolgirls in the classroom to close their eyes, to feel at peace and then to draw a 'mind-picture'. His examination of these mind-pictures (193) led him to believe that:

> Below the level of consciousness and extending to a level of
> experience which is more than individual, a wider and
> deeper chaos seeks the harmony and stability of the aesthetic
> pattern. . . . On the most primitive level of our unconscious
> being, we seek conformity with the organic laws of nature and
> the cosmic laws of matter.

Read's description may sound to us today a little too abstract and romantic. But there is a fascinating article entitled 'The tendency towards patterning and order in matter and in the psyche' by Elizabeth Osterman (1968) in which she suggests that the basic forms in the macrocosm, the basic forms in the microcosm and the basic forms in the art work of young chimps, young children, disturbed adults and men who seek to create ritualistic protection (Navaho and Tibetans) have strangely close affinities. A similar discovery has been made in 1917 by D'Arcy Thompson (1961) and also by Schwenk (1965). They all seem to have found that there tends to be a continuous movement from simple to more complex forms, and that there appear again and again the circle, the sphere and the spiral, that is, patterns that are distributed around and

orientated towards a centre. Clearly the relationship between such patterning in both matter and in man's aesthetic expression is still beyond our understanding. But it may by now seem justifiable to postulate that there is in man an innate archetypal disposition to develop an aesthetic reaction to certain formal elements and compositions.

Art, therefore, it can now be suggested, exists in response to *two* vital needs in man: the aesthetic need on the one hand, and the symbolic need on the other. The way in which the artist satisfies these two needs varies and depends on an innumerable number of factors, but especially on his personality, that is on the relative urgency of the many emotional, aesthetic and ideological pressures within him, on the internal reasons that impel him to make art, on the particular function his art work is to serve in his society and on what, in general, his society thinks, desires or even prescribes that art should—or should not—do or achieve.

This may be the moment to sample some of the aesthetic thought, theories and work of a few other cultures.

Aesthetic theories in different cultures: some examples

China In China in the fifth century A.D. a famous art critic, Hsieh Ho, proposed six criteria for the judgment of paintings (see Read, 1967). Being thus clearly and explicitly formulated and expressing, as they seemed to do, the characteristic preoccupations of the Chinese people, they remained for many centuries the guiding principles of the art of painting in China. The following are the six criteria proposed:

1 The first principle is fundamentally metaphysical and concerns the concept of the Tao, or Ch'i, that spiritual energy that moves through all things and unites them in harmony. A painting must somehow express and convey spiritual resonance of this Tao.
2 The brush stroke must be powerful enough to convey something of this stream of cosmic energy. The brush strokes must therefore be cursive, co-ordinated, not angular and mechanical.
3 Each object has its own appropriate form.
4 Each object has its appropriate colour.
5 The elements in the composition should be properly planned so that the composition itself conveys what is important and what is

unimportant, what is near and what is distant. The unity of the parts with the whole should be implied.

6 There is to be 'copying'. This is not like the Western idea of tradition, concerned with the handing on of techniques and styles, but implies that there is an informing spirit to be transmitted which is more important than the form itself.

Basic, then, to this conception of art is the belief in a cosmic force, of which the living forms of nature are the visible manifestations; and that it is the artist's task to convey the presence of this force in its four basic manifestations—man, things, place, and time—and in its three modalities—image, form and rhythm. An object is thus conceived as being primarily a symbol, and objective reality is to be conveyed through personal experience.

India In India an aesthetic theory was developed in the fifth century A.D. and later elaborated in the eleventh century A.D. in relation to the dramatic arts, where visual and auditory stimuli are combined. It is a complicated theory, a sophisticated theory, involving an intricate system of categories and sub-categories. Essentially it is concerned with the artist-spectator interaction, with the nature of the symbolic experience and how this can be evoked; for this is regarded, quite explicitly, as the essential goal of art. Such symbolic experience involves transcendence of any particular feeling, thought or fantasy, so that the spectator can achieve the 'Supreme Bliss of ultimate release from birth and death' (Rawson, 1966, 121). It is therefore enjoined upon the actor not to cause the spectator to react as he would to a real person, and the pretty actress for instance, must not be allowed to serve as the actual 'cause' as she might in real life.

Rawson cites as a very pertinent analogy the various stringed musical instruments—Sarod, Sarangi, big Vina and Sitar—where a long series of smaller strings is arranged beneath the main playing strings. 'The smaller strings are never struck but are expected to resonate in sympathy with the notes struck on the main strings above them.' Thus the melody progresses, accompanied by a continuous aura of sympathetic sound. The consciously stated elements of an artistic design are then analogous to the melody of the main strings while the resonance evoked in the unconscious mind is like the effect of the smaller strings. It is thus the role of art to

bring the mind to an experience of the transcendental. The way in which this Indian aesthetic theory states the task of art, making it quite clear that the artist must not create the effect of actual, but of transcendental or symbolic reality, provides, I think, a fascinating conceptual statement concerning the connection between stylization and the symbolic attitude, and lends further weight to the remark Read has made concerning the goal of cave art, which I have quoted earlier.

Indian art is thus conceptual rather than perceptual, based on contemplation and visualization. It attempts to sum up an idea and to produce a desired state of mind and body. Its greatest works are meant to evoke that aesthetic ecstasy which India's philosophers have regarded as one of the roads to enlightenment.

Tibet In Tibet art tended to be connected exclusively with the service of the Lamaist religion. Most Tibetan artists were monks and the pictures they made were destined to be aids to concentration and meditation, turning away the thoughts from this world to the world of mystery. They were to help give more complete patterns for visions, being personifications of certain powers, and so to be used for liturgical purposes. Painting itself was regarded as a form of religious ceremony and the painter—as amongst the Dan—must do his painting in secret; no secular person must see him; nor was the painting shown to strangers. The painting was completed with a consecration and was thus charged with magical powers. The artists themselves remained anonymous.

There was a prescribed iconography to identify the different kinds of gods, such as the Buddha, who is always cross-legged and in the centre of the picture; the Bodhisattvas, who are usually portrayed as graceful Indian princes; the Defenders of the Faith, who are ugly and repulsive creatures and who, like the medieval gargoyles, function as powerful protectors against harmful demons. Only in his choice of his tutelary god, which each monk could select for himself, did the individual artist have an area of some iconographical freedom.

As death, ruin, decay and putrefaction mean nothing bad for the Tibetan monk, so that symbols of life and symbols of death are for him equally acceptable and valid, the art of Tibet is characterized by an immense vitality. It seems to represent highly charged paradoxes, and so conveys quiet in restlessness and restlessness in

quiet, repulsiveness and attraction, putrid death and scented flowering.

Yoruba The anthropologist Joan Wescott (1962a and b, 1963) has made a special study of the sculpture of the Yoruba of Nigeria. She has discovered that a remarkable orderliness distinguishes the production of Yoruba art from that of other African tribes. First, the corpus of Yoruba art can immediately be seen to serve three distinct sets of social purposes:

1 *Secular* The production and decoration of architectural details such as doors, posts and lintels, and of household furnishings such as stools and chairs. The motifs used for the decoration of these domestic works, however, are often of religious as well as secular themes.

2 *Ceremonial* Here art serves the identification, continuance and celebration of the hierarchical social and religious structures. It consists in the making and decorating of royal insignia such as palace drums, and the crowns, staves and other adornments of kings and chiefs. This category also includes the stylized portrait heads of the ancestors of aristocratic lineages.

3 *Religious* This involves the production of traditional ritual forms such as figures, masks, offering bowls and wands. These ritual objects help the worshippers to experience the nature and presence of their gods by providing an image to which they can relate and which they can experience jointly, communally. Just as secular art forms include religious themes as part of their decorative content, so do ritual forms contain secular themes.

Second, there is considerably more freedom and innovation in the secular arts than in the ceremonial and religious sculpture which must remain faithful to the traditional forms produced generation after generation. The symbolic meanings invested in these forms make it imperative that they survive intact. The exceptional feature of Yoruba art in comparison with other African tribes, including the Dan, is that the cult for each of the gods in their pantheon has its distinct iconographical forms, so that a piece of Yoruba sculpture may not only be identified in relation to the categories outlined above, but also more precisely as to the god and cult ritual it serves.

As each Yoruba may choose the god whom he wishes to worship and whose character, myths and rituals seem compatible with his

own personality and needs, these people have evolved a system in which flexibility of personal expression—through choice of cult—is combined with extreme stability through the enduring sculptural forms characteristic of each of the gods.

Byzantium The art of Byzantium is strangely close in its objectives to the art of the East—China, Tibet, India, etc.

The Byzantine artist, who also remained anonymous, experienced his anonymity as parallel to that of the priest officiating at the altar. His art was thus in the service of the Church and its dogma and set out to express the divine power and man's supernatural aspirations. Unlike the Western European artist, who had tried to stir the heart, the Byzantine artist addressed himself to man's spirit.

His freedom to invent was strictly limited and, indeed, the iconography of the sacred persons was essentially traditional and could not be easily tampered with. In fact there is evidence to suggest that many believed that the icons were based on original portraits of the persons who had actually been involved in the Holy Story, and that the power of the image to protect and to exorcise evil was, in consequence, strictly dependent on it being a faithful copy of the original.

Recapitulation and discussion

To recapitulate some of the points that emerge from this second part: art fulfils a number of different functions in any one culture at any one time. A culture group may emphasize some of them and minimize—or actively prohibit—some of the others. The role of art and of the artist depend very greatly on what the community expects to be the origin and the purpose of art.

Nearly all cultures distinguish sacred art, that is, art in the service of magic or of religion—from art which serves the cohesion and self-identification of society and of its various sub-groups—such as art for ceremonial purposes, the art of insignia and emblem-making, and art for communal entertainment and communal social learning; the latter purpose being more frequently served by the performing arts—dance, drama, song and story-telling. Finally, there are the popular and the decorative arts, with no apparent purpose other than to express feelings or to enhance the aesthetic qualities of practical objects—of weapons, household articles, clothing, etc.

These, then, seem to be the direct expression of man's joyful delight in the making and the handling of objects that are not only useful but also beautiful; clearly in order to make them a person needs to combine both technical and artistic skills. The modern industrial designer is perhaps one of the few descendants from what used to be defined as a craftsman in pre-industrial society—although even here, because of modern sophistication of the techniques of manufacture, the making and the decorating of objects are rarely done by the same person. Thus craft has become much divorced from the minor artistic skills and this must cause a great deal of hurt, frustration and boredom in a great many people today.

The artist who works in the service of magic or religion has often been regarded—and has often regarded himself—as someone full of 'mana', that is, full of an invisible but powerful, trans-personal force which sets him apart, either permanently or only while exercising his art, from ordinary people. As the carrier of such a power he tends to be felt as 'awesome'. Consequently the artist has often been considered as a magician or a priest, and he has frequently combined his work as an artist with the social role of magician or priest, being felt, or feeling himself to be, the voice of the gods, a prophet or a seer. Experience in the third stage of the creative process, when inspiration is felt as coming as if from outside oneself, undoubtedly facilitates this belief that the artist is a medium, is the voice of the gods. But the artist may also be used as the carrier or the repository of collective knowledge and collective experience, as the servant of tradition, or else as the sensitive instrument of revolution and change; and sometimes he is thought to express the unformulated and as yet unconscious hopes, urges or fears of his people. However, he may also, as is more general in our own modern culture, feel himself to be a very much more private and individualized person than the average more conforming and more collectivized man or woman, and so believe that his art is in fact the expression of a more intimate relationship with himself, giving him more sensitive insights into his own psychic life and experience.

Society, then, tends to define the function of art in terms of its own ideology and system of values. In China, for instance, as we have seen, art was judged in terms of its capacity to evoke and to make manifest the Tao, the Cosmic Force. In India, its power to facilitate a symbolic rather than a concrete and direct experience was invoked as an aid towards the feeling of Supreme Bliss. In

Greece, Rome and in post-Renaissance Western Europe art has been required to be more object-orientated, to concern itself with ideal forms, with the dignity of man and with the imitation of nature. In the last few decades in the West the expression of inner experience has been regarded by many as art's principal function; others in more recent times have demanded that art should be committed to a social cause and serve as a commentary on social actions and forces. Some have demanded that art should teach; others that it enshrine beauty; some have wanted it to reflect courtly manners—like many of the Moghul paintings—or to encourage such desirable qualities as courage or love; some have sought from it no more than innocent amusement or else the power to thrill, to shock, or to reveal new ways of perceiving what surrounds us. Society's claims on art can, therefore, be multiple and even contradictory.

On the whole both the creation and the preservation of 'great' art, that is, of the sacred art of a people, is safeguarded by many rules and taboos; it therefore tends towards continuity and stylization. Such art is primarily spiritual, preoccupied with the divine and the eternal rather than with the temporal and the individual; it is bent on transcending the human in order to search out absolute truth. In contrast the secular and particularly the more popular arts in most cultures are rather more free, lively and impulsive, even if less powerful and impressive.

Another point needs to be made here, which might help explain why rigidity and traditionalism tend so often to develop after a certain time, rendering the art form more and more lifeless: we must bear in mind that symbolization is by no means easy and that on the contrary most people find it very difficult to have or to hold on to an 'as if' attitude. Consequently symbolization is always at risk and may sooner or later be depressed to the psychologically more primitive level of the symbolic equivalence. When this happens the artistic experience is reduced to a fetishistic one. And instead of the statue of the God being experienced both as an intrinsically beautiful form and as constellating, through its own material existence, the incarnation of the God as a psychic phenomenon, the statue itself becomes the God; and so image devolves into fetish. Signs of such regression are, for instance, evident among the Dan, the Tibetans and in the Byzantine world. Indian aesthetic theory appears to have been quite particularly concerned

with this possibility and has been anxious to ensure against it by instructing both artist and audience most carefully in the art of art experience.

Edgar Wind (1963) has argued that in this age of science art has ceased to be either mistress or servant to man, for its influence has shrunk as that of science has advanced. One of the consequences of this is that it has acquired more freedom, because it is thought of as having less impact. However, the last few years since the appearance of Wind's book have revealed that the relative impact of art and science on the minds of men might well be disturbed once more; and that as men come to experience a vacuum in the area of meaning, which cannot be filled by the facts of science, the arts might again come to assume immediate relevance to a wider circle of individuals and social groups. This renewed importance could make the arts either areas of strife and of controls, or else growing points of aesthetic sensibility and personal development.

General summary

My survey up to now has explored some of the reasons why man makes art. On the one hand there are needs and pressures inside him that are primarily personal and psychological in nature, such as:

1 the need to externalize internal images;
2 the need to preserve his sensuous experience by making it gel into a form which exists outside and independently of him;
3 the need to communicate to others—and so to validate further—his private imagery and experience;
4 the need to give expression to what seems to be a fundamental impulse to make—and to make, whatever he does, according to certain quasi-universal aesthetic rules;
5 the need to find meaning by relating disparate and individual objects of experience to wider, more generalized and more abstract ones; he does this by means of his capacity to symbolize. These needs are particularly closely related to the fact that having acquired consciousness man has also acquired knowledge of the existence of death. It is probably this knowledge which drives him on to ask about the meaning and the purpose of life, about his place on earth and in the universe, about the laws that govern the world and about the sort of existence that awaits him after death and that he might

have experienced before birth. Koestler has put this point rather poetically when, in a broadcast in 1960, he said: 'Take the word "death" out of our vocabulary and your great works of literature become meaningless; take that awareness away and your cathedrals collapse, the pyramids vanish into the sand and the great organs become silent.'

It is particularly this last need that finds expression also in man's collective existence; it is therefore the point where personal and social pressures combine to evoke art. The various social forces and needs that call forth art might thus be enumerated as follows:

1 the institutions of magic and of religion with their ritual and liturgical needs and their concern to 'incarnate' the God in a tangible form in order to evoke and to facilitate for the majority of people, who need this, a communal experience of awe, of mystery and of worship;
2 the need of a community to imbue its members with a knowledge of its history, its myths and legends, its ethos, laws and beliefs;
3 the need to share in the inventive and imaginative exploits of its more gifted members;
4 the general enjoyment of making and possessing aesthetically pleasing shapes and forms.

3 Reflections about art today

We in the second half of the twentieth century find ourselves at a particularly critical point in relation to the arts. For the advances of science and technology have fractured our cultures, our values and our understanding of ourselves. The Humanist Movement which had come to birth—or to a rebirth—so exuberantly in the fifteenth century, with its accent on individualism, on secularity, dynamism, flexibility and inventiveness, its fascination with the study of the physical world and of man's personal psychology, and with its respect for the dignity of the human being, this movement which had given to art and to science such a dynamic impetus seems now to have run full circle. While the advent of photography interfered quite directly with man's interest and delight in the natural world around him and his wish to represent it as faithfully as possible, the miracles of science and technology have now palled

in the face of the price they exact from man: excessive social mobility and hence uprootedness; work that is more and more impersonal and meaningless; the fragmentation of personal ties in the presence of ever larger social units; the divorce between man and nature; the increased speed of social and technological change; the sacrifice of the individual to the efficiency of the machine and the system; the regurgitation of the detritus of the machine which pollutes the world and threatens to choke the various natural and unnatural systems; and finally the loss of religious beliefs, institutions and experience. This social upheaval cannot but affect art and the artist. For, as Herbert Read (1967, 21) has suggested: 'The same forces that have destroyed the mystery of holiness have destroyed the mystery of beauty.'

It is thus not surprising that modern art should also have fragmented into a number of separate trends and movements. Such fragmentation does allow the artist to explore and to express his own personal interests, beliefs and inclinations with a greater freedom than has at most times been granted to him. Admittedly this new freedom is not as absolute as might appear; for the constraints of social values and judgments and the dogmas of religious institutions have already been replaced by new tyrants: connoisseurship, fashion and the art critic. But on the whole, personal experimentation has at present more scope than it has probably ever had before.

The sort of trends that seem to have constellated over the last few decades can perhaps be classified in terms of the goal and purpose that an artist or a group of artists and their public consider to be the essential and principal role of art, and of the sort of stance that they adopt, explicitly or implicitly, towards the changes going on around them.

Thus some have participated with more or less enthusiasm or cynicism, with more or less voluntary or involuntary fascination, with more or less love or disgust in the explosion of technology and its effects on men (see Leger, Caro, Rauschenberg, the pop artists and the 'junk-paintings' or 'junk-sculptures' of Burri, Tapiès, Paolozzi, etc. In fact one might now be tempted to wonder whether these 'junk' artists have expressed through their art an intuitive awareness of the problems of pollution, conspicuous waste, etc. which have so recently burst upon the conscious awareness of the majority of people).

Some artists seem to have thrown themselves excitedly into the eruption of violence, of rage, of despair or of revolutionary fervour (the Dadaists, Bacon, etc.).

Some have gone more 'coolly' into science and turned their studio into something more like a laboratory in which they can experiment with new media, new forms, new expressions and new discoveries—the Op artist is one example of this group; the Constructivist is another.

Others have turned away from outer reality and have instead withdrawn inwards in order to explore their own emotional and symbolic world and to wrest open the gates of what promises to be a treasure house, the unconscious (post-Impressionists, Symbolists, Surrealists, etc.).

Some artists in this latter group have been particularly impressed by the impact on them of the work of those who seem to have more direct access to the unconscious: children, men living in primitive societies and the insane.

Some others have attempted to catch the essence of their inner experience, be it of themselves or of the objects around them, by setting aside altogether the representation of objects, such as we seem to see them, and to produce instead non-representational 'abstract' forms through which to express and to communicate.

And then there are those like Pollock, Toby, Masson, Miró, Rothko and others who have been influenced, either directly or indirectly, by oriental art and thought. They seem to express in and through their art a longing to go once more beyond the ego limits in order to re-link themselves to a greater reality, a reality that transcends the personal, and so makes possible the experience of un-self. They seem indeed set to attempt once more to embody something of that spiritual energy which the Chinese had called the Tao. Perhaps their very existence confirms Burckhardt's belief (1943, 20) that: 'from the beginning of time we find the artists and the poets in solemn and great relationship with religion and culture . . . they alone can interpret and give imperishable form to the mystery of beauty.'

New equations may have to be discovered in order to make a new synthesis out of the need for relationship to 'un-self' and that growth of consciousness, of personal identity and reflective self-awareness that has accompanied the un-making of the old cultures.

For such growth in consciousness and awareness and the development of skills, technology and rational understanding cannot be undone without grave consequences—both to art, which would take on a phoney and pseudo-primitive form, and to the artist and his public, who cannot regain paradise but would instead become decadent and perverted.

Concern with the unique, the individual, that is with true individualism, has been the gift of Humanism. Humanism, together with the discoveries of psychology, has led us nowadays to look on art as one of the means of self-expression and self-discovery.

However, Humanism has bypassed the phenomenon of the transpersonal, and it has overlooked—as it probably had to at that time—man's need to discover meaning, to speculate about his existence and to experience something that lies beyond him. The particular expansion of personal consciousness which is accompanied by some capacity for awareness and experience of 'un-self' has been described as 'individuation' by Jung, as I have mentioned earlier (p. 28). This concept of individuation seems to me to be valuable and relevant to any discussion of art and the artist; it might provide that conceptual tool with whose aid we might unravel the difficult interaction and interdependence between consciousness, personal identity and individualism on the one hand, and the experience of something beyond one's self on the other. It would thus be important in any discussion of the use and purpose of art, particularly as this might affect art-educators and art-therapists. For it is likely to colour the whole controversy about art as a means of 'self-expression' and 'self-exploration' as against art as a means of transcending the immediate and the purely personal through absorption in or devotion to some non-personal goal—be this trans-personal goal conceived of as God, spirit, the Muse, Nature, Humanity, or even as skill, technique or excellence.

Clearly mediocre art usually fails to evoke our deepest responses precisely because it has remained the vehicle of ego needs only; in which case the artist has probably remained encased in individualism, in self-centredness and possibly in a spurious self-aggrandizement.

On the other hand those who seek out the transpersonal without being firmly anchored in the personal and in the awareness of who and what they are, tend to produce work which either seems false and sentimental, or else they are carried off into the distraught,

gruesome, grotesque and formless chaos of an unbounded, obsessive, unconscious world.

Art-makers, art-appreciators, art-educators and art-therapists may well find that they need to do battle with the problem of how individualism can best relate to the process of individuation, and how consciousness and personal identity can coexist with the experience of there being something beyond one's personal self. In art this conflict between individualism and individuation is likely to be expressed in terms of self-expression, against self-transcendence, or between novelty versus conformity, obedience to a master or a school versus rebellion, objectivity versus subjectivity. Jung's concept of individuation as well as Winnicott's concept of the 'area of experience' both really suggest that there is in fact a valid way, perhaps the only way for us today, in resolving and living with this paradox—though everyone will inevitably re-experience the paradox again and again, and under many different guises, when he finds himself in the actual situation of making or of relating to art.

Surrender and control, consciousness and unconsciousness, skill and invention, the personal and the transpersonal, form and expression, 'creative thrust' and 'creative mastery' (Schneider, 1950)—we can only serve the arts and serve ourselves and each other if we do not flinch in the face of these new paradoxes with which through our own explorations into the nature of man and society we are now confronted; they challenge us to live by them, to make use of them and to transcend them.

References

Arnheim, Rudolf (1966), *Towards a Psychology of Art*, London: Faber.

Burckhardt, Jacob (1943, based on lectures 1868–85), *Reflections on History*, London: Allen & Unwin.

Cassirer, Ernst (1953), *An Essay on Man: an introduction to a philosophy of culture*, New York: Doubleday.

Gerbrands, A. (1971), 'Art as an element of culture in Africa' in Otten, Charlotte (ed.), *Anthropology and Art*, New York: Natural History Press.

Gimpel, J. (1968), *Contre l'art et l'artiste*, Paris: Editions du Seuil.

Herrigel, E. (1953), *Zen in the Art of Archery*, London: Routledge & Kegan Paul.

Jung, C. G. (1954), 'The aims of psychotherapy' in *Collected Works 16*, London: Routledge & Kegan Paul.

Jung, C. G. (1958a), 'Psychology and religion' in *Collected Works 11*, London: Routledge & Kegan Paul.

Jung, C. G. (1958b), 'A psychological approach to the dogma of the Trinity' in *Collected Works 11*, London: Routledge & Kegan Paul.

Jung, C. G. (1960a), 'Psychological factors determining human behaviour' in *Collected Works 8*, London: Routledge & Kegan Paul.

Jung, C. G. (1960b), 'The stages of life' in *Collected Works 8*, London: Routledge & Kegan Paul.

Jung, C. G. (1963), *Mysterium Coniunctionis: Collected Works 14*, London: Routledge & Kegan Paul.

Jung, C. G. (1966), 'On the relation of analytical psychology to poetry' in *Collected Works 15*, London: Routledge & Kegan Paul.

Kellogg, Rhoda (1969), *Analysing Children's Art*, San Francisco: National Press.

Langer, Susanne (1941), *Philosophy in a New Key*, London: Oxford University Press.

Lévi-Strauss, C. (1963), *Structural Anthropology*, London and New York: Basic Books.

Morris, Desmond (1964), *The Biology of Art*, London: Methuen Paperbacks.

Osterman, Elizabeth (1968), 'The tendency towards patterning and order in matter and in the psyche' in Wheelwright, J. (ed.), *The Reality of the Psyche*, New York: Putnam.

Rawson, P. (1966), *Indian Sculpture*, London: Studio Vista.

Read, Herbert (1936), *Art and Society*, London: Faber.

Read, Herbert (1943), *Education Through Art*, London: Faber.

Read, Herbert (1960), *The Forms of Things Unknown*, London: Faber.

Read, Herbert (1964), *The Philosophy of Modern Art*, London: Faber.

Read, Herbert (1967), *Art and Alienation*, London: Thames & Hudson.

Schneider, D. (1950), *The Psychoanalyst and the Artist*, New York and London: Mentor Books.

Schwenk, T. (1965), *Sensitive Chaos: the creation of flowing forms in water and air*, London: Rudolf Steiner Press.

Segal, H. (1957), 'Notes on symbol formation' in *International Journal of Psychoanalysis*, vol. 38, no. 4.

Thompson, D'Arcy (1961), *On Growth and Form* (ed. J. T. Bonner), London: Cambridge University Press.

Wescott, Joan (1962a), 'The symbolism and ritual context of the Yoruba Laba Shango' in *Journal of the Royal Anthropological Institute*, vol. 92, part 1, January–June.

Wescott, Joan (1962b), 'The sculpture and myth of Eshu Elegba, the Yoruba trickster: definition and interpretation in Yoruba iconography' in *Africa*, vol. 32, no. 4, October.

Wescott, Joan (1963), 'Traditions and the Yoruba artist' in *Athene, Journal of the Society for Education Through Art*, Summer.

Wind, Edgar (1963), *Art and Anarchy*, London: Faber.

Winnicott, D. W. (1958), 'Transitional objects and transitional phenomena' in *Collected Papers*, London: Tavistock.

Winnicott, D. W. (1967), 'The location of cultural experience' in *International Journal of Psychoanalysis*, vol. 48, 368–72.

Winnicott, D. W. (1971), *Playing and Reality*, London: Tavistock.

Further reading

Clark, Kenneth (1956), *Landscape into Art*, Harmondsworth: Penguin.

Clark, Kenneth (1960), *The Nude*, Harmondsworth: Penguin.

Clark, Kenneth (1969), *Civilisation*, London: BBC and John Murray.

Ehrenzweig, Anton (1967), *The Hidden Order of Art*, London: Weidenfeld & Nicolson.

McKellar, Peter (1957), *Imagination and Thinking*, London: Cohen & West.

Rugg, Harold (1963), *Imagination*, New York and London: Harper & Row.

Sheehan, Peter (ed.) (1972), *Function and Nature of Imagery*, New York: Academic Press.

Vernon, Philip (ed.) (1970), *Creativity*, Harmondsworth: Penguin Modern Psychology Series.

3 Art education in relation to psychic and mental functioning*

Mel Marshak

Introduction

Someone says to you in another time and place from where you are now, 'We would like to do a book'—in this instance, something new on art education—'and we would like a contribution from you', and in that time and place and existence which you lived then, you say 'Good', for in that *then* you thought genuinely that you knew something true, and when you feel convinced of the truth there is a natural inclination to unfurl a banner and make some assertion.

I think I have written some six papers bearing on art education, creative processes and those almost indescribable mental events that seem to be significant to these areas. I have published none of them, partly because something peculiar happens to me at the point at which I have made explicit some revelation of 'truth' that has illuminated my consciousness. It would not be accurate to say that the new-found 'truth' has exactly died on me but it has acted as a stimulus for something 'newer', the effect of which renders the past somehow irrelevant. So as I write this now I find myself in my present existence and among thoughts that, in many ways, are far distant from where I was even last year.

I mention this reluctance to publish deliberately, for it seems to me that our age does not count for much the value of testimony and least of all uncertainty. It is reckoned to be a weakness not to assert boldly and assuredly what one reasonably knows, but since reason

* There is obviously never enough space to acknowledge all the sources from which one has derived help in the production of an article of this sort. I am therefore grateful for the opportunity to acknowledge the writers from whom I have begged, borrowed and stolen and the students and colleagues who are always a source of inspiration. Particularly I want to thank Mr Eric Smith to whom I owe the final structure of the article.

has finite limits in areas of application, it cannot cope with the dimensionless depths which lie beyond. Somehow we all fear to set down our intimations of thoughts, our daydreams and musings, for they seem unfinished or inconclusive, and hence perhaps much precious material born from these uncertainties is lost—except perhaps in such writers as Tolstoy, Dostoyevsky and Blake who adopt their weaknesses as strength. And since we are addicted to believe that nothing can be said until ultimately defined, we conclude with the notion that has long pervaded our age, i.e. that reason not only provides 'answers' to all questions but that it alone provides us with certitude and knowledge.

The Cartesian insistence upon doubting all but clear and distinct conclusions of which one could be wholly sure has made inaccessible those more subtle areas of human experience. This, in turn, has given us nineteenth-century science which seeks to destroy the concept of personality by reducing it to a complex in continual flux from moment to moment, and in so doing it destroys the very foundation of the spiritual and emotional life which ranges itself unyieldingly against reason. Such reason, therefore, lacks depth and dignity. This is no indictment of reason but rather of a particular mode of reasoning which, itself envisaging no limitations to its capacities and applications, does render as irrelevant those questions and profounder areas of human living most significant to human experience.

There is another reason, another doubt, passionately held, which consists of the eternal conflict between reason and feeling, science and life, logic and vital processes. This antithesis of reason and doubt cannot avail itself of any provisional ethic: it has to found its ethic on the conflict itself. An ethic of battle has to serve as the foundation of religion.

This short introduction is not so much an apology as a hope that the reader will be tolerant of my inner musings, for the style of my life is to live in continual scepticism which is produced by a clash between my reason and my faith and by a belief that within incertitude lies my supreme consolation. But more than a reflection of my hope, what has been said so far will perhaps be seen to be not irrelevant to what I would like to say about *the significance of art for human development*; *the nature of the creative*; and *the limitations of education regarding these two areas*.

3

The significance of art for human development

1

There has been so much written and so many contributions made in an attempt to understand the creative process that anything else one might try to say seems almost superfluous. Yet it may be said that it is one of man's attributes to try to find expression for the inexplicable. It has been said that truth must not be understood but attained. To understand, to know, is to break in, to take to pieces. To attain is to let in, to apprehend. Knowledge of the former kind is always aggressive and implies conquest. Attainment is a pull, a burden from above. In attaining, it is we who become captive. In my own case it is certain that I have become captive to this inexplicable process called 'creativity', mostly because so much of what I have read has lodged in my memory and because I am susceptible to those persons who show themselves to be so obviously creative through their biographies and during my personal encounter with them.

There are three thoughts which have emerged from such encounter, regarding—if not the nature of the creative—at least essential ingredients with which the creative seems closely associated:

1 That the individual must preserve his anonymity, i.e. that the process has not so much to do with preserving individuality or a quest for identity as it has to do with the need to manifest and preserve one's personal existence by means of the artefact.
2 That the activity is religious in the sense of a necessity to reach beyond the 'passing flux of immediate things'; it is something to be realized yet it stands beyond reach. The word 'religious' here should not be confused with its theological meaning.
3 That these activities are orientated towards that which lies in the future, i.e. it is not so much that the individual is pushed by the past or transfixed by the present as that he is drawn by the future towards itself.

2

It seems to me that any understanding of the creative principle in man or, for that matter, any understanding of individual human development must take account of some generic human attributes whereby man in his evolution achieved his human status. It is not

just a biological problem or a problem of social origins or a problem that involves the development of the human mind. Any explanation of man's uniqueness and the total conditions underlying his evolution must also describe and account for man's capacity to create culture. Man's capacity to create society or a social structure is based on attributes and ingredients which can be explained by his socio-biological structure, much of which he has in common with infra-human species. To account for his culture-making capacities one must seek those attributes which are particularly human and are not shared with other animals.

For the purposes of this article I wish to call attention to only two of these human attributes which make it possible for man to function differently from any other animal; to act in ways which are denied to them and which are unique to him.

There occurred a rapid shift in human evolution from simple levels of adjustment to a higher level of integration by the emergence of some dominant centre of the 'personality' which allowed for the development of ego-centred processes. The consequence of this new level of organization permitted man to become an object to himself. Associated with this emergent centre we have those universal characteristics of the human being such as self-consciousness, self-identification and reference, self-evaluation, self-stimulation, self-control. Among other things which were contingent upon man's becoming an object to himself was his capacity for self-direction and self-control: this capacity laid the foundations for all societies holding the adult individual morally responsible for his actions. It can be seen that an animal capable of self-awareness can be expected to develop a capacity to create elaborate systems of meaning which become the foundations of a social order, and to implement a type of adaptation which makes his role intelligible to himself and to his fellow men. But the factor to which I wish to call attention, which was the result of such self-objectification, is concomitant self-consciousness whose character is such that it also brought with it an awareness of his 'tragic sense of life' in that it made it possible for him to anticipate his own death. One might say that even in sub-human species the physical struggle for survival is an illustration of the animal's awareness of death, but I think that this is to misunderstand a level of existence to which I am trying to refer and the significance that consciousness brings in the realization of its death.

Throughout the recorded history of man there seems to me to be ample evidence to suggest that the death of the body was not the most fearsome thing to anticipate, but that most awesome and terrifying of all was the ceasing of individual consciousness. We need not enter into the realm of too much speculation to imagine our ancestors suddenly faced with the dawn of consciousness simultaneously discovering the 'idea' of their own annihilation, for one has only to talk to children seriously at the moments when they, too, experience the first murmurings of their own self-consciousness, or perhaps to listen to those secret chambers in ourselves for that shadow of uncertainty.

In order to triumph over his death, man became something more than the mere struggle for physical survival, and it seems to have led to the will to meaning in an indomitable affirmation of his Promethean conquest: man's unique capacity for symbolization. The consequences of the emergence of this dominant integrative centre meant also that his emotional nature became structured in such a way that anxiety, guilt, depression, etc. became indices to the integrative level reached by the personal adaptation of the individual in relation to symbolically expressed and mediated forms of his society. This peculiarity of man involves, of course, the concept of the super-ego as part of the personality-structure of man; it is this concept as an intrinsic part of the psychobiological structure of man that bridges the gap between the 'inner man', the social order and the cultural tradition.

3

Obviously the organization of these generic human attributes is somehow facilitated by the socializing process and, although I do not wish to elaborate here on the genesis of these, there is no doubt that symbolization enters into this very intricate process; the capacity for symbolization might be said to be the *sine qua non* of the human condition. The transition or evolution by which man achieved human status is epitomized in this unique process. Man's capacity for dealing effectively with objects and events outside the field of direct perception and his capacity for adapting his behaviour to past and future objects and events distinguish him in fact from all other animals.

In a more technical psychological sense this means that the

psychobiological structure that man evolved is one in which intervening variables, which mediate between immediate stimuli and overt behaviour, come to play a more primary role. Variables of this type include unconscious processes such as dreams as well as conscious operations like thinking and reasoning.

The common denominator of these intervening variables or transitional phenomena, that so intimately link man's inner world with his adaptation to the outer world and his fellow man, is the symbolic or representative principle. This means that at a level of human adaptation the representations of objects and events of all kinds play as characteristic a role in man's total behaviour as does the direct manipulation of objects and events in perception. Thus skill in the manipulation of symbols is directly involved with the development of man's rational capacities. But symbolization is likewise involved with all other psychic functions—attention, perception, interest, memory, dreams, imagination, etc. Representative capacities are at the root of man's ability to deal with the abstract qualities of objects and events, with the possible or conceivable, the ideal as well as the actual, the intangible along with the tangible, the absent as well as the present object or event, with fantasy and with reality. Even culture as well as the personal development of each individual gives evidence of this, both at the level of unconscious as well as conscious processes.

Symbolic forms and processes colour man's motivations, goals and ties which affect life in characteristic ways. These forms and processes are as relevant to an understanding of his psychopathological as of his normal behaviour. If man's ancestors had remained literal realists like other animals then man as we know him would never have evolved. Consequently, one of the basic questions which a consideration of the generic aspects of man's psychological structure involves is a consideration of the root of man's capacity for the symbolic transformation of experience.

I do not intend to go fully into this difficult question here but, among other things, it would appear to involve the transition from capacities for intrinsic representative processes in animals below man to the creation, when we reach the human level, of extrinsic symbolic systems. An animal for whom intrinsic symbolization is possible is capable of carrying away with it from a situation some inner change or state which stands for the response which it will later make when it re-encounters the same situation. In other

words, a central process is involved which functions as a substitute for actual sensory developments. Imagery is a concrete example. But there is no way of directly projecting or communicating intrinsic symbolic processes. For this communication to occur, some media that can be externalized by the organism must be employed. Extrinsic symbolization, then, involves the operation of the representative principle on a higher and more complex level. Symbols of this category can be responded to not only by the individual himself but by other individuals to whom the socially significant symbol is communicated. If you think carefully about it, it is nothing short of astounding that by means of drawing, vocalization, or perhaps even by gestures, I can make you acquainted with a dream of mine. Consequently, in the case of man, extrinsic symbolic systems made it possible for groups of human beings to share a common meaningful world. A meaningful world in man, being in part symbolically mediated, implies a cultural milieu which becomes inextricably meshed with the world as biologically and physically constituted.

The process of symbolization is intrinsic to the psychodynamics of human adaptation and it is the major mechanism through which man becomes psychobiologically structured in the socialization process. Indeed, it is far more significant than training which is, of course, a mode of adaptation shared not only with other primates but also with animals far lower on the phylogenetic scale. Consequently, there is nothing particularly human about learning *per se*. The 'law of effect' does not apply to man alone. What is unique is the role which symbolization plays in the learning process. As Mowrer and Ullman (1945, 79) say, 'Living organisms which are unable to employ symbols versatilely are doomed to relative fixity of response, which in the case of responses which have both remote and immediate consequences, is almost certain to result in a failure of "integration".' It has also been pointed out that loss of flexibility in personal adaptation is one of the key problems in the psychopathological aspects of human behaviour. Thus the transmission of culture, if realistically viewed, must be thought of not as the acquisition through a simple conditioning process of habits or cultural traits, but as part of a very complicated and symbolically mediated process in which mechanisms like conflict and repression play their role in the total integrative structure that we call human personality.

There are several aspects of these generic characteristics that need to be emphasized in considering man's individual and evolutionary survival. First, these characteristics have helped to liberate him from his immediate environmental influence. The notion of environmental determinism as applied to man is limited when one recognizes that man survived because he was able to transcend the particulars of his environment rather than adjust to them. Second, he is not at the mercy of the lock-and-tumbler mechanisms of other animals, i.e. the systems of innate release stimuli and mechanisms. Rather man creates his own IRS's that act as energy releasers and these he embodies in his artefacts, particularly his art. (This notion will be discussed more thoroughly below.) Third, he is not compelled by impersonal power, i.e. his instincts, that push him hither and thither, but by the emergence of a dominant integrative centre, e.g. ego-centred processes, he is capable of experiencing and interpreting his world. This means that the search for meaning is of greater importance than drive gratification. The idea of a psychosomatic unity which underlies the generic characteristics implies that a 'mind' or experience uses the body rather than the 'body' drives the man. Traditional terms like 'psychic unity of man' or 'human nature' which have been somewhat emptied of their original meaning become genuinely significant again in the context of a primate whose level of adaptation implies such mechanisms and processes. As Roheim once remarked (see Devereux, 1945, 122), 'The most basic of all basic personalities is the one connected with the fact that we are all human.'

4

The lock-and-tumbler systems

Recent advance in ethological work is in accordance with the suggestions put forward above. A great many of the specific activities and responses of infra-human species are not learned. Mating behaviour, territorial behaviour, flight and migratory behaviour, nest-building behaviour, etc. are not necessarily acquired through a process of learning but are evoked in the presence of specific stimuli. It is also true that the acquisition of new reactions to environmental stimuli and responses can be transmitted to the progeny of a species. In genetic terms this means that the structure of DNA is not quite so inflexible as we have hitherto considered.

In psychobiological terms this suggests the primacy of the general or abstract over the particular and the concrete. The words 'possibility' or 'potential' take on more significance if this advance in the life sciences can be appreciated, that is, that living systems develop and differentiate in accordance with a hierarchical organization of abstract relations governing the *order*, which gives particulars their distinct place. Prior to this advance, theories of knowledge started with the assumption that the general or abstract presupposed the concrete. What is now seen is that the concrete presupposes the abstract.

The theory of innate release mechanisms and innate release stimuli is based on the observations of infra-human species whereby a specific reaction pattern on the part of individuals in the species is evoked in the presence of specific environmental stimuli which act as releasers to the behaviour. This lock-and-tumbler mechanism gives rise to the hypothesis that within each species not only are there hierarchical orders which 'apprehend' the specific stimulus which acts as a releaser for a certain form of behaviour, but also that inner organization and structure suggest an 'anticipation' of the stimulus. Lorenz has gone so far as to say that there is a 'preformed' image which predestines an organism to 'recognize' a given and specific stimulus. One example among many will suffice to illustrate the lock-and-tumbler mechanism. Chickens exhibit a typical fear and flight reaction in the presence of a hovering hawk or its shadow. Chicks artificially incubated and hatched with no opportunity of learning this behaviour will show the typical fear reaction when placed in the presence of a facsimile of a hawk. The question is: how did the image of the hawk get into the chick's brain? This is, of course, an evolutionary and genetic problem that present-day advances in these fields are attempting to answer. What is observable is that the hawk, or its facsimile, acts as an innate release stimulus for some mechanism which is geared and built to recognize the hawk. Behaviour of fear is released. Experimental work seems to indicate that the lower down the phylogenetic scale the more specific is the stimulus, resulting in less adaptation-stereotypy; and in many species the absence of an appropriate stimulus not only inhibits typical behaviour but can result in the death of the animal, e.g. the beak of the female of a certain species of gull contains a red dot on a yellow background, the shape of the beak being specific to females of the species. Absence of any part of

this IRS results in failure on the part of the chick to open its beak—
which means that the chick cannot be fed.

The most important point to be made with reference to this
section is that the stimulus is environmentally produced. In other
words something in the natural world, be it the presence of other
animals or environmental conditions, acts as a specific IRS.

Supernormal stimuli

Ethological work on certain species, for example the grayling
butterfly, suggests that it is sometimes possible to offer stimulus
situations that are even more effective than the natural situation.
In other words, the natural situation is not always optimal. For
instance, the male of the grayling assumes the initiative in mating
by pursuing a passing female of a darker rather than lighter hue—
and to such a degree that if a model of even darker hue than any-
thing known in nature is presented, the sexually motivated male will
pursue it in preference to the darkest female of the species. Professor
Portman (1953, 333–4) writes in comment:

> Here we find an 'inclination' that is not satisfied in nature,
> but which perhaps one day, if inheritable darker mutations
> should appear, would play a role in the selection of mating
> partners. Who knows whether such anticipations of particular
> sign stimuli may not play their part in the support and furthering
> of new variants, inasmuch as they may represent one of the
> factors in the process of selection that determines the direction
> of evolution.

Not enough is yet known about the mechanisms behind such
behaviour, but the term *supernormal stimuli* has been applied to this
kind of stimulus. A supernormal stimulus is one which is not
found in the natural environments of the species but, when artifi-
cially introduced, leads to atypical behaviour or to an enhancement
of typical behaviour.

The word 'artefact' is used in art not only to refer to a man-made
object, but also to suggest, certainly in man's language and his art-
forms, supernormal stimuli which seem to act as releasers for
emotion and thought. Not only does art evoke or heighten emo-
tional ingredients leading to refinement of response but, if the
geneticists' suggestions are indicative, they may add to, or indeed

3*

change, the gene pool, that is to say, alter the adaptation mechanisms themselves. Another way of saying this is that man seems to produce his own supernormal stimuli which may have the effect of altering, modifying and refining his responses. Man's adaptive capacities far exceed those of even his closest relative, the ape. Despite Desmond Morris's painting apes, man still seems to be the only creature who not only speaks but also creates artefacts which seem to act to increase his adaptation of responses and which carry him across critical periods of his development.

5

Earlier in this article I said that any explanation of man's uniqueness must account for his capacity to create culture, and any understanding of the process of creation must ultimately be related to life processes. To substantiate this we may look for pointers from the anti-reductionist biology which has been rapidly developing and I intend to link these developments with developments in relativity physics.

It is extremely important to understand the shift that is taking place in the higher echelons of the sciences. Much of the science that filters through to the layman is still the world picture of post-Newtonian physics of formal dynamics and of old-style biology which were characterized by assumptions (often so well worn as to be unconscious) of linearity, of uniform quadral logic and of determinancy. According to this picture, if a process could be viewed 'mechanically'—that is to say, in the light of a blueprint with a firm mathematical basis—all the better. It was the inadequacy of this mechanistic ideal in major areas of astronomy, physics, biology—and psychology—that brought on the great shift in the sciences. This shift occurred first in the physical sciences when the 'hard core' of matter, that is, the atom, was smashed and the scientist confronted energy which did not obey the same laws of matter. The notion of a hard centre of causality became illusory when it was seen from particle physics that the 'centre' cannot hold and the principle of uncertainty or indeterminacy was born. The old science was hard-edged, based on a linear causal bone structure with a graphic logic. Today, scientific sense of dynamic processes is beginning to focus on the unstable shell, on the membrane whose functions now appear to be as much a matter of permeability,

active transmission and metamorphosis as they are of separation and distinct identity.

We are less confident today that 'the facts' have a stable eternity outside the contaminating range of our altering psyche which is culturally and linguistically governed. To observe is to alter; to define and to understand, even in the most neutral abstract fashion, is to invest the evidence with a particular matrix of human choices, images and symbolic reflexes. Every nineteenth-century scientist and present-day classical scientist fears the inclinations of Yeats's 'Mere anarchy is loosed upon the world'. Today, it is the 'field', the 'manifold', the 'vibratory amplitude' of phenomena that are being stressed.

It is not easy to paraphrase the highly technical issues in the life sciences, i.e. genetics, biology, biochemistry, etc. but the notions that the anti-reductionist scientists have put forward touch on almost every facet of human history and social conduct. And certainly they provide a new viewpoint regarding the genesis of new forms in art and their significance. Put briefly and highly simplified, the suggestions being made are that in living systems the structure of the whole determines the operations of the parts; in a machine, the operation of the parts determines a pre-set outcome. Further, that it is an innate capacity of living things to alter while retaining their identity. (By 'identity' we mean what remains innate and unchanging in a living organism with capacity for change.) There is increasing evidence to suggest that the Darwinian–Mendelian theory of random mutation plus natural selection cannot account for the capacity for these changes in living systems. As soon as any living organism evolves it will change the environment of all other organisms with which it interacts. Life ends and alters the space that surrounds it; that is to say that living forms create their environment and are in turn recreated by it.

The geneticists introduced the idea of a very generalized form of learning into the fundamental mechanics of evolution. Thus the fascinating hypothesis that the memory code of living organisms, far from being fixed and essentially automatic (as is that of a computer), is itself in a constant process of being restructured. With regard to human organisms and in accordance with the Piagetian theory of equilibration, we repack the past for our needs as we travel ahead. Some of the most characteristic, speculative arguments in modern science are to be found regarding the zone of

creative self-regulation of all living organisms. The geneticists emphasize that it is not the response itself to a specific environmental situation that is inherited, but the capacity to respond to the environmental *stresses* in the appropriate way. In the words of Waddington (1969), 'Thus genetic assimilation makes it possible for evolution to exploit what one might call the cleverness of physiological reactions to stressful situations.' Thus discomfort becomes the spur to life.

The nature of the creative

6

The potentially creative individual may be characterized as a system in tension sensitive to the gaps in his experience and capable of maintaining this state of affairs. Some individuals go no further than this point in the creative process; their creativity is manifested in the fact that they have played a critical role in calling the attention of others to the gap that exists. For others the creative process continues by means of seeking various solutions that would close the gap or would effect closure. To be capable of developing such solutions or closures it is suggested that there need be communication between some or all of the inner personal regions of the individual. Stated somewhat differently, the creative individual is characterized by permeable boundaries that separate the self from the environment and in addition some or all of the regions within the self. There are times when this permeability does not exist but may be induced by the taking of drugs or alcohol. Or it may exist when a person is distracted, or devoting himself to other work. This interaction and some of its hazards are well illustrated in Schiller's response (1875) to a friend who complains of his lack of creative power:

> The reason for your complaint lies it seems to me in the constraint which your intellect imposes upon your imagination.
> Here I will make an observation, illustrated by an allegory. Apparently, it is not good—and indeed it hinders the creative work of the mind—if the intellect examines too closely the ideas already pouring in, as it were, at the gates. Regarded in isolation, an idea may be quite insignificant, and venturesome

in the extreme, but it may acquire importance from an idea which follows it; perhaps, in a certain collocation with other ideas which may seem equally absurd, it may be capable of furnishing a very serviceable link.

The intellect cannot judge all those ideas unless it can retain them and until it has considered them in connection with these other ideas. In the case of the creative mind, it seems to me, the intellect has withdrawn its watches from the gates, and the ideas rush in pell-mell, and only then does it reveal, view and inspect the multitude. You worthy critics, or whatever you may call yourselves, are ashamed or afraid of the momentary and passing madness which is found in all real creators, the longer or shorter duration of which distinguishes the thinking artist from the dreamer. Hence your complaint of unfruitfulness for you reject too soon and discriminate too severely.

The intensity of the 'momentary and passing madness' is correlated with the depth to which the experience goes. Instances of such experiences are described by many creative persons. Thus Zervos (1935, 87–8), in discussing Picasso's creative process, says:

His only wish has been desperately to be himself, in fact, he acts according to the suggestions which come to him from beyond his own limits. He sees descending upon him a superior order of exigencies; he has a very clear impression that something compels him imperiously to empty his spirit of all that he has only just discovered, even before he has been able to control it, so that he can admit other suggestions. Hence his torturing doubts. But this anguish is not a misfortune for Picasso; it is just that which enables him to break down all his barriers, having the field of the possible freed to him, and opening him up to the perspectives of the unknown.

Most geniuses responsible for the major mutations in the history of thought and the philosophy of science, including most artists who were mutations in their time, seem to have certain features in common: on the one hand, scepticism—often carried to the point of iconoclasm—in their attitude towards traditional ideas, axioms and dogmas, towards everything that is taken for granted; on the other hand, an open-mindedness that verges on naïve credulity towards new concepts which seem to hold out some promise to their instinctive gropings.

Out of this combination results that crucial capacity for perceiving familiar objects, situations, problems or a collection of data in a sudden new light or new context: seeing a branch not as part of a tree but as a potential weapon or a tool; associating the form of an apple not with its ripeness but with the motion of the moon; the discovery of perceived relational patterns or functions or analogies where no one saw them before, as the poet sees the image of a camel in a drifting cloud.

The act of wrenching away an object or concept from its habitual associative context and seeing it in a new context is an essential part of the creative process. It is an act both of destruction and creation, for it demands the breaking up of a mental habit and the melting down with the blow-lamp of Cartesian doubt of the frozen structure of accepted theory to enable the new fusion to take place. This perhaps explains the strange combination of scepticism and incredulity in the creative individual. Every creative act—in science, art or religion—involves a regression to a relatively primitive level, a new innocence of perception liberated from the cataract of accepted beliefs. It is a process of going backwards in order to leap forwards, of disintegration preceding the new synthesis, comparable to the dark night of the soul through which the mystic must pass. (See Koestler's description of 'bisociation': Koestler (1966; first edition 1964), 35 *et seq.*; (1967), 182.)

Another pre-condition for the occurrence and acceptance of basic discoveries is what one might call the 'ripeness' of the age. It is an elusive quality because the 'ripeness' of a science or art for decisive change is determined not only by the situation in that particular science or art alone but also by the general climate of the age. It was the philosophical climate of Greece after the Macedonian conquest that nipped in the bud Aristarchus's heliocentric concept of the universe; and before that concept was rediscovered astronomy went on happily for over 1,500 years with its impossible epicycles because that was the type of science that the medieval climate favoured. Moreover, it worked. This ossified discipline, split off from reality, was capable of predicting eclipses and conjunctions with considerable precision and provided tables which by and large were adequate for the demand. On the other hand, the seventeenth century's ripeness for Newton or the twentieth century's for Einstein and Freud were caused by a general mood of transition and awareness of crisis which embraces the whole human spectrum of

activities—social organization, religious belief, arts, science, fashions, etc. The symptom that a particular branch of science or art is ripe for change is a feeling of frustration and malaise not necessarily caused by any acute crisis in that specific branch of knowledge—which may be doing quite well in its traditional terms of reference—but by a feeling that somehow the whole tradition is out of step, cut off from the mainstream, that the traditional criteria have become meaningless, divorced from living reality, isolated from the integral whole.

The attempt to locate the source of creative energy—in some past events, for example—reminds me of the advances in physical theory over the last two centuries to find the 'ultimate' and 'irreducible' primary qualities of the world. Each of these advances in physical theory with its rich technological harvest was bought by a loss of intelligibility. Compared with the modern physicist's picture of the world, the Ptolemaic universe of epicycles and crystal spheres was a model of sanity.

Let us take the example of a single particle which is contained in a box whose base represents zero energy and whose walls represent increasing potential energy. If the particle has insufficient kinetic energy to overcome the potential-energy barrier of the walls it can still be predicted with confidence that at some time the particle will appear outside the walls of the box, i.e. it will pass through what appears to be an impenetrable barrier. The point about this is that any electron—which is both a particle and a wave—to accomplish the above feat must in fact make a 'jump' which means that it dematerializes and rematerializes outside the box; that is, it does not pass through space and time. This phenomenon is known as 'quantum-mechanics tunnelling'.

The notion of transubstantiation holds, therefore, no terror for the modern physicist and the psychological notion of transformation and transformational time is a perspective not as far-fetched as was originally thought. The list of such paradoxes could be continued indefinitely; in fact the new quantum mechanics consist of nothing but paradoxes, for it has become a truism among the physicists that the sub-atomic structure of any object, including the chair on which I sit, cannot be fitted into a framework of space and time. Words like 'substance' and 'matter' have become meaningless or, at least, invested with simultaneous contradictory meanings. Consequently, the ultimate constituents of matter are substance and

non-substance, particles and waves. But waves of what? A wave is movement, vibration, but what is it that moves and vibrates to produce my chair or, in the field of creativity, a work of art? It is nothing that the mind can grasp; it is not even empty space, for each electron requires three space co-ordinates for itself; two electrons need six space co-ordinates; three electrons—nine space co-ordinates to coexist. But electrons do not always behave like solid particles at all; in fact, in some experiments they behave like waves. In some sense, these waves are real; we can photograph the famous 'dartboard' pattern they produce when they pass through diffraction gratings, yet they are like the grin of the Cheshire cat.

Bertrand Russell writes (1927, 163–5),

> For aught we know an atom may consist entirely of the radiations which come out of it. It is useless to argue that radiations cannot come out of nothing . . . the idea that there is a little hard lump there, a cause, which is the electron or proton, is an illegitimate intrusion of commonsense notions derived from touch . . . matter is a convenient formula for describing what happens where it isn't.

These waves, then, on which I sit, coming out of nothing, travelling through a non-medium and multi-dimensional non-space, are the ultimate answer modern physicists have to man's questing after the nature of reality. The waves that seem to constitute matter are now interpreted by physicists as completely immaterial waves of probability, marking out disturbed areas where an electron is likely to occur. They are as immaterial as are the waves of depression, loyalty, suicide, creativity, and so on, that sweep over the country or manifest themselves within an individual.

From here, there is only one step to calling them abstract—mental—or brain waves in the universal mind—without irony. Imaginative scientists, of such different persuasions as Bertrand Russell on the one hand and Eddington and Jeans on the other, have indeed come very near to taking this step.

In Eddington's words (see Sullivan, 1933):

> The stuff of the world is mind stuff. The mind stuff is not spread in space and time; these are part of a cyclic scheme ultimately derived out of it (i.e. matter derives from it!). But we must presume that in some other way or aspect it can be

differentiated into parts. Only here and there does it rise to the level of consciousness, for from such islands proceeds all knowledge. Besides the direct knowledge contained in each self-knowing unit there is inferential knowledge. The latter includes our knowledge of the physical world.

And again:

Today there is a wide measure of agreement, which on the physical side of science approaches almost to unanimity, that the stream of knowledge is headed towards a non-mechanical reality; the universe begins to look more like a great thought than like a great machine. Mind no longer appears as an accidental intruder into the realm of matter; we are beginning to suspect that we ought to hail it as the creator and governor of the realm of matter . . .

Thus, the medieval walled-in universe with its hierarchy of matter, mind and spirit—in a series of causality—has been superseded by an expanding universe of curves, multi-dimensional empty space, where the stars, planets and their populations are absorbed into space crinkles of the abstract continuum—a bubble blown out of 'empty space welded onto empty time'.

7

And what has this to do with creative processes? I am not quite sure, but it reminds me of Balint's thesis, supported by the observations of many analysts working with creative people, that there are no objects in the area of the creative. It is not like the area of object-relationships at all. Certainly it is not the area of communications in the sense that the word 'communications' implies the *me* and *not-me* concepts. Nor can it be said that what an artist or scientist creates is derived from the sensory world at all: what may be said more accurately is that what is seen or heard or experienced in the concrete world is derived from the operations of the mind itself. I shall return to this point later.

Certainly the apparent dematerialization and rematerialization of a particle without its passing through a continuum of space, or a series of steps, has similarities with the inspirational moment in the creative process—indeed it can be said to be the *sine qua non* of the

creative, i.e. transformation in *now time*, which must be conceived as different from *linear time*. The problem in studying the creative is the limitations in our conceptions of causality and what had been our orientation towards reductionist thinking. The idea that 'some' past has affected the present has in many hierarchies of knowledge led us to suppose that we can find the ultimate irreducible cause in matter or in the concrete world or in events that have 'caused' this present. When it was supposed that the universe was mechanical, composed of hard little atoms, it was not unreasonably assumed that causality worked by impact, as on a billiard table: that events were caused by the mechanical push of the past, not by any pull of the future. But we know that on the sub-atomic level the state of an electron or a whole atom is not determined by its past. If the notion of its causality has broken down and events are not rigidly governed by pushes and pressures of the past, the question arises: may they not be influenced in some manner by the pull of the future? This is one way of saying that purpose may be a concrete physical factor in the evolution of the universe as well as in the development of individuals. If time is treated in modern physics as a dimension almost on a par with the dimensions of space, why should we exclude *a priori* the possibility that we are pulled as well as pushed along its axis? The future has, after all, as much or as little reality as the past, and there is nothing logically inconceivable in introducing into our equation as a working hypothesis an element of finality supplementary to the element of causality. We are bound to consider the question in the light of the creative for the creative individual's time perspective is orientated towards the future.

Wertheimer (1945), discussing Einstein's thought-processes while working on the Theory of Relativity, says: 'During all these years there was a feeling of direction, of going straight toward something concrete—it was neither rational nor logical—these developed later, but a kind of survey in a way visual. . . .' It is also important to note that the creative individual is not wrapped up in himself but in his work or other than self. An article in the *Observer* remarked that Jung hardly 'belongs to his generation' for in a sense he is timeless and points the way to the future.

Many creative individuals working on their own processes observe that they somehow owe their allegiance to a mysterious task-master who pulls them towards some new reality—certainly posterity to many creative people is their main concern—and meaning and

purpose lies in the attempt to reveal this vision in the minds of other men.

Creative people sense in the present some aspects of the final form in which the product will appear. I suggest that the depression which arises in individuals during or just preceding inspirational moments in the creative process is a result of anxiety that is brought forward by the lack of direction. During these moments the creative person does not feel that he is going forward and still he cannot enjoy the present state. The lack of direction may be a consequence of an excessive number of hypotheses that occur to the individual and the feeling of inadequacy as to the possibility of testing or communicating any of them. '. . . the momentary passing madness . . .' (op. cit.).

Whitehead in the 1925 Lowell Lectures, summing up the situation of the split between mind and matter, religion and science, and the decay of religious influence in European civilization, wrote this (which is very reminiscent of what creative people experience about their own processes) (Whitehead, 1936):

> Religion is the vision of something which stands beyond,
> behind, and within the passing flux of immediate things;
> something which is real, and yet waiting to be realised;
> something which is a remote possibility, and yet the greatest of
> present facts; something which gives meaning to all that
> passes, yet eludes apprehension; something whose possession
> is the final good, and yet is beyond all reach; something which
> is the ultimate ideal, and the hopeless quest.

Beddoes's words ask this question in poetic fashion: 'Bodiless childful of life in the gloom, crying with frog-voice, "What shall I be?" '

The mind itself can never know what governs mental operation. In other words, I would say it is trans-conscious and it eludes full self-awareness and self-consciousness. Max Scheler has emphasized the fact that the person or the subject cannot be fully objectified, that it eludes objectification both by itself and by others. This, in turn, reminds us of the statement in the Vedanta that that which does the knowing cannot be known; that which does the seeing cannot be seen. In other words, that which does the seeing is not perceptible to itself. Now what is mirrored here is a general law we meet again and again, for instance in clinical practice. Often we are confronted with patients who are over-conscious of what they are

doing, sometimes to such an extent that performance of the sexual act and of artistic creation are impaired. Frankl (1969) has coined the phrase 'hyper-reflection' to express this phenomenon. Thus, one could say that full self-awareness and self-consciousness are self-defeating or, in positive terms, that the essence of existence is not based on or characterized by self-reflection but rather by self-transcendence. That is to say, human reality is profoundly characterized by its intentionality, its directionality. Being human means being directed beyond oneself, being directed at something other than oneself. And unless one lives out this transcendence, human existence falters and collapses, and a pathological case results. There are cases in which the eye may well see itself but to the same extent the function of the eye—the seeing capacity—is impaired.

It is taken for granted generally that in some sense conscious experience constitutes the 'highest' level of the hierarchy of mental events and that what is not conscious has remained sub-conscious because it has not yet risen to that level. There can, of course, be no doubt that certain events do remain sub-conscious and that many neural processes through which stimuli evoke actions do not become conscious because they proceed on literally too low a level of the central nervous system. But this is no justification for assuming that all the events determining action to which no distinct conscious experience corresponds are in this sense sub-conscious. It can be argued, and indeed has been argued by most eminent men of science, that we are not aware of many events in our mind not because they happen at too low a level—that is, sub-consciously—but because they proceed at too high a level. Hayek proposes to call such processes not 'sub-conscious' but 'super-conscious' because they govern the conscious processes without appearing in them.

When we consider theories such as Jung's archetypes, theories postulated by biologists of the primacy of the general, Von Helmholtz's conception of unconscious inference, Bartlett's interpretation of perceptions as inferential constructs, Michael Polanyi's conception of tacit knowledge, and Hayek's concept of the primacy of the abstract, we find the suggestion in all of them that development, both physical and mental, proceeds from a state of generalization to a state of particularization. This implies that richness of the sensory world in which we live and which defies exhaustive analysis by our mind is not the starting point from which the mind moves toward abstraction. Indeed, these theories are themselves the

product of a great range of abstractions which the mind possesses in order to be capable of experiencing that richness of the particular.

What we call 'mind' consists in the beginning of a system of abstractions that govern its operation. It is doubtful whether we can ever be conscious of all the higher abstractions which govern our thinking. Rather significant in this connection is the fact that we seem to be unable to use this abstraction without resorting to concrete symbols. The symbol appears to have the capacity of evoking the abstract operation that the mind is capable of performing, but of which we cannot form an intuitive picture. In this sense we are not conscious of the mind's operations. It seems to me that if we ask whether we can very strictly be conscious of an abstraction in the same sense that we are conscious of something that we perceive with our senses, the answer is at least uncertain. Jung, however, called particular attention to the fact that the archetype is an inference and can never be known, though it can be recognized by its imagery. This suggests that an abstraction had best be described as an operation of the mind which can be induced to perform by the perception of appropriate symbols, but which can never figure in conscious experience.

As far as the nature of the creative process is concerned it appears to me that what seems primary does not constitute sensory objects in the real world—perceptions and 'experience'—but the confrontation of a mind with its own operations; that is, its discovery of something which already guides its operations. Hence it is most difficult to make the point in everyday language, without resorting to metaphor, that the formation of creative abstractions seems never to be the outcome of a conscious process, not something at which the mind can deliberately aim.

There is an increasing stress in all fields of thought and knowledge including quantum mechanics—even biological development—on mental factors which govern all action and thinking without being known to us and which can be described only as abstract rules guiding us without our knowledge. It is most apparent in the field of modern linguistics that our mental activities are not guided solely or even chiefly by the particulars at which they are consciously directed, or of which the acting mind is aware, but rather by abstract rules which it cannot be said to know but which nevertheless guide it. An important point to be made here is that the operations for language are already innately present. This was brought out

as long as 200 years ago by Adam Ferguson (1769) in one of my favourite passages in his great work, which I cannot refrain from quoting:

> The peasant or the child can reason and judge and speak his language with a discernment and consistency and a regard to analogy which perplexes the logician, the moralist and the grammarian when they would find the principles upon which the proceeding is grounded or when they would bring to general rule what is so familiar and so well sustained in particular cases.

What I am saying, in short, is that the mind must be capable of performing abstracting operations in order to be able to perceive particulars, and that this capacity appears long before we can speak of a conscious awareness of particulars. Objectively, we live in a concrete world and may have the greatest difficulties in discovering even a few of the abstract relations which enable us to discriminate between different things and to respond to them differentially. But when we want to explain what makes us tick we must start with the abstract relations governing the order which, as a whole, give particulars their distinct place.

This may sound rather obvious but when we reflect on the implications, it means little less, as I have suggested earlier, than that philosophy and the theory of knowledge frequently start at the wrong end: that is, with the assumption that the abstract pre-supposes the concrete rather than that the concrete presupposes the abstract; that the abstract can exist without the concrete but not the concrete without the abstract.

Our mental activities are not guided solely, or even chiefly, by the particulars at which they are consciously directed or of which the acting mind is aware. They seem to be directed by abstract rules which the mind cannot be said to know, yet which nevertheless guide it. Jung's way of saying this is that the archetype predeter-mines—e.g. is there before—regulates, what is observed. The archetype is an abstraction in the sense that it is far more general than any particular object or event. For example, behind one's particular object *mother* lies the abstraction of the archetypal mother in Jung's terms—but archetypal mother is already an image, a particularization of something far more general and even more abstract.

The so-called abstract rules to which I am referring may be seen to be dispositions, sets, or propensities towards certain kinds of inner movements—or in terms of quantum mechanics, waves, oscillations—that occur prior to a perception of an object or the creation of an image. These can be regarded as adaptations to typical features of the environment. But the recognition of such features in the environment is the activation of these 'movement' dispositions. The perception of something as round, for example, would consist essentially in the arousal of a kinaesthetic kind of those movements of limbs, muscles, in different dimensions that lead to a round movement. Bernard Leach, for example, says: 'I make a pot with my whole body.' The primary characteristic of a person is the capacity to govern his actions—thinking, seeing, etc.— by 'rules' which determine the properties of his particular movements. In this sense our actions must be governed by abstract categories (combinations of a kinaesthetic kind) long before we experience conscious mental processes, and what we call 'mind' is essentially a system of such rules, conjointly determining particular actions. The disposition for a kind of action comes before and determines the particular action.

The point I want to make about this with reference to creative processes is that it is a process which by-passes the environment and makes use of the *prima materia* (if this phrase is appropriate for non-material phenomena) of mental operations itself. Certainly in music what is organized are the oscillations or movements of energy itself; and in mathematics, thought to be the purest form of creativity, symbols have no direct reference to objects in the environment but represent perhaps the abstract operations of mind itself. Hadamard (1945) carried out an interesting study among eminent mathematicians including Einstein; with only two exceptions all these people reported that their thoughts relied on curious movements—vague and hazy—some of which reach visual imagery. The ego-adaptiveness of most creative people is a very precarious business: they must learn to avoid any particularization or object-relating or their failure to do so often has disastrous effects either on themselves or on people related to them or on both. Adaptation-particularization puts limits on and localizes movement in a certain direction giving it a certain form and a certain action—living in the environment among objects calls for just this kind of adaptation: materialization of what is essentially energy waves in oscillation.

We can never know about the mind, or its operations, by gazing at objects. For the objects themselves, all sensory experience, perceptions, images and concepts are derived from the particular properties of our inner movement. 'The songs made me, *not* I them,' Goethe says and likewise, Lamartine declares 'It is not I who think—it is my ideas that think for me.'

The anathema, I think, is that object-relating sets a limit on the infinite possibilities of the inner movements or oscillations and produces a set. In Blake's terms, adaptation closes the door to perception. Creative people do not survive by adapting to their environments but by transcending them. They achieve this by abrogating material laws—the so-called hard lumps of reality out there—and tune in to what is essentially true, i.e. that all is a bubble blown out of 'empty space welded onto empty time', and beyond this there are the operations of mind itself—the oscillations and reverberations that represent the laws of life and order in the universe; and this they represent in its ultimate beauty and awesomeness in an artefact.

The limitations of education to creative processes and for art

8

The last sections have attempted, through analogies drawn from recent concepts in the sciences and through exposition and relation of these concepts to man's unique endowment represented by his symbolic processes, to show that his creative capacities are intimately bound to his need to stay alive. Staying alive in the field of human experience is not only a struggle for physical existence; of greater import is the need for assurance of conscious survival—both within the individual and for the species. One prerequisite for an orientation towards psychic survival is the differentiation of experience which brings a conscious awareness of impending death. Another prerequisite is the revelation that one is oneself an effective cause, i.e. that one must take action on one's own behalf. It is a psychic revelation of great moment to discover that one is not dependent on those impersonal forces of nature or the environment for one's own survival. Once this is 'revealed' to us we enter into that psychological condition so well embodied in Unamuno's phrase (1921),

'the tragic sense of life', and are faced with a kind of depression in which the life/death struggle goes on inwardly—no longer projected on to external conditions and situations. The destructive/constructive forces described so well by Ehrenzweig (1967) become an inner creative reality. Our time awareness is changed and we become orientated to transformational processes; to an inner need to make the best of our short time, due to our inner recognition of our ephemeralness and to a new psychic reality that what is lasting is not the body or material things but the significance of human consciousness. The 'idea' is lasting—like the Ghost in the Holy Trinity; that which is eternal is man's psychic capacities which embody his tragic sense of life in his eternal experience of himself in the world. This psychic revelation binds a man to all men who have ever lived and to those who will come after. He draws on the common pool of humanity, contributes to it and 'lives' long after his body has turned to dust.

Man's creative experience in every realm, particularly his art, is testimony to his separation from nature and his independence from it as well as being a symbolic reinstatement of his unity with it. His art not only represents the creation of his own IRS's, unlike other animals whose IRS's exist in nature and their immediate environment, but represents a non-material unity with nature where the dynamics of man's eternal relation with objects and events in his world are symbolically recorded. This ultimately means the loss of 'bodily' dependence upon these objects and events which are sacrificed to the purpose of increased liberation of the human spirit. For the word 'spirit' it might here be sufficient to substitute: thinking about or feeling the 'thing' without the thing being palpable.

Education, in so far as it refers to making young people socially viable adults, has little or nothing to do with the prerequisites and characteristics of the creative processes. And indeed it may be argued that it ought not to have anything to do with these.

The ingredients necessary to maintain a social order are very different from those which are necessary to the creative principle. In the first place society must maintain itself by inducing a kind of stability amongst the young which is antithetical to the free-ranging which characterizes the creative processes. It is the job of education, through the schooling of young people, to channel and to use the early primitive energy of infants for socially acceptable endeavours.

No society can be left at the mercy of unbridled infantile energies if it is to survive. Yet it is essential to the creative process that regression take place to primitive levels of experience and that ego boundaries be temporarily dissolved.

Society's continuity rests in great part on conventional order and conventional belief, tuned to the lowest common denominator of human experience, i.e. dependence. Education to sustain this must tune itself to a different component in human nature: to wit, psychological rigidity. It must induce a kind of consciousness on the part of its young which is antithetical to the ingredients of the creative which are described above; that is, it must induce a belief in individuals that their survival is dependent on the state, the social order and their representative establishments. Any society must 'con' the individual into supporting the system upon which it is based, and formal education is one of the tools used to inculcate into the minds of the young the kind of consciousness needed to maintain the social order. On the most mundane level this can be seen to be necessary. For example, for a society to be economically viable its produce and products must be felt and seen to be necessary and a certain kind of consciousness, that helps the society to maintain its economic viability, must be fed into individuals.

My own opinion is that psychological insights incorporated into educational philosophy and methods have had a sinister effect for they have enabled education to wield even more power than formerly in manipulating individuals. For though 'individual growth and potential' has become almost a hackneyed phrase in educational circles, its main object and purposes cannot be orientated towards individual need when it is obligated to the social order.

Now that education interests itself in creative processes I am in fear and trembling for it can do more harm than good. The aphorism 'you cannot serve God and Mammon' has some validity in this context, particularly given education's addiction to manipulation, control and prediction in the service of social demands. It would, I think, be a big step forward if education could recognize its limitations. We have come to believe that education can accomplish all sorts of miracles given sufficient money and technical knowledge. This is omnipotent and, I believe, dangerous. We would be better to become cognizant of our own limited boundaries, making provision by our attitudes rather than our methods for individuals to develop themselves and their creative possibilities,

thus encouraging an attitude in our young people to expect compara-
tively little from 'education' as well as from those other establish-
ments which condition us to rely on them.

References

Devereux, George (1945), 'The logical foundations of culture and personality
studies' in *Transactions of the New York Academy of Sciences*, Series 2, 7 (5).
Ehrenzweig, Anton (1967), *The Hidden Order of Art*, London: Weidenfeld &
Nicolson; Paladin (1970).
Ferguson, Adam (1769), *Institute of Moral Philosophy*, Edinburgh: Kincaird &
Bell.
Frankl, Victor (1969), 'Reductionism and nihilism' in Koestler, A. and
Smythies, J. R. (eds), *Beyond Reductionism—The Alpbach Symposium*,
London: Hutchinson.
Hadamard, Jacques Salomon (1945), *An Essay on the Psychology of Invention in
the Mathematical Field*, Princeton, New Jersey: Princeton University Press
and London; Dover Publications (1954).
Koestler, Arthur (1966), *The Act of Creation*, London: Pan Books.
Koestler, Arthur (1967), *The Ghost in the Machine*, London: Hutchinson.
Mowrer, O. H. and Ullman, A. D. (1945), 'Time as a determinant in integrative
learning' in *Psychological Review*, 52, 61–90.
Portman, Adolf (1953), 'Die Bedeutung der Bilder in der lebendigen Energiel-
wandlung' in *Eranos-Jahrbuch*, Zurich: Rhernverlag.
Russell, Bertrand (1927), *An Outline of Philosophy*, London: Allen & Unwin.
Schiller, Friedrich von (1875), 'On naive and sentimental poetry' in *Essays
Aesthetical and Philosophical*, London: Bell (for Bohn Standard Library).
Sullivan, John (1933), *The Limitations of Science*, London: Chatto & Windus.
Unamuno, Miguel de (1921), *The Tragic Sense of Life in Men and in Peoples*,
London: Macmillan.
Waddington, C. H. (1969), 'The theory of evolution today' in Koestler, A. and
Smythies, J. R. (eds), *The Alpbach Symposium*, London: Hutchinson.
Wertheimer, M. (1945), *Productive Thinking*, New York and London: Harper
& Row.
Whitehead, A. N. (1936), *Science and the Modern World* (The 1925 Lowell
Lectures), London: Cambridge University Press.
Zervos, Christian (1935), 'Conversations with Picasso' in *Cahier d'Art*, quoted
by Herbert Read in *Art Now* (1960), London: Faber.

Further reading

Campbell, J. (1960), *The Masks of God: Vol. I Primitive Mythology*, London:
Secker & Warburg.
Jennings, E. (1961), *Every Changing Shape*, London: Deutsch.
Jung, C. G. (1969), 'The spirit of man, art and literature' in Read, H. *et al.*
(eds), *Collected Works 15*, London: Routledge & Kegan Paul.

Kenmare, Dallas (1960), *The Nature of Genius*, London: Owen.

Koestler, Arthur (1959), *The Sleepwalkers*, London: Hutchinson.

Koestler, Arthur and Smythies, J. R. (eds) (1969), *Beyond Reductionism—The Alpbach Symposium*, London: Hutchinson.

Marshak, M. D., 'A psychological approach to mythology' I, II and III in *Didaskalos, Journal of the Joint Association of Classical Teachers*, vol. 2 (1) 1966; vol. 2 (2) 1968 and vol. 3 (3) 1971.

Steiner, George (1971), *In Bluebeard's Castle: or some notes towards a redefinition of culture*, London: Faber.

Steiner, George (1972), *Extra-territorial—papers and literature and the language revolution*, London: Faber.

Tomas, Vincent (1964), *Creativity in the Arts*, Contemporary Perspectives in Philosophy Series, Englewood Cliffs, N.J. and London: Prentice-Hall.

Whitehead, A. N. (1933), *The Adventures of Ideas*, London: Cambridge University Press.

4 Study of the context of participation in the arts*

John Newick

I

A group of seven-year-old children once asked me if they could model their clay in the school orchard. I agreed, and then wondered what would happen when they no longer had a flat surface to work on. Would their clay become hopelessly mixed with the newly-mown grass? It did not. They sat beneath the trees, holding their clay in their hands, modelling rounder, fuller forms than was customary on the tables. I thought of this incident some years later in Ghana while watching students in a well-equipped secondary school remove their clay from the tables to model it in a bending position, characteristic of posture in the open-air kitchens of West Africa where the ground is the working surface.

It is more than likely that teachers of the arts make assumptions not only about such an apparently simple matter as the physical conditions in which it is 'natural' to make art, but about the 'right' way to educate the artist and, indeed, about the context of art in society. The purpose of this article is to draw attention to what we could know if we more often challenged our hasty beliefs.

Let us first look at the diversity of empirical clues to attitudes to the arts which the human community provides. In some societies the making of art is a role expected of everyone. As Mountford (1961, 7) says: 'There is no special artist class in an aboriginal community. Every member of it, young and old, will sometimes be an artist.' In some Western societies it may not be an expected role

* I wish warmly to thank Professor Elliot Eisner and Dr Geoffrey Franglen for their invaluable comments on a draft stage of this article and in particular my wife, Shula, for her perceptive criticism throughout the whole period of writing.

but it is the prerogative of all who wish to take part. Painting, movement and drama, for example, are sometimes regarded as activities in which everyone has a right to share at any time, irrespective of ability. Prior experience is not a condition of participation; street arts claim parity with the academies. In other societies such as are found in West Africa, a boy may be apprenticed to sit for seven years beside an experienced weaver, learning to ply his craft in well-defined stages, and must earn recognition as an artist through the high quality of his performance. One certainly cannot generalize about the credentials for being an artist.

Turning to the appreciation of the arts, is this the result of a special kind of education, and hence restricted to an elite, or is it a natural capacity in everyone? Again the evidence is conflicting. Commenting on contemporary art in North America, Susan Sontag (1964, 295) claims that 'art is becoming increasingly the terrain of the specialist. The most interesting and creative art of our time is *not* open to the generally educated; it demands special effort; it speaks a specialized language.' She further claims that the appreciation of some contemporary music, painting and dance 'demands an education in sensibility whose difficulties and length of apprenticeship are at least comparable to the difficulties of mastering physics or engineering'. In contrast, it is sometimes held that aesthetic response is inherent and cannot be educated—that it is, at base, supra-cultural. The absolute validity of unsophisticated responses to the arts is a conviction sometimes supported fervently by teachers in the field. In some cultures appreciation of the arts demands a high degree of active involvement; the boundary between art-making and art-receiving is blurred or even crossed. The receiver is not a separate category of participant. Conversely, in other cultures the spectator/listener has virtually no control over the form of the art object or performance. Yet all these examples accommodate experiences which may properly be described as art experiences.

The conclusion must be that in every society attitudes to the arts and assumptions about participation in the arts define the concept of art in that society. If art is only for those who have been specially prepared to take part, this prescribes what should be called 'art' in that society. Professional painters in the West who assign part of their work, such as painting in some of the colours, to non-professional friends are changing the ground rules. They are enlarging—

or perhaps limiting—what may be called 'art'. 'They are saying what art need not be' (Sontag, 1964, 289). In some societies attitudes and responses which might appear to conflict can be seen to coexist in one environment, not only across the arts but within one class of the arts. Diversity is, of course, no new feature of human societies. In the words of Meyer (1967, 111): 'Cultures, particularly complex ones, are not monolithic.'

In view of the intimate interrelation of the arts and of the specialized interests which readers may have in particular art forms, it seems important to keep the concept of art as open as possible. In consequence I shall employ the word *artefact* to signify configurations and ideas in the arts in general—a poem, a dance, a painting or an event combining several forms of the arts. The use of one word is not intended to imply that what is true of one form of the arts is necessarily true of others.

My purpose to this point has been simply to draw attention to what may seem to be a truism: that in the art/music/drama workshop, in the museum and the concert hall, in the school, in the street, what is made, or what is made *of* what is seen or heard, is prescribed by complex cultural and personal factors. It seems evident that these factors act as a guide to our perception and action; they act as *cues* for behavioural response.

This article will consider the particular need for teachers of the arts to study these cues. The art historian, the psychologist and the sociologist may each have a special concern to understand the factors at work in art experiencing, but I wish to discuss here what distinguishes the insight required by the teacher of the arts and, as a corollary, how it is possible to develop this special kind of insight.

It may never be easy for an observer to detect these cues and, moreover, it appears to be strangely difficult—without special capacity—to uncover those which relate to our own participation. When we succeed there is a tendency for us to assume that the factors which we find acting as cues in guiding our own action and behavioural responses in the arts are general and will be shared by cultures other than our own (or at least by others in our own culture) when they may be no more than local or idiosyncratic.

It may be useful at this point to speculate about what some of these factors—cultural and personal—may be, and how they may operate as cues. Thinking first about the environment, the most obvious hypothesis would be to suppose that everything in our

environment acts as a cue. It is important to entertain this supposition. Some of these factors are part of the physical environment— technological resources, existing artefacts; others are part of the social environment—attitudes to art, censorship, social organization—to name but a few. Next we should consider personal attitudes and values located in the inner world of man—the psychic reality of the individual, his aspirations, fears, inhibitions, needs. These play a transcendent if transient role in participatory behaviour. When we consider all the potential factors in the physical and social environment and in the inner world, we have to conclude that these factors as cues will not rank as equally significant all of the time, and that they will vary with the individual. There is no ground on which we could arrange these factors as a hierarchy in any general sense. Each culture ascribes values to all of them, sometimes overtly and sometimes tacitly. Some are embedded in the personal world. The strength of all these factors as cues to the individual will rest on his mental set, although he will not necessarily be conscious, either of the relative values he attaches to them or, indeed, what some of them are. All of these factors—environmental and personal —the relativity among them and the degree to which they may fluctuate in a temporal sense within the culture and within the person are potentially influential on the behavioural responses of participants in the arts.

A number of questions arise. Are some cues more significant than others? Are cues which are explicit more insistent than those which remain implicit? Does the *quality* of art experience, both in forming configurations and ideas of our own, and in receiving those formed by others, relate in some way to these cues?

It is my conviction that the teacher of the arts has to come to terms with the reality of these factors as potential cues—must study them with a sense of the necessity to understand how they function. In the second section of this article I shall give my reasons for this conviction.

The reader must have realized that there are two facets to such study. One facet is theoretical as distinct from empirical, often general rather than particular. This would include, for example, theories of the structure of society and the mental processes employed when participating in the arts—symbolizing, imagining and so on. Studies such as these would help to alert us to what *may* be involved in specific situations. This brings us to the second,

complementary facet of the study, which does not rest on abstractions and generalizations, but on empirical evidence and conjecture in actual situations involving the participation of individuals. The two facets of the study are reciprocal and overlap: theories about the potential factors in general spring from a particular awareness that some are known to act as cues; and the empirical study of behaviour, prompted by such cues, creates the need for further, closer, theoretical studies of the environmental and personal factors from which these cues are believed to emanate.

We are, then, dealing with two classes of factors: (1) factors believed to be involved but undetected, either by participants or observers (inference); and (2) factors known to be acting, or to have acted, as cues (observation). When referring to factors in participatory situations, *whether inferred or observed*, I shall often use the word *dimensions* since this is suggestive of the measure of the experience available to the participant at any particular time and place.

It is clear that theoretical and empirical studies go hand in hand, and in this article the phrase 'the study of the factors' should be read to include both facets of the study. At first sight the range of the potential factors may seem to be an overwhelming field of study. It is—if taken piece by piece. The intention of this article is to take an overview.

No attempt will be made to provide a detailed category of the potential factors since to do so might put the reader at a disadvantage in the way he structures his thinking. However, in broad terms the factors (and hence the dimensions) fall into two main areas: environmental and personal. The person exists as a psycho-physical entity within a physical context with certain characteristics, such as climate, location, light; similarly, the person has physical characteristics, such as body size, strength, agility, energy. He also exists within a culture which embodies innate attitudes towards, for example, knowledge, history, education, and these attitudes are structured into complex patterns of social interaction and codes; similarly, the person, in relation to his perceptual experience and his capacity to conceptualize, has attitudes and values of his own, and these are realized in his internalized constructs. The culture finds expression in, and is communicated by, language and technologies (ranging from the simple to the complex); similarly, the person has skills of his own through which he communicates with others and with himself across the threshold of consciousness.

4

'No one will deny,' wrote Herbert Read in 1931 (1949, 190), 'the profound interrelation of the artist and the community. The artist depends on the community—takes his tone, his tempo, his intensity from the society of which he is a member.' The artist's 'dependence' on the community, and the community's 'dependence' on the artist can assume a variety of disguises and undergo a variety of transformations. For this reason it is necessary to keep an open mind about the way this interrelation is expressed. Plato conceived of it in terms of the public responsibility of the artist to the community, a responsibility which would demand identification with the ideals of the Republic but which was of such significance that he would be unable to meet his obligation without the help of divine forces. Classical African art, with a different nuance, transferred attention firmly away from the personality of the artist to the function of the art object in the community; the maker of the art object was often anonymous and the making sometimes shared. For some contemporary artists in the West the relation of the artist to the community may involve, as an essential dimension of participation, a measure of alienation from society, not only in negative rejection but as a positive need for isolation and privacy. (*Hundertwasser* is an example. Readers may like to refer to an essay by Archie G. Rugh in *Hundertwasser*, edited by Chipp and Richardson for the University of California, Berkeley, University Art Museum, and distributed by New York Graphic Society.) Each of these examples makes a statement about the culture of which it is a part. Although they are perhaps at the polarities one might feel that the proposition that art is peculiar both to the community and to the individual who created it, remains intact. Read (1949) recognized the influence of the personality of the individual artist—whether publicly admitted or not—but raised a further issue:

> If art is not entirely the product of the surroundings, and is the expression of an individual will, how can we explain the striking similarity of works of art belonging to distinct periods of history? The paradox can only be explained metaphysically. The ultimate values of art transcend the individual and his time and circumstance.

The author of this article shares the mystery but offers an explanation in different vein.

We have paid little or no attention to the shape and character of

the artefact. It may indeed be possible to establish that behavioural responses of the participant are determined by cues in the external and internal world, but is the *form* of the artefact a function of these cues? So far I have inferred that cues and artefact are related. Suppose we could establish that these cues determined the form of the artefact, would this enable the teacher of the arts to construe outcomes—outcomes in the form of the artefact? If this were so without qualification, then optimum dimensions would, as it were, yield optimum responses and hence artefacts of predictable form. Alternatively, let us consider the possibility that dimensions determine outcomes to be entirely untrue and that the converse is true, namely that the arts exist independently of the context in which they appear. Sach (1962, 133), for example, claims that 'Very little music can be fully traced to social and technical changes, and any attempt to unveil the inner processes of art creation is doomed like a search for the soul with the anatomist's scalpel.' If the dimensions of art participation are irrelevant to the shape and character of the artefact, then prediction is impossible. Or is it simply that we find it difficult to identify the forces which are at work?

To clarify the relation between dimensions and outcome involves a consideration of the notion of cause and effect in a general sense. The reader may feel the matter to be one of simple alternatives: either it is a case of the effect of cause—which would have implications both for the teacher and artist; or it is not—which would also have implications for both teacher and artist. It is, however, more complex than this. Causation is not to be understood only as observable or proved connection. The form of the arts is not *caused by* environmental and personal dimensions; as Meyer (1967, 108) says: 'No one will doubt that there is a continual and intimate interaction between styles of art and the cultures of which they form a part. But what is continual is not necessarily simple; and what is intimate is not necessarily direct.' Circumstances do not cause the artefact but define the measure of it.

Participation in the arts—both as making and as receiving—is characterized by subtle nuances which, often unnoticed, foster changes both in dimensions and responses, and *inconsequentially* in the forming of artefacts. It is not a static situation. 'The relation between art and culture is one of reciprocity. Artists shape and, at the same time, are shaped by the culture' (Meyer, 108). Even when

change is to be seen neither in behaviour nor in the forms of the artefact, change may have taken place in the cognitive and affective domains of the individual which, in terms of human capacities and mental health, may exceed in significance the effects which we believe we see or believe we hear.

We are, then, discussing a complex area of human activity. Paradoxically an over-zealous and over-conscious search for tangible explanations may prevent us from developing the sensitive tracking capabilities which are necessary. The quest for the tangible, it has been claimed, has often inhibited scientific thought, even physical research. When the hunt for causes is too persistent, this can impede understanding.

The relation between dimensions and artefact is not such that the teacher of the arts will be able to find a total explanation for this. There is, however, an important sense in which the control exerted by the dimensions of art experiencing may be more clearly discerned, in that the arts exist within a degree of permitted randomness—randomness limited by current cultural posture. In some respects it is this limit on what is possible at any time which is an essential condition for the making of apprehensible visual imagery. If some of the options were not closed, the arts would exist in a vacuum—making no sense to anyone, including the maker.

Does this cultural posture towards apperceptible imagery hold the artist in chains? 'When one speaks of a man one speaks of him *along with* the summation of his cultural experience' (Winnicott, 1967, 370). But this does not acquit him from the need to risk excursionary separation from the cultural bedrock. For Winnicott the 'interplay between originality and acceptance of tradition as the basis of inventiveness' is 'just one more example, and a very exciting one, of the interplay between separateness and union'.

The shape of the arts may be totally unpredictable, although in retrospect it appears to have been inevitable. To anticipate the shape of the arts is virtually to make art—no less. And this, above all, is what the artist as teacher should *not* be doing.

2

How would one justify the study of the potential factors of art participation by the teacher? Some teachers of the arts, although certainly not all, would consider such a study to be justified on

non-instrumental grounds alone: they are interested in the cultural and mental processes involved, and do not expect to find such studies relevant to their function as teachers, except at a most general level. Many teachers, however, will not be satisfied with this and will wish to find tangible evidence of practical usefulness. They would hold the view that the study of, say, the psychology of spatial awareness, should have a direct application to educational procedures and programmes in almost all forms of the arts—certainly in movement, drama and sculpture. In certain circumstances it would be reasonable to expect direct relevance of this kind, but I believe it would not be valid to set out to justify each area of study in terms of its direct and particular application.

I am concerned here to justify the need for an overview of the interrelated factors in art participation, and to put forward reasons for this study in a general sense rather than in relation to specific teaching programmes. Against a grasp of the whole it may often be appropriate to pin-point the direct application of differentiated research and theories, but I am convinced that it is important never to lose sight of the complexity and subtlety of participation in the arts. Many readers will have experienced the consequences of the failure of a teacher to be cognizant of the plurality, even the ambiguity, of his role, failure which can lead to narrowly conceived teaching methods and to outcomes so simple in character that they are virtually predictable—in short, to attitudes which negate the possibility of experiencing the arts in any real sense. A knowledge of, say, the psychology of perception—assuredly of importance to an understanding of participation in the arts—should lead one to be more open-minded towards modes of representing the world 'realistically', but when this knowledge is not leavened by philosophical considerations of the nature of reality, it can lead in an educational situation to closed, didactic procedures.

If the teacher is to open the opportunity for the participant to be involved in art experience in any significant sense he must, I believe, comprehend the dimensions of such experience as interrelated and interdependent. The cues, it is true, can sometimes be differentiated, but they cannot be assessed in isolation. In operation the dimensions of the individual's art experience fluctuate yet remain closely interwoven, are often transitory yet show signs of consistency, and are invariably elusive. When this is understood and accepted by the teacher, he is more able to enter empathetically

into the participation of others. He will be more likely to under-stand, for example, the association of uncertainty and insecurity with the individual's efforts to reach personal goals; he will be more tolerant, more patient, more sympathetic towards 'failure', more open to the unusual, the unexpected and the culturally bizarre. If an inclusive, intuitive grasp of the dimensions leads to these characteristics and attributes in the teacher, it may be thought to be sufficient justification. But, a further question now comes to the fore: is it valid for the teacher of the arts to bring changes in the dimensions which in consequence may modify the measure of the participant's experience?

To consider this question we should now look more closely at the kinds of areas in which change may be contemplated. We shall find that some factors could be changed easily (light, space, time); others could be changed with difficulty (social organization, levels of co-operation among students); yet others could be so embedded in the culture of the student or the teacher that the notion of change in any simple sense is inappropriate; others, for example, the personality of the teacher, would require a change of teacher—which, in passing, ought to be an option more frequently open.

It may be thought by some that the teacher would exceed his duty if he sets out consciously to modify the physical and social structure, and that he should rather confine himself to facilitating the participant's involvement within the existing context. The participant could then react within this context in harmony with cultural modes and personal need: he may set out to become emancipated from the so-called 'limitations' which he finds; he may exploit them in some way, or make efforts of his own to change the conditions on which the limitations appear to rest; alternatively, he may accept the context passively and work modestly within it. By others it may be thought that the teacher should concentrate his efforts on increasing motivations to participate in the arts, or on teaching definable skills, or on acting as guide or psychological support. If we look at these alternatives we shall immediately find that each could represent a substantial change in the dimensions of the participant's experience.

From the teacher's angle two alternatives present themselves: he could set out consciously to make changes; or he could set out consciously to make no changes. In any event he will unwittingly

make changes and will be party to change since all human relationships are subject to constant readjustment. The question now to be considered is this: what would constitute valid reasons for the teacher of the arts to make changes which he believes would impinge on the participant's dimensions of experience? To answer this it will be necessary first to consider the concept of the teacher and the nature of educational goals in the arts—in short, to locate the function of teaching.

I have spoken of 'the teacher' in an unqualified sense. Who is 'the teacher' in art-making and art appreciation? This is a question to which it is not possible to give an unequivocal answer. We may find—and this is something the reader may wish to dispute—that under other names and in other acknowledged roles, a 'teacher' may have been part of the decision-making process in the arts more persistently than is usually admitted. Much of the art and craft in museums, for example, would have been made under conditions which should be described as educational. Some of these situations would have been not unlike the traditional 'school', such as the master painter's workshop or the tribal elder passing on his traditions to the initiates. Other situations would have had more affinity (I would guess) with the informality of the contemporary laboratory-for-learning type classroom, for example, community ventures in which fellow workers, friends and relatives would all at some time have been involved.

As Mumford (1963, 154), writing in 1944, says:

> Even historians forget too easily that the largest part of every culture is transmitted, not through a few institutions and a handful of texts, but by a million daily acts and observances and imitations. Remove even a third of the population, and with it will go a multitude of skills, a vast heritage of living knowledge, an abundance of sensitive discriminations, passed from parent to child, from master to apprentice, from neighbor to neighbor.

In this passage are to be found elements which, if overtly described as educational, would bring more flexibility to concepts of 'teaching'.

The contemporary teacher of the arts in the West is perhaps recognizably distinct from his predecessors. He is not primarily concerned to pass on skills of which he is already master (although this can be an important element). This is not his sole concern, even

when teaching those who need to acquire these skills for a vocation. The contemporary teacher of the arts often expresses his awareness of the enlarged scope of his responsibilities. He is likely to claim a concern for not only performance and aesthetic responsiveness, but far-reaching aspects of human development and personal expression, and to regard his role as laced with social responsibilities which are crucial to the mental health of the community. His function is multi-level, often perplexing and at times lonely; it is concerned with the pulse of others in an inherently ambiguous context within which lie apparently conflicting claims for priority: when individual expression becomes bizarre, interpersonal communication is endangered; when facility is revered, the capacity to sustain the struggle to find new solutions is disrespected; when the perpetuation of tradition prevails, the will to bring change in the form of the arts is suppressed. Such a portrait of the teacher of the arts and his context, although roughly drawn, points up the dichotomy in which he may believe he is trapped. It is a role from which many would shrink, and the reader may like to know in advance that the final section of this article is designed to discredit it.

There is no doubt, however, that the complexity of the role of the teacher of the arts makes it difficult—or appears to be difficult—for him to make decisions about the learning environment in which his students function. Educational objectives in the arts, except those of a limited kind, tend to be conceived of by teachers as sequential, leading to ultimate goals which are expected to recede to a virtually unattainable point as they are approached. Readers may wish to consider whether there is a special justification for this idealistic view of objectives in education in the arts. Such a stance may be inevitable and irreproachable.

Throughout the West, and indeed over a large area of the world, there is a growing attempt to establish the psychology of learning as an autonomous study and for procedures to be defined in the light of the teacher's assessment of the receiving, responding and valuing postures of the student. It is perhaps the area of valuing posture which poses the most subtle and most fundamental challenge to the teacher of the arts, since valuing posture relates to the affective domain of mental functioning.

There is, however, a tendency for affective objectives to be acclaimed in principle but neglected in practice, or eroded over the

course of time. Krathwohl, Bloom and Masia (1964, 15–23), investigating the erosion of affective objectives in high schools in the United States, found that this was due in the main to failure of teachers to appraise the extent to which students were developing in affective behaviours. A major contributory cause of the erosion of affective objectives in the arts is located in the inseparability of the valuing posture of individuals from the cultural posture in which these values are embedded—and this applies to both student and teacher. In societies with high levels of cultural continuity it is comparatively easy for the teacher to relate to the valuing posture of his students. In passing it is a matter of conjecture if such societies are increasing or decreasing. But in societies with high levels of cultural discontinuity it is more difficult for the teacher to make the necessary adjustments to accommodate change and to conceive of the notion of a culturally relevant education in the arts. (There may be a sense in which fluctuating stability or *stasis* in the arts is independent of cultural discontinuity. By far the most challenging writer on this theme is Meyer (1967). The unpredictability of fluctuation does not, I think, undermine the argument advanced above.) Whatever the nature of the culture pattern, there will be a recurring need to establish immediate goals if ultimate objectives are to be brought within sight. 'While one benefits from clarity about ends in education, it is often true that we may discover or rediscover new ultimate objectives in the process of trying to meet more modest goals' (Bruner, 1960, 69).

The point which must be stressed here is that even immediate, seemingly modest objectives in the arts tend to embody elements which are often simultaneously cultural, psychological and moral. Suppose a teacher decides to take steps to reduce the 'difficulties' thought to hinder involvement in the arts. Such a decision could rest in part in socio-cultural consideration of the degree of difficulty the individual should be asked to face; it could rest in part in psychological assessment of the optimum load of frustration which is appropriate as a form of motivation; it could in part be moral in the belief that surmounting difficulties may develop certain desirable qualities of character. This example is reasonably straightforward; decisions in matters of, for example, censorship or standards are likely to be even more complex.

We could say, then, that the study of the dimensions of participation in the arts and the study of cultural/educational objectives,

4*

taken together, locate the teacher of the arts in his society. So located, he becomes immediately ensconced and immediately vulnerable: he has the option to make decisions yet he must recognize his fallibility; he may preside yet not prescribe. Not only the teacher has goals; not only the learner has emotive drives.

This brings me to the threshold of a controversial proposition of some importance. I have argued that any changes in dimensions, inferred or observed, lie within the context of (1) tenuous connections between dimensions and artefact and (2) a complex of cultural/educational priorities—in any event difficult enough contingencies. On such insubstantial, shadowy footing is it reasonable for the teacher of the arts to regard himself as the sole arbitrator for changes in these dimensions? Can he, with any certainty, by making such changes ensure in others the development of the capacity for participation in the arts? Even if he has the capacity, has he the right?

It may be argued that he is, after all, in possession of special knowledge about the arts, has special insights into the educational process; he would expect, and would probably recognize, changes organic to the situation; and would carefully examine the bases on which he would modify the context of participation for others. Many teachers may regard this apparent responsibility as a prerequisite of their function which they must shoulder unflinchingly— a persistent obligation from which there is no escape. But will autonomous changes made by the teacher fall inevitably within the orbit of his own projections? However perspicacious he may be, the artefacts may bear too close an affinity to his own aspirations. If, as I have argued, dimensions and artefacts are in a state of reciprocity, cognizance of this reciprocity should become part of the conscious concern of the participant—adult and child. If the participant is to have an art experience (and what else would serve?) this should include the notion of his control over the context of art-making and art-receiving. It may be argued that the destiny of the artist is most fulfilled when he transfers his concern to the physical and social environment in a qualitative way. Will the human environment, after long disguise and neglect, become the ultimate artefact?

A further justification for involving the participant in a conscious concern for the dimensions of his own experience would be sustained if it were found that a consequence would be a more incisive

response to the arts of the past and the present. The arts of the past and man in the present (as the only datum of experience of art-making) may have a special relation. Comprehension of this relation rests on taking a common attitude to both the arts of the past and the arts of today. The arts of the past are the result of a response to human need within a particular set of dimensions (including, of course, contemporaneous education, even from the earliest history of man); similarly, the arts of today are a response to human need within the prevailing opportunity. This conception carries promise of the integration of attitudes to cultural heritage and to participation today in two important ways: comprehension of the past is informed by discerning involvement in the present; and the needs of the individual today, as fulfilled in his opportunity, relate with organic continuity to the response of man as seen in the history of the arts. The past is augmented by the participant's activities in the present, and this includes what transpires in the arts in education—a fact which is often ignored.

It has been claimed that if one is to account for the *form* of a building, it is necessary to consider it in several respects. It will in part be explained by the structural means used to build it, in part by the purpose for which it was built, in part by its location in the history of building, and in part by aesthetic preference. Such a piecemeal account leaves much unexplained and would, at most, do no more than define the range of probability within which the form had become a physical reality. Full appreciation would depend on comprehension of the whole as a whole. If the capacity to respond in an inclusive mode rests in a general consciousness of the historical/psychological continuum of which the art-maker-appreciator today is a living part, then the question is: does an education in the arts which includes maximum responsibility for the context of one's own involvement favour inclusive, rather than piecemeal, responses?

What has been envisaged, then, in respect of the appreciation of the arts is an education which would draw on (1) the participant's knowledge of the dimensions of his art-making, and (2) confrontation by artefacts from the past and the present with inevitably less contextual knowledge. The student of teaching will wish to assess the possibility of this duality yielding significant bilateral insights. Such insights might become the springboard for philosophical, psychological and sociological studies in the arts—

as yet almost entirely unexplored in the secondary/high school—
and to a more active assessment of historical and contemporary arts
criticism.

3

How is the comprehension of the context of arts participation to be
developed? What are some of the ways of study open to us? Where
and how should we look for evidence?

We could say that we have evidence for this comprehension from
the *artefact* and evidence from *man*—what he feels, how he acts,
what he says. It will be immediately apparent that the artefact
sometimes provides evidence of an extrinsic kind, such as informa-
tion on the technology used in its making. Whether 'embodied'
meaning (see Reid's article in this volume) symbolized in the arte-
fact provides evidence of the dimensions of art experience is a
further question. It is a possibility which the reader will wish to
consider. But to return to man, the most copious sources are books,
articles, television and radio; discussions of attitudes, values and
belief by philosophers, aestheticians and critics; the investigations
of psychologists and sociologists; the interpretations of historians
and anthropologists; the assessments of educational theorists, and
the accounts and testimonies of pioneer teachers. Students of
teaching, especially those on initial credential programmes, have
increasingly to develop the capacity to cope with the range and
quantity of this material—material which is in need of rigorous,
ongoing reappraisal of its relevance to today's needs. Such an
appraisal involves, at base, an evaluation of the character of human
knowledge.

A valuable source of information is the introspection of artists.
Painters, sculptors, musicians, poets, dancers and actors have often
written perceptively about their procedures, attitudes and feelings.
What artists say about their involvement is analogous to observation
of their behaviour: both may be accepted at face value; both
become the subject of further interpretation. As Ecker (1966, 58),
writing in 1963, says:

> It is my contention that careful study of what painters *do*
> when ordering their artistic means and ends, as well as what
> they *say* they are doing, will provide the bases for significantly

improving our generalisations about the plastic arts and our conceptions about education in the arts.

In day-to-day teaching the observation of behaviour as a means of studying participation in the arts is often neglected by teachers in the belief that to be valid observation must be systematic. For certain purposes it clearly has to be, but much can be learned by sensitive observation in an informal way: from posture, gesture, social intercourse, degrees of interdependence/independence. Observation, as the basis of measurement of behavioural changes, is a very important aspect of the teacher's skill, perhaps especially in the arts.

For me the stimulus to observe and to inquire has been greatly increased by teaching in cultures other than my own—in West and East Africa, the United States and Canada. The experience of working outside one's culture points up, dramatically at times, the degree to which notions one has about art and attitudes to art are local rather than universal—if indeed there are attitudes which are universal. I returned to England from Africa with a new realization of electricity as a local source of power for the potter; a vivid consciousness of learning and familiarity as factors in the perception of man-made imagery; and the strict sex-role divisions in weaving and pottery drew my attention afresh to disguised sex-roles in the arts in my own society.

In all the cultures in which I have taught I became far more aware of the relation between educational procedures and attitudes in the culture at large. Consider the situation of a West African teacher in a rural school, familiar with modern theories of art education which will have taught him that for art to contribute to their development in the most fruitful way, children should be allowed to express their ideas freely. This might appear to conflict with the norms of a culture which expects children to wait upon the wisdom of their elders. My observation of this dichotomy draws my attention more acutely to ambiguities in the teacher's role in my own society: what kind of dilemma awaits the teacher who is expected to work within a traditional curriculum when he knows in his heart that education could be structured to help his students far more adequately to face 'persistent and literally vital questions of our time'? (See Eisner (ed.), 1971, Introduction.)

Teaching in another country is clearly a very good way of

sharpening one's capacity to detect the covert context of the arts, although it should be said that comparisons do not necessarily emerge unbidden. Another way of stepping aside from the familiar is for a teacher accustomed, for example, to teaching in an urban secondary/high school to teach hospital patients, senior citizens, youth in a club situation, disadvantaged children or any section of the community with unfamiliar life-styles. New dimensions of art experiencing will be uncovered, new needs will emerge, which may illuminate the context which he believes he understands.

Another source of cross-cultural comparison is the museum— not only the great teaching museums designed with comparative study in mind—but picture galleries, folk, social, industrial and science museums, music, literature and drama libraries. The museum is potentially a multi-level experience and since it is a basic principle of comparative method that criteria for selection of phenomena must be established, it is important to have a special purpose in mind: for example, one might seek strictly technological comparisons, or one might compare the relation of form and function, or the aesthetic response evoked when all extrinsic information is consciously excluded.

The form of inquiry required by comparative method may be thought by some to be too overtly structured. They may feel that the transcendent means of insight reside within one's own, non-instrumental involvement in the arts. I have much sympathy with this, but would add that passive participation does not necessarily increase insight into one's own experience, or that of others. There has to be an inclination, even the will. It may be insufficient to engage in retrospective analysis as this is not synonymous with insight sought in immediacy. Some aspects of experience tend to settle in the unconscious; furthermore, conscious reactions are transformed in the process of *re-membering*—literally putting together the past. For reasons such as these it may be important, especially for some, to keep a journal or in some other way record their attitudes and conclusions at the time of participation, and so trap a source of insight to complement that which persists in recall.

All the ways of studying the factors and dimensions of art participation discussed briefly above may result in no more than a fragmentary, or at best, enumerative assembly of disparate elements. The participatory experience of the arts is emphatically not disparate

and fragmented: it *is* an art experience by virtue of being integrated and inclusive, an experience in which cognition and affect, conscious and unconscious, merge imperceptibly. Knowledge of all the factors/dimensions may seem too pluralistic and multi-level—with, on the one hand, physical realities of pigment, musical instruments, time, light, acoustics; and on the other hand, intangible, emotive forces in the inner world—for synthesis to result. It is, however, because it is so complex that analysis will inevitably fall short.

The individual is the only datum of experience. Experience *qua* experience cannot be shared (see Marshak, 1966). No matter how sensitively the teacher may relate to the involvement of others, even within a close teaching relationship, he cannot *possess* the insight of the participant; neither can the participant *possess* the insight of the teacher. The experience of the child/student is singular; the experience of the teacher is singular. Experience itself cannot be exchanged—only the way in which each apprehends his experience. The supreme, perhaps the only, way in which the sharing of such apprehension can be achieved is through an art form. Communication at this level is symbolic. It is, one may feel, the most fundamental annunciation of the human spirit and the most fundamental means of human discourse. Such a claim ascribes to the artefact a unique place in human discourse.

It may be thought that interpersonal communication through the arts is sufficient expression of the interdependence of teacher and student as a necessary condition of all learning/teaching relationships. Many teachers of the arts may feel that tacit admission of reciprocity is adequate. My own view is that mutuality would be far more productive if given the overt status of a joint enterprise in which everyone involved may properly feel a degree of responsibility for others, and in which everyone may accept dependence on others for the understanding of ideas. Interdependence which is merely inferred can disguise non-communication.

It is not intended to suggest that open recognition of interdependence (between teachers and students, and among peers) requires frequent reinforcement in structured encounters, but rather that it should be ongoing and resourceful. To make this a reality will require new structuring of school, college and university communities to enable groups to form in purposeful and fluid ways, and not to be restricted to categories often determined by irrelevant criteria or administrative convenience. The flexible grouping of

students is an urgent practical issue, especially in secondary and higher education. It is a field in which there is a need for teachers not only to facilitate student-initiated co-operation, but to gain the insight and experience to counsel students positively on potentially productive associations with other students who possess complementary capacities or temperaments (James, 1970, 158). Administrative facilities must match educational needs in this respect. Readers who are unaware of the measure of flexibility made possible in the organization of modular schedule schools in the United States should make a point of finding out how this is achieved (see Stewart and Shank, 1971).

Is there a special necessity in the arts to draw on this mutuality? If one accepts the view that the concept of experience *as a state* is more appropriate to the arts than the concept of experience as an advantage gained from the accumulation of certain 'experiences', then the experience of the teacher and the experience of the student rank in complementary validity. In the arts, the young, even the artistically 'inexperienced', often reveal insights and capacities which are virtually denied those with 'more experience' by virtue of the fact that they are excluded from the experiential state of being young or artistically inexperienced.

There are, of course, many levels and modes of communication, some factual, others analogic and vicarious, and in the discussion which follows it is intended to include all these ways of sharing as adjunctive to symbolic communication through art objects. Nowhere is the profusion of modes of communication better shown than among young children for whom interdependence is commonly a natural and productive part of their lives. As they grow older pressures often force them to accept a measure of intellectual and emotional isolation from each other as a condition of learning, even in the arts.

Whenever and wherever people come together for any form of participation in the arts, both making and receiving, there exists a largely untapped pool of insight—untapped by reason of deeply rooted notions (at least in the West) about the intrinsic merit of the lonely struggle of the artist. This notion carries with it self-reliance and autonomy as desirable goals, made manifest in the importance ascribed to self-expression and in the recognition given to individual merit. Attitudes of this kind can discourage discussion and inhibit co-operation.

What people can communicate of their involvement, their difficulties, their discoveries, their ecstasy, is important. Sharing, of course, in some societies is a subtle matter. Some individuals will be willing, at least at first, to reveal only those thoughts which they would consider mundane; others would be able to contribute only within the psychological protection of an active, co-operative venture of some kind; yet others may wish to verbalize only at an intense, intellectual level. Sometimes penetrating insights come from those whose performance in the arts commands less attention. It is perhaps worth noting that evidence suggests that when verbal language is used to communicate insight into the arts, this does not always depend on the use of a sophisticated, specialized vocabulary (see Feldman, 1971, 199).

It is not unusual to find students of teaching on initial credential programmes almost totally ignorant of each others' procedures, attitudes and aspirations in the arts. They should reflect on how this may influence the teaching of the arts, especially in general education. Is it possible that active, person-to-person communion, particularly in the West, is in need of rehabilitation? Is Mumford's vision of the transmission of culture 'by a million daily acts' and 'an abundance of sensitive discriminations' beginning to fade? If so, at what cost? Should formal education do more to recognize the genesis of these discriminations?

Schools and colleges in many urban parts of the world are increasingly multi-cultural and ethnically diverse. The reasons for this are well known—historical and recent migrations, adjustments in ideologies which in turn foster new and often more fluid allegiances, and numerous other causes. The result is that students and children come together from a wider spectrum of the human community. The individuals in any human group will, in any event, be different from each other. Homogeneity is always comparative and all groups contain variations in life-style, interests, skills, needs and motivations. It is commonly found that study groups with high levels of heterogeneity are more productive of ideas than groups which are more homogeneous. It could be pointed out in passing that synectic problem-solving groups are formed by deliberately bringing together individuals from different training and subject fields to focus on problems which each member alone would be unlikely to solve.

If diversity can be shown to favour new comprehensions, the

multi-cultural diversity of schools should be regarded as an educational asset of considerable importance. Diversity, in particular ethnic diversity, may have a special significance for interdependent study of the dimensions of art experiencing. Persistent communication in 'multi-cultural groups tends, I believe, to focus attention on life-styles, customs and expressed thoughts and feelings, and away from generalizations about imagined characteristics often ascribed to social class or ethnic origin. Differences emerge, as in all human groups, but are *seen* to relate to distinctive life-styles and distinctive ways of dealing with experience. If the members of a multi-cultural group have well-developed capacities to apprehend the dimensions of participation in the arts, they will be ready to regard the differentiated imagery and responses which they notice in the group as relating to dimensions of the individual's experience. Some of these dimensions will be special skills, say in dance or rhetoric; others will be attitudinal. But to be understood and respected these personal dimensions must first become part of the consciousness of the group, including the teacher.

Mutual respect, however, should mature into dynamic interdependence. When diversity is seen as an educational asset, conservation, as distinct from preservation, becomes an important concept in cultural and educational contexts as well as in the environmental context. According to James (1970, 155):

> Men are born diverse, and everywhere are under pressure to become the same. . . . By welcoming the fact that people are different, have different pulses, talents, growth rates, physical build, interests, sexual ambitions, temptations, temperaments, even physical scales of perception, we have some hope of countering the in-built tendency of all modern large-scale organisations to quantify and depersonalise, which is one of the threats to survival.

Every member of a multi-cultural group has a cultural history. Certainly those cut off from their homeland should have special opportunity to study their cultural history, but every member of such a group could play a part in bringing to bear greater insight on all the cultures represented. I believe that this can happen naturally since it is well known that persistent intercommunication tends to uncover, not only individual concerns and unique characteristics, but also matters of common concern. Human concerns at the most

profound level are universal and public, but need to be worked out in many different expressive modes and symbolic systems.

Most teachers of the arts appear to welcome the range of experience inherent in heterogeneous groups and communities, and favour new juxtapositions of peoples and arts. Some would claim for these juxtapositions the means to social harmony in a world in which the technical potential to communicate has overtaken man's accommodation of new patterns of behaviour.

Interdependence in the arts is, I believe, no threat to cultural diversity. It could foster individual differences in new forms of cultural cohesion. For this reason, in particular, interdependence in education in the arts is proposed here as a pedagogic and social necessity.

References

Bruner, Jerome (1960), *The Process of Education*, London: Vintage Books.

Ecker, David (1966), 'The artistic process as qualitative problem solving' in *Journal of Aesthetics and Art Criticism*, 21, 3 (1963); reprinted in Eisner, E. and Ecker, D. (eds) (1966), *Readings in Art Education*, Waltham, Mass.: Blaisdell.

Eisner, Elliot W. (ed.) (1971), *Confronting Curriculum Reform*, Boston: Little, Brown.

Feldman, Edmund Burke (1971), 'The non-verbal fields as neglected areas of study' in Eisner, E., *Confronting Curriculum Reform*, Boston: Little, Brown.

James, Charity (1970), 'Flexible groupings and the secondary school curriculum' in Rubenstein, D. and Stoneman, C. (eds), *Education for Democracy*, Harmondsworth: Penguin.

Krathwohl, David R., Bloom, Benjamin S. and Masia, Bertram B. (1964), *Taxonomy of Educational Objectives II—Affective Domain*, Harlow: Longman.

Marshak, M. D. (1966), 'A psychological approach to mythology' I, in *Didaskalos, Journal of the Joint Association of Classical Teachers*, vol. 2, no. 1.

Meyer, Leonard B. (1967), *Music, the Arts and Ideas*, Chicago: Chicago University Press.

Mountford, Charles R. (1961), 'The artist and his art in an Australian aboriginal society' in Smith, Marion (ed.), *The Artist in Tribal Society*, London: Routledge & Kegan Paul.

Mumford, Lewis (1963), *The Condition of Man*, London: Mercury Books.

Read, Herbert (1949), *The Meaning of Art*, Harmondsworth: Penguin.

Sach, Curt (1962), *The Wellsprings of Music*, The Hague: Martinus Nijhoff.

Sontag, Susan (1964), *Against Interpretation and other Essays* (3rd ed., 1967), New York: Farrar, Strauss & Giroux.

Stewart, James and Shank, Jack (1971), 'Daily demand modular flexible scheduling for small schools', in *Education Leadership, Journal of the*

Association for Supervision and Curriculum Development, NEA, 28, no. 5, 537–41, February. (See also *Further reading*).

Winnicott, D. W. (1967), 'The location of cultural experience', *International Journal of Psychoanalysis*, vol. 48, 368–72.

Further reading

Bourdieu, Pierre (1971), 'Intellectual field and creative project' in Young, M. F. D. (ed.), *Knowledge and Control*, London: Collier-Macmillan for the Open University.

Bourdieu's paper is directed to the development of a view of the arts as socially constructed. It presents an interesting analysis of 'degrees of cultural legitimacy', ranging from 'the entirely consecrated arts—the theatre, painting, sculpture, literature or classical music . . . to systems of signs which (at first sight anyhow) are left to individual judgment, whether interior decorating, cosmetics or cookery' (176). 'Creative project' is seen as 'the activity in which the intrinsic demands of the "intellectual field" (the mediating set of agencies which confer cultural legitimacy) and the external context of the social and economic order of the time are joined in the work of art itself' (Young, 10).

Bourdieu claims that 'The school is required to perpetuate and transmit the capital of consecreated cultural signs' (178). Readers may wish to discuss the conditions under which such a view of school would not conflict with that proposed in my article.

Elkind, David (1971), 'Teacher–child contracts' in *School Review*, University of Chicago, 79, no. 4, 579–89, August.

Elkind believes that 'We need a theory which will look at teacher–child interaction as a new phenomenon not entirely reducible to the personalities and backgrounds of the participants' (589). He discusses this interaction as an emergent contractual relationship which, in my view, forms a very useful extension of the concept of mutual interdependence in the arts discussed in my article.

Landes, Ruth (1965), *Culture in American Education—anthropological approaches to minority and dominant groups in schools*, New York, London and Sydney: Wiley.

The author 'believes that adults teach and pupils learn in keeping with habits absorbed from their cultural background' and as an anthropologist is interested in the *behaviour* of all parties and how cultural traits 'mesh or clash at school'. She is convinced that 'teachers can be trained to apply . . . anthropological methods and concepts to their work and conduct'. Although founded on a study in Southern California the book is relevant to multi-cultural communities throughout the world since it moves from the particular to the general.

Stewart, James and Shank, Jack (1971), 'Daily demand modular flexible scheduling for small schools' in *Education Leadership, Journal of the Association for Supervision and Curriculum Development*, NEA, 28, no. 5, 537–41, February.

It is not only large schools that have something to learn from flexible scheduling. Indeed, the reduction of the size of student groups does not necessarily eliminate the problems thought to be associated with teaching students in larger

groups. This account of 'hand' modular scheduling in a small American high school describes the operational arrangements for studying as the responsibility of teachers and students, not as an administrative convenience. It is worth reading by anyone with a concern for pupil participation and for the preservation of vitality in teachers.

5 Education in the arts*

Leslie R. Perry

Introduction

The central concern of this article is to see what study of the fine arts has to do with producing educated persons. Is such a study merely a decorative optional addition to education, or is it essential to any education worth the name? Discussion of this question looks first at educated persons and educated minds. It draws attention to the intellectual pressure felt in all curriculum planning for formal education, namely the habit of making cognitive education the principal emphasis, subordinating other things to it and then requiring of those other things, which are apparently less cognitive, a justification for their presence in the curriculum in terms of what *cognitive* advance they can achieve. The predicament thereby arising for less ostensibly cognitive subjects is looked at here in the context of the fine arts. A false justification of study of the fine arts, leading to a merely ornamental status for them, is described and challenged, and the strong claim is then made that their study is essential to the education of persons and minds. In the effort to substantiate this claim, noteworthy aspects of education in which study of the fine arts appears to contribute considerably to the outcome are examined, and the areas selected are situation, motive, adventure, communication, imagination and objectiveness. In conclusion we point to the implications of the discussion for a fresh view of cognition itself.

I

All human beings, it seems, whether educated or not, are described as persons quite soon in their lives, and they are also thought to have

* The author wishes to express his grateful thanks to Professor L. A. Reid whose advice and help have been most valuable in the preparation of this article.

minds. It is generally understood that both of those descriptions are verdicts by society on its members to be, rather than attributes arising from the biology of man. In terms of biology children turn into ex-children, though we prefer the word 'adults', but persons and minds, with which we are credited so soon, do not grow larger and heavier and stronger and do not age, like organisms, though they may grow richer or poorer, more sophisticated or more simple, more learned or more ignorant.

Person and mind, however, are not identical terms. Person is a word to do with conduct as well as mental possessions, whereas mind stresses the latter and is vague about the former. Mind is the subsidiary word, for it is something only attributed to persons and as a concept is parasitic on the concept of a person. Person, however, implies mind and more than mind. When we speak of a mind we are trying to intimate a particular area of personal life, a kind of activity of which there may be no outward sign, mental things going on when we are out of touch with action—a view which has survived the detestation of Ryle. Mind is also concerned with and connected with action but, unless we wish to emphasize the mental setting of action and conduct, we pass over here to speaking in terms of persons. So, criminal persons, detached persons, active persons, are phrases referring to conduct rather more specifically than do criminal minds, detached minds, active minds. This is also true of educated persons and educated minds.

2

Person and mind were described above as verdict words, for children are credited with them early, in the confident expectation that as they grow up they will act in much the same way as other adults and be involved with much the same things. For this, no formal education is needed—only informal education is essential. If, however, our children obtain a formal education as well, we add another verdict wherever we think that education has been successful—that they are educated persons. For now we think that, as well as being involved in normal human concerns, our children as they grow will take part in conduct and thought of some degree of complexity and sophistication, will display informed judgment, and so on. It is assumed that as educated persons and educated minds they can do such things. For the most subtle, complex and insightful

types of thought and behaviour are not open to all persons, but only to educated ones. There is no exclusiveness about this—anyone can participate in educated conduct and thought whenever he is ready and able. Someone might ask, where do we see that a person is educated—what distinguishes them from others? Perhaps in three places:

(a) in increased perceptual range, along with conceptual readiness;
(b) in aptness of judgments, practical, aesthetic, or meditative;
(c) in increase of knowledge, complexity of reasoning processes and the closely allied types of intellectual judgment.

When we speak of educated persons, any combination of the above, or any one of them, may be meant. When we speak of educated minds, however, it is rare for the emphasis to be elsewhere than on the third, although some of the non-practical judgments of the second are sometimes indicated. No logical point is made here: what we are exploring is the customary restrictive intention in using the word mind.

If this is so, then what underlies the descriptive verdict, educated person or educated mind? Either of these descriptions will testify not only to the immediate response elicited by social intercourse, but also to a disposition, something influencing thought and behaviour that we come to expect of a person over a lifetime, and for the most part rightly expect it, although an education has to be *maintained* when attained. Educated persons and minds have been involved in a learning process under skilled guidance, in which knowledge, ways of thought and conduct, perception, feeling, current in and selected from a tradition of living that is around these persons, were mediated to them. They have come to grasp and explore and to become constructively critical of that tradition. They have learnt how to be sensitive to safeguarding it whilst amending it. All this may not be completely true of any one educated person, but merely instances the type of consideration that arises in oneself when judging whether people are educated.

The point of keeping both notions, that of an educated person and that of an educated mind, before us, is that should we analyse what it is to be educated in terms of what produces an educated mind, we may fail to throw into relief those aspects of an education which must be attended to when talking of an educated person. To

say that someone has an educated mind tends to pass a verdict on one side of his formal education, and to say that it comes to fruition. But the restriction in the customary use of the word mind often results in failure, in the case of educated minds, to report on other sides of the achievement of the persons possessing them, which sides are properly the concern of formal education. To put the matter another way: to dwell upon knowledge and cognition and intellectual judgment, and to treat of the formal educational process as if it were a quality of intellectual acumen that is aimed at, involves, or can involve, neglect of areas of judgment other than intellectual ones, not to speak of education in perception and conception in terms of awareness not markedly cognitive in quality, such as the aesthetic kind. In fact, curricula being what they are, liberal and general education is not more than in part a cognitive affair. So the issue of what constitutes an educated person *can* be different from what constitutes an educated mind.

This is not to do with curricular planning round a cognitive centre. That is a matter of procedure—it may be and quite possibly is more convenient to organize an educational process in a way causing the cognitive side to be the most ostensible and salient aspect. But it is not implied that therefore the main *aim* of education is cognitive achievement, though perhaps it is the most tangible aim. No criterion for arranging the aims in a hierarchy logically arises from educational procedure. The other sides of education mentioned above, and appearing in educated persons, should not be described as an afterthought or as an acceptable context for cognitive achievement; they should be alongside that achievement in judging an entitlement to be called educated. Education, viewed as knowing, analysing, judging, valuing, meditating, is no less to be seen in how we live than perhaps in how we understand as minds. Education may be detected in trained scientific analysis, philological investigation, but no less in personal relationships, planning of policy, aesthetic judgment. So, if we try naming educated men, we may think like Spencer of a scientist; yet this phrase evokes other images, for Aristotle, or Quintilian. Part of the reputation of Socrates rests upon his wisdom rather than his intellectual acumen, and as for Leonardo, to talk of his scientific achievement stakes only one part of his claim to be educated. Of course we may offer cognitive proficiency as the supreme example of education in the achievement sense, and doubtless its place is in all accounts very high. But it is

not a substitute for other aspects of education; it goes along with them to produce educated persons.

3

Those who take an intellectual view, in which logical thinking and knowledge are taken as the salient features of an educated mind, nevertheless hesitate at including the specialist among the educated. This is strange because it is precisely his intellectual proficiency that constitutes his strongest title to be called educated. He is, of all others, the person whose education may seem least open to doubt on the intellectual side. It is surely an enterprise without point, if we know a man to be an economic statistician, or an engineer or audio-visual technologist, to search round for further evidence before we decide to call him educated. In knowledge and logical and methodological mastery he has all the aces. But at this point we are told that knowledge and intellectual skill are not enough. The specialist must exhibit at least a modicum of capacity to realize the relevance of his knowledge and methodological skill in other places. And what seems to be meant is that this sense of relevance must be rather more than cognitive. Yet *what* is required of him is nowhere very clearly specified. One doubts whether it ever can be, so long as the matter is argued in terms of educated minds, though it may be clearer if we think of this objection to the specialist in terms of whether he is an educated *person*.

The real doubt about the specialist, one in fact suspects, does not really arise from his lack of range, whether cognitive or other. Rather it arises from the observed incapacity for *judgment* in diverse complex situations by a man who clearly has the intelligence and the level of education needed for coping with them. And what this discloses is that cognitive proficiency in an area is not enough, the ability to apply that proficiency in making judgments is what lacks. One sign of an educated person is precisely such a capacity for judgment. The specialist is clearly educated in terms of knowledge and intellectual skill but fails in the other two areas mentioned above.

How it comes about that some educated persons display this type of behaviour in judgment and other equally educated ones called specialists do not, is a very nice problem. Possibly (i) it arises because, though the curriculum, with its cognitive centre and

penumbra of subjects like the fine arts, is soundly planned, the teaching procedures used tend in some cases to bias in an intellectually cognitive direction what is learnt. Or (ii) it might be that the extent to which subjects are cognitive and non-cognitive is rather a matter of traditional approach than clear analysis, and some areas of education might be suffering from a false conception of what can be done with the subject-matter. For example, the study of science might carry a lower cognitive loading, and that of fine art a higher one, than is commonly thought to be the case. Finally, and most disconcertingly, (iii) perhaps we are astray in our conception of what it is to cognize, which might result in our skewing all learning and producing an imbalance in the cultivation of educated persons and minds; and the casualties of this imbalance are called specialists in a pejorative sense.

This last view has drastic implications: concepts linked with cognition, such as knowledge, intelligence and understanding, all stand to be modified if there is any truth in it. But whichever of these possibilities be favoured the matter cannot be further developed here. The case, however, for a close look at what the fine arts contribute to education is supported whichever of the three possibilities is true. If, then, we free ourselves from the tendency to ask after their cognitive contribution first, we may inquire what the fine arts do in the education of feeling, judgment, perception, without thereby linking any of these to supporting intellectual cognitive progress. To turn to the fine arts with an inquiry as to what they contribute to awareness of an intellectual type is like walking the woodlands in quest of the flowers of the field; flowers there are, and those people sensitive to them do not waste the occasion by celebrating only the few field flowers they find.

4

Let us, before exploring areas in which the fine arts are influential, look at one viewpoint, according to which the fine arts are the cachet of an educated person. This way of talking appears to assume a person already educated and receiving some sort of accolade. To what he has shown himself to be, we now add the achievement signalized by evidence of his awakened abilities in the fine arts. The serious business of his education was, it seems, brought to completion in other subject-matter: over a period of time it could be

theology, ancient language and literature, history and geography, science, according to which is favoured from time to time as the most important subject area. Such a view of the fine arts has a long lineage, recalling as it does the education of the nobility in many countries. In such a situation as that of a nobility disposing of a large leisure, education could be held as properly concerned with ease and flexibility in a diversified social intercourse. In extreme cases, which were not lacking, this could and did lead to some vestigial role for the fine arts as an elegance of cultured conduct, for the life of nobilities was fatally open to trivialization. However, even nobilities frequently held that the serious business of life was elsewhere than in pursuit of the fine arts, and this belief was not uninfluential in their education.

The trivial role for the fine arts gained emphasis when the work/leisure distinction tended to put the fine arts on the leisure side of the balance. Work was for long thought of as morally superior to leisure, and this conception has a long history particularly in Protestantism. Subject-matter strongly or obviously connected with work therefore figured higher up in the curricular hierarchy. The conception of leisure suffered too; a passive leisure, or at least one employing less than the full range and concentration of one's energies, seemed the best counterbalance to work. This also broadly suggested that the best and most worthy motives might be absent from one's leisure, which was described as merely for enjoyment (some sort of lower state of being). Such an opinion, linking with an economic transformation of society which rendered the status of the fine arts much more suspect than it had been, made eccentric outcasts of many artists to whom previous generations would have accorded acclaim, and the whole study of fine art into some vague pejorative relationship with useless, if not neurotic, self-indulgence. The position of fine arts in the curriculum suffered accordingly.

Even now the work/leisure distinction is found in educational discussion. Yet it is clearly a social and economic distinction, and not relevant to the solution of educational problems if education is concerned with the whole man and in all circumstances. Any notion that the curriculum is grouped into work subjects and leisure subjects, or that work and leisure appear as an emphasis in the teaching of subjects, belies the view of education expressed above because it suggests different subjects and approaches to work and

leisure, as if persons were divided in two by work and leisure. There is no need to argue the unsoundness of this; suffice it to say that education is of persons, and that persons are involved as such in work and leisure alike.

If this is true, then the fine arts contribute to the education of persons and do not provide an informal training for one or other leisure occupations. And this leads on to the assertion that they educate a person no less than other curricular areas, and contribute to any of the titles to be educated. So that if a person is not educated in the arts, his title to be called educated would not be fully sustained. In thinking of this assertion we must rid ourselves of any notion that *knowledge* about the fine arts is being set up as essential to education. What is being suggested is that study of the fine arts provides, in cognition, in feeling, in judgment, essential parts of that experience which leads to an educated mind and an educated person. To put the matter another way—in making sense of a subtle and sophisticated world, in obtaining readiness of thought and appropriateness of behaviour both within the rules and in breaking out of them, in exploring the riches of personal relationships (anything but a simple thing to acquire but a sure sign of civilized and educated living), study of the fine arts has a contribution to make. The man who lacks it moves one step in the direction leading to the specialist. Finally, so far from being a bauble, to be worn or left aside as social occasion demands, the fine arts play their part in enabling us to proceed from what we are, which is persons, to what we aim to be and in large measure are able to become and to remain, namely educated ones.

5

Up to now it has been suggested that an intellectual and cognitive approach to education warps one's judgment of the fine arts in that context, and it has been further put forward that the fine arts are essential for education, viewed in any of the three facets mentioned above. What is now proposed is a discussion of several areas in which study of the fine arts is seen as making a considerable contribution to education. These are

Situation
Motive
Adventure

Communication
Imagination
Objectiveness

and they may appear a very arbitrary selection. But each seems to represent an area in which study and activity in the fine arts are of critical and not dispensable importance, for education.

6

When education is planned with the cognitive content uppermost, characteristically syllabuses become a listing of factual items and leading interpretative principles mixed with those items. This conglomerate is offered to those who want a compressed account of what the subject is about. Now, the fine arts centre round a *situation*, not an account in terms of factual knowledge, and this complicates syllabus drafting. What is central to them is not led up to by means of a record of past achievement but is part of the currency of present achievement. If we are to understand the distinctive nature of one of the fine arts, we must be familiar with this situation. Familiarity in this context may cover an ambiguity—it may mean learning of an intellectually critical kind about the subject-matter comprised by past artistic achievement by persons who have not become proficient in any branch of that achievement. In such a case, the fine arts provide problems for intellectual analysis. On the other hand, familiarity may imply an experience of making, both cognitive and non-cognitive in character, which one has had, and to which it is one's hope to return. There is a wide insistence among educators in the fine arts that an experience of the situation in which art arises, or is made, is an essential prelude to any analytical treatment or reflection hoping to do justice to it. So education here must provide for that situation of making. It will not be sufficient to interpret 'understand' as grasp in terms of a conceptual framework. Understanding in the fine arts involves cognitive activity, certainly, but in connection with a very specific situation, that of art-making.

Every art accretes past achievement, and a man may, of course, spend a lifetime understanding it in, say, basically historical terms. It is easy to take Milton, Fragonard, Monteverdi in this way. This is an engrossing side of historical studies but none the less an historical way of taking matters, that is, aside from the central concern of fine art. Those who are being taught understanding in

the arts may study the achievement of artists in the past, but in that case such studies are merely instrumental to the artistic intention, and past artists can be caught up or thrown aside as the occasion suits, since their historical importance is not relevant. Past artists can do no more than direct the student to a situation which must be actual for anyone wanting to understand art; for on this condition, both understanding and judgment depend. This is not some variety of the assertion that experience teaches. Rather it is to be thought of as an experience which must be actual to the pupil if teaching is to go on, and education to make progress. Through having such an experience a different kind of understanding from the cognitive, yet including both cognitive and non-cognitive elements, becomes available. This is an understanding of which the prelude is not mere elementary factual learning, but the experiencing of a specific situation peculiar to the fine arts. We may conclude on this matter of situation in the fine arts, that whatever it contains (of which more below) it is part of the education of persons in human understanding, representing a whole area of education not otherwise to be obtained. As science centres round experiment and morals round special practical predicament, so the fine arts centre round making. Intellectual approaches to them will not remedy the lack of this.

This insistence upon the situation of making, in contrast to the role of history in the fine arts, not to speak of other intellectual studies of them, does not necessarily imply a sharp distinction between making as active and appreciation as passive. The appreciation of highly sensitive and educated persons whether, say, in looking at painting or playing of music or reading of poetry, is a very strenuous and creative matter, very far from resting upon the thought and feeling of others, but rather a re-creation of the art-making situation for oneself. People who do not make art but can do this exist, though they may not be numerous, but for most people, the way to this state of mind lies through art-making. But because some arrive at this very high level of relationship to art products, the distinction between making and appreciation is not absolutely watertight.

7

One of the ways in which we might look further into the situation of making in the fine arts has to do with *motivation*. The word is used

in two different ways: what motivates people has general reference to the motives they happen to have, but there is also the usage occurring when motivating pupils is spoken of, as if this were in some way part of a teacher's responsibilities, or at least his prerogatives. Often motives are discussed as if there were a natural theory of them; they just occur in whatever form happens. When we start to educate people, however, there is some vague hope that students get involved in what they are doing and their motives change. No suggestion is made of any detailed control, rather that change of motives happens adventitiously and on the fringe of the learning concern. Learning is clearly compatible with many motives, some strongly antipathetic to learning at all, though there is a long tradition, well seen in Dewey, that commendable motives make for more commendable educational achievement. Sometimes this is thought of as maximum and sometimes as optimum achievement.

The culmination of the human motive situation is apparently doing something for its own sake. One can do the something from other motives but optimal performance necessitates the appearance of this state of doing. There is a puzzle here, for the language of motives belongs to explanation of action, whereas one simply *does* whatever one does for its own sake, and motives seem not so much commendable as irrelevant to the matter. What lends colour to this is that most baffling aspect of the puzzle, the absence of formulable purpose. People doing things for their own sake commonly have no awareness of aims, they just get on with the job. They may well deny they have an aim at all. This is characteristic of the making situation in fine art. The fine arts, however, are distinctive from other curricular subjects in that learning does not start at all without motivation for learning's own sake! Other subjects can proceed on less reputable motives, but the making situation in art does not have any motivational transition stage, does not start at all if one is not involved in the situation 'for its own sake'. Perhaps, however, we could say that if enjoyment and interest are present, then the art-making situation can arise. If these are *motives*, they would be the only kind compatible with making in the arts. For many educational reformers they are the only acceptable motives. However, the view taken here is that they are not motives at all for the art situation, whatever they may be elsewhere. Rather, they signalize our memory or impression, any time afterwards, of a singularly absorbing period of occupation and preoccupation. In recollection it seems that

INTRO

pleasure, enjoyment and interest turned up whilst one was at work, but they were not at command: the best motivational use to which they might be put is to return one to the occupation of art-making in the hope of recapturing the subsequent enjoyment. This is, of course, spurious, not why art is done: it is the absorption, the loss of conscious awareness of self, which is a state afterwards invested with enjoyment. An affair, we might therefore say, without the account of motives which may be necessary to account for practical action and many other kinds of learning, but vivid and stirring in recollection, haunting a man until he revisits and re-experiences it. The making situation of art may even be repellent, but it is still done for its own sake, and is the prelude to artistic understanding: once touched by the muse, Eliot wistfully said, never left by the muse.

It seems, then, that the central situation generating fine art is incompatible with what Peters has called extrinsic motivation. If, then, fine arts or any other area of the curriculum, represent subject-matter incompatible with some evolution of motive in those studying them, then the fine arts might be regarded as a particularly crucial area for attempting to guide pupils to do things 'for their own sake'. And this is consistent with the embarrassment of art teachers, for instance, with syllabuses and their insistence upon the right conditions in which this state of mind can emerge. For no progress at all can be made without experience of the art-making situation, irrespective of whether the achievement is successful or not. Further, this experience adds to our feeling-states and enhances our judgment of one whole area of human activity. As to whether the state of doing things for their own sake can be generalized from one curricular experience to another, we do not know, but if it has transfer value it may well be that it transfers from fine arts to other subjects. I am personally not convinced that this state of doing things for their own sake is one in which analysis of motives is appropriate at all (not only because questions of motive do not normally rise there, but because it has never been suggested that the motive-procedure-realized aim model of activity applies to *all* activity) but, nevertheless, consider that this aspect of the central making situation in fine art contributes powerfully to the education of persons.

Finally, people may use the media of art extrinsically, of course, but the working of paint, stone, words, notes, will achieve nothing

5

but a paying of homage to past achievement at most and, at least, a mere copying of the situation in which the making mind is intent.

It seems likely that if the art situation is taken in this latter way, cognitive advance, in the intellectually restrictive sense of the word cognitive, can still be made, and understanding bearing on the fine arts is achieved, though understanding *them* is not. This state of affairs can mask the fact that progress is halted in the fine arts when the situation fails to reach an absorbed state of mind in the pupil, in which he does the work for its own sake. Once he reaches this, however, his cognitive advance is linked to other kinds of advance and cognition is thus in a setting essential for aesthetic judgment.

8

However, the most salient aspect of the situation central to the arts is not the motivation of those involved in artistic making. Rather it is what might be called the *adventurous* nature of that situation. The word may appear an arbitrary choice, and some may wonder why the word creative has not been used. The explanation is this. When the problem is completely open, when, that is to say, we do not even know what to take to the solution of it, then (reliving a now forgotten childhood), we struggle on our own midden, hazarding a solution and learning from the failure of the hazard we made. In past times, and especially but not only pre-civilized ones, probably enormous numbers of problems were of this kind, and in the relics that have come down to us, say early toys of Ancient Egypt, pots of Lepensky Vir, Paleolithic axeheads, we can study solutions of practical problems which bear the impress of individual thought and effort. With the passage of time, however, has come an abundance of standard solutions, known to be capable of solving problems facing the mass of the people, say going from one place to another, or keeping clean. And this is very convenient. As well, it circumscribes the area in which one can make an individual attack on the problem, utilizing whatever resources one has. In *this* type of onslaught there is the germ of *adventure*. It seems to be a necessity to people for there is clear evidence of important frustration in a world of standard solutions, and adventure seeks many alleviations in which the old situation of individual initiative is reasserted, often quite needlessly, that is, avoidably. Such a seeking for alleviation played its part, no doubt, in taking Magellan through the Straits and

Livingstone up the Zambesi. And this, which is adventure writ sensationally large, is as clearly seen when people buy an old cottage and turn it into a home, with a piece of wasteland which becomes a garden where one may linger in congenial peace, as when a man rows the Atlantic or rounds Cape Horn in a frail yacht. So one suspects that adventure is not a luxury, it arises from the necessity of affirming oneself by trying out one's powers at stretch and overcoming difficulties, though this smacks a little too much of Dewey's evolutionism. Rather, the knowledge of one's self, the increase of the assurance of one's sense of identity, involves experiencing the zest of complete reliance on one's powers. Nowhere is the quality of individual living better seen than in the stamp a man sets on his way of dealing with problems; the enterprise announces a man's individuality, and a world of standard solutions is one in which no man can achieve full individuality without great difficulty.

Now adventures like an expedition to Antarctica are dwindling fast save for what is promised by space travel, and are perhaps subtly trivialized by deliberately sought hardship and endurance in ultimately safeguarded situations. Adventure, though, must be found within the framework of society if it is necessary. It is always open to those on the boundaries of the things they have mastered, but perhaps most universally offered *in the arts*. For the situation central to them is just such an opportunity of confronting problems with one's own resources, which brings it about that the artist can adventure in his own garden. For no move can be made of a kind to result in the production of art, save as arising out of a *new* tackling of the problems. The person doing it may have studied art and know about it, yet no matter how often a man puts himself at the problem of making art, each successive attempt strips him of the beginnings of a routine solution constructed in the experience of the last occasion. The standardizing of solutions produces technique and imitators in the arts. The outcome of artistic endeavour is not membership of a class of solutions: the self-portraits of Rembrandt may be grouped as masterpieces, but in each, the enterprise of a new exploration was fully undertaken, and the preceding ones convey hardly a hint of the conception to succeed them. Somewhere in artistic achievement there is the reaction of an adventurous person to this particular instance of time, place and circumstance, that is the art production—a reaction of that person at that stage of his powers. The following of routine solutions can lead, in many ways,

to valuable knowledge and tradition, say in history, and in art there is the record of past making, but the poet, the dramatist, the plastic artist, have only a contingent need of it whilst intent upon their own work: it is present only in the level of education of the mind they bring to that work, not in the form of willed and conscious application of mental resources.

Now this, if it is so, provides an important educational opportunity in study of the arts. If it is true that the understanding of them requires in an education, as was previously asserted, the experiencing of a central situation, it is also true that this provides, by the element of adventure it contains, opportunity to discover the range of one's personal resources by furnishing a type of making that incorrigibly defies solution by conscious application of knowledge. Perhaps this happens elsewhere: but in several other subjects, progress is made by learning to apply what is previously known and understood, and an effective impact cannot be made on, say, historical problems without this. The problems cannot even be fronted without high education; for the problems of elementary history are pseudo ones. But in the arts, the making of poetry and sculpture does not permit such organized and deliberate recourse to previous experience, though no doubt awareness, sensitivity, knowledge, judgment, are in some recondite sense all present in the highly sophisticated consciousness of the artist. Even at the beginning, when children paint, they draw on what they have, not as recalling a memorized thing but as adventuring forth.

The nature of artistic making resists postponement whilst some minimum level of proficiency is awaited: the individual enterprise which is the peculiar mark of such making begins with the first attempt at making, where the fine arts are concerned. It will be seen by now that the view here taken of the fine arts is to envisage them as a group of activities marked out by an adventurous act of making. Insofar as there is a tradition, it comprises recorded outcomes of the making of others who in the past have confronted the artistic situation. In the ancient world, the two kinds of making were quite sharply distinguished, whilst we now tend to reserve making for ordinary practical tasks and talk of creating where the arts are concerned. Yet ordinary making and artistic making are not so far apart in some ways: both have a practical side, both require concentration upon particular problems, but the decisive difference is between the functional efficiency which is looked for as the out-

come of practical problems, and the making of a new world, without regard to its fate, which is the outcome of artistic ones. Such a way of thinking centres the arts round the fine arts, and distinguishes between them and the practical arts like teaching or engineering, and from the conventional use of the word in university faculties of arts: for we are looking at what distinguishes them from other areas of an educational curriculum. Often the fine arts have a side reminding one of the practical arts, which are no more than the practice of a tradition of making for all sorts of ends: in this sense, there is an art of driving, of psychology, of laboratory physics, or salesmanship.

To make a new world, then, out of the surrounding one, is a call to adventure on the resources one has, which is exactly true of the situation in which fine art comes about. It is not necessary to argue that the capacity for new adventure, whether mental or physical, is essential to education, and safeguarded in the fine arts at least as much as anywhere in the curriculum.

9

Any subject of the curriculum, including the fine arts, can be conceived of as a *communication*; and there is much pressure to view all education as a complex problem of communication. We are told to promote in our teaching that which facilitates understanding between people. This understanding depends in turn upon efficient communication, which should be the teacher's first care. Tacitly it is assumed that failure in learning is wholly a matter of failure in communication, and that perfect learning depends upon perfect communication between teacher and pupil.

The difficulties of this view are many. Let us list four. First, there is something to communicate of which the teacher has complete possession. Second, the communicative medium must be capable of completely passing over that something to the pupil. Third, the teacher must have a complete mastery of communication by this means. Fourth, the medium must 'transliterate' other types of communication or arrange for them to be brought into a context of the main type of communication (which is, of course, verbal). On the first point, what is communicated is often made in the act itself with the help of the pupil. Second, complete communication requires the reduction of an entire state of mind to the principal

educational medium, that is, the verbal medium. The difficulties of this need not be stressed. Third, communication is always imperfect to those lacking mastery, irrespective of the mastery of the teacher. Learning failure is vastly more complex than communication failure; an initial lack of communicative proficiency may be present as a symptom rather than a cause. But, of course, perfect mastery of communication is never found; what is remarkable about communication between persons is its imperfection. Educational communication is no exception. Fourth, to style what we conclude from the non-verbal behaviour of others as communication at all removes it from the realm of deliberately transferring fact (the favourite stamping-ground of communication) to that of obliquely and contingently surmising a state of affairs and then likening it to willed verbal communication, clearly a horse of another colour. To go on to talk of translating one thing into another verbally equivalent, one which is daily supposed to go into teaching of the fine arts, is a mere exuberant vagary of the verbally minded. No doubt verbal communication can *direct attention* to some non-verbal concern like the situation in which art is made, but it does not follow that what happens to the learner thereafter can be verbally communicated.

The study of the fine arts presents particular trouble if considered in these ways. Verbal communication can, it seems, convey much that is factual, logical and itemized, but the nature of what goes on in fine art is so resistant to verbalization that we would do better to consider other ways of originating artistic states of mind as well as verbal description and exhortation. Verbal communication enjoys, and rightly enjoys, an undisputed primacy in teaching and education, but there is no reason to suppose that all subject-matter benefits equally by this or that it cannot be used to excess and to the detriment of certain kinds of education. In the fine arts, it can result in some perversion of the nature of the activity in an intellectual direction, which merely impedes the educative trend.

Instead, however, of concentrating upon the difficulties of communication here, let us consider the notion of communication itself in this area. If communication is conceived of as a metaphorical extension of what goes on when someone writes a letter to someone else, then what is communicated, the intention of the communicator and the system of communication in its cognitive assumptions about the mental structure of those using it, all need study. And in the

fine arts, what is communicated may defy exact specification, the intention of the communicator may be unknown or irrelevant, and the mental structure suitable for willed communication incompatible with that of the poet or artist or composer. In this sense of communication, the teacher's intention may not even be relevant: for such a kind of communication merely requires attention and subsequent learning on the part of the student. If Cézanne, for example, especially in his later years, intended to communicate anything, it was that the rest of the world could go to hell. The communication of his art is a vision so authentically written across the Provençal countryside that the tourist is hard put to it to enjoy that country without the overmastering suggestions of Cézanne's brush. Irremediably, there is something contingent about the artist judged as communicating. To communicate, in the sense of a conscious and willed act, is not pertinent here: the communication is rather that which other people use the occasion to obtain. There is no shaping of communication by an art, no fashioning of an object, even in words like a poem or play, with the intention of telling the story of the artist's acts or feelings or thoughts. The occasion of making such things as a painting is the registration of a state of mind, by means from which others can, if they wish, derive information. This state of mind is not intact before registration and then communicated, with words. Rather, it comes to completion in the act of registration; it is compounded of a medium such that, in satisfying the artist that this state of himself is present, it incidentally announces the fact to others. But the use of media in order to achieve one's own purposes and arrive at a state of mind in which they are accomplished, throws up a communication which the artist, when he is spectator, may comprehend very completely, but which others may gain little or nothing from; since there is no planned and deliberate communication, the degree to which the artist communicates is contingent and a matter of minor importance. So Cézanne bodied forth his life's struggle and preoccupation with the Jas de Bouffan and its surroundings, and the world learnt, not that its antics concerned Cézanne.

Now the point of going into all this is, that the arts deal in this contingent kind of communication as a central feature; that is to say the struggle of the poet, the painter, the dramatist with himself and the outcome in terms of what can incidentally, and often non-verbally, be utilized as communication. Willed and contrived

conveyance of information can, of course, occur in the arts as in other subjects, for the course of education in a subject deals with areas of application as well as with central concerns. The typical communication in the arts, however, is one in which the occasion of the activity is not an intent to communicate it. This central part is the struggle of the maker to move into awareness of a novel state of mind, which state is being built in the course of his artistic doing. This is not a communication 'of the artist to himself' or 'an expression of the artist's intention' as if he were two people, one of whom knew all about it in advance and the other kept in ignorance until the hour struck. It is the fashioning by a man of an object or experience or situation which at once achieves and registers his arrival at a culminating state of mind. And the experience of this form of contingent communication (as it turns out to be, viewed from one aspect) is not the least part of the education derived from the arts, and not the least helpful thing in the fashioning of educated, and cultivated persons. The arts here direct our attention away from ostensible communication towards incidental communication. Ostensible or consciously willed communication deals for the main part in the verbalizable, the logical, the public, the commonly shared; incidental communication deals in the private, the novel, the unique and the cryptic. Conscious awareness was not present in the art-making situation in the sense of a rational, logical, verbally communicable state of mind; yet through the product of the artist we can, if our wishes go that way, glimpse the recesses of one side of personal life, obliquely and obscurely, from which we can derive communication. What, however, we see more fully is an object fashioned in complete absorption, that is, free of ideas of practical application and utility. In this situation aesthetic judgment can arise.

Finally, to watch the situation in which art is made and to study those making it, is itself an opportunity for that kind of communication which derives not from receiving in accordance with another's intentions, but from watching the work of that other. Education in the fine arts provides perhaps the best of all occasions to train in the business of *deriving* communication from a situation. And since a great deal of learning depends wholly, or partly, upon this, fine art study contributes powerfully in the habituating of pupils to contingent and unintended communication in other than standard verbal ways. But the organization and procedure of logical and

factual verbal communication is not best seen in the fine arts, though it is certainly present there.

10

It is a commonplace to say of the fine arts that their study cultivates the *imagination*. One can instantly assign a meaning to this and find reasons for agreeing with it. The present writer, however, is in doubt whether we have here more than a remnant of a bygone theory of mind, something abstracted to explain certain kinds of mental activity when no ideas were derivable from psychological research. Clearly this is not something completely separate from and other than cognition; in one sense it is a variety of cognition.

Recent studies in imagination are beginning to disclose this. They range from a treatment of suppositions in logic or mathematics, which seems at first sight hardly to merit place as imagination at all, to more complex examples involving analysis of the act of imagining. Imagination in any of its descriptions is very active in the fine arts, ranging from something closely resembling supposition, to the fantasies of Poe, Dali or de Chirico, which exert such compelling and almost hallucinatory forces at times on the minds of their creators that they appear less as the creatures of those minds than as taking charge of them. Here we have two extremes—the one such a minor deviation from what is actual that we doubt whether it is imagination, and the other so circumstantial and so specific that we doubt whether it does not overpass imagination. If we describe imagination as the mental fashioning of things other than as they are, both instances are covered. They are, however, of different kinds. Supposition involves a use of imagination, as is so often the case, to resolve questions of intellectual inquiry or practical policy, and this is simply conforming to a method which is systematic. The fabrications of Hoffmann or Poe, on the other hand, have no practical aim in view, though they may obliquely contribute to sustaining the balance of conflicted personalities. And we have to distinguish between such fantasies in an art context and in another setting. So there are two points—a type of imagination, often called fantasy, with no specific end in view, and the appearance of this type in the fine arts. Here, imagination is used to make a world out of the materials of the real world, not to ease or facilitate one's passage in the real world, but 'like a kitten playing with coloured wools' as

5*

Degas said of Renoir, or like the world-child Zeus in his play, as we are told by Heraclitus. Sometimes this is called creative imagination, to distinguish it from that imaginative construction which is pursuant to deliberate purposes. It is customary, too, because of the intense care with which such worlds are made, the fastidious regard for form, the intimacy with the medium, the quest for coherent unity, the rapt state of mind of the maker, to confer the judgment called aesthetic on the result. It is a world to please us, as Kant has pointed out, not one for our practical interest. Because artists like Poe had this approach, they distinguish themselves from abnormal persons building a fantasy world.

This use of the imagination can be enormously strenuous, equally with practical analogues like formulation of policy, or the complex review of possibilities preceding the formulation of a scientific hypothesis. For it remains in close and constant touch with what is actual yet forges a novel product from its materials. Contingently, social use accrues from artistic work. (Fashion in advertising is influenced by discovery in plastic art.) Here, as elsewhere, practical problems draw upon expert work in a related field. Apart from this, the fine art product is the point at which we judge change and progression in this area. Change is constant and critical: the arts never emerge from the tension which results from the unending effort to work in terms of a tradition whilst at the same time superseding it. So great a hold has tradition here (for a tradition is the recorded and cumulative insight of the imagination proper to other times, and among the prized possessions of the culture where the fine arts are concerned) that only new creative imagination can move us from the beloved grip of the art we know to this new product from fine art, perhaps strange, like the music of Webern, or repulsive, like the paintings of Clift and Kline.

The making of a world, novel and pleasing, without thought of what it finally is, is very different from attending to the perception and conception of what is actual. This is very much a cognitive affair, of words, logical thought, and the kind of imagination that goes with them. This reality-orientated state of mind of which consciousness, awareness, reflection, feeling and intellect can be predicated, involves postulating a person. The use of imagination, however, disturbs this arrangement. Imagining as it turns up in the fine arts is always in quest of freedom from the bunch of associated solutions and habits that arise from orientation to the actual. It

seeks a new actual and uses imagination to soften the 'set' of the person that has been built hitherto. This is passed off casually with words like 'identifying', but the fundamental disturbance of one's 'set' so far as actuality is concerned has not been examined nearly enough. When we imagine in the fine arts, creatively, we throw off any prosecution of practical or intellectual or cognitive and specifiable aims and open up a free situation. All this is necessary to generate change; the predicament of artists, like all others, is to achieve change and to recognize that they have done so.

This is, perhaps, the core of the training in judgment offered by the fine arts. They offer indefinitely many occasions for the free construction of a world, intently and systematically brought about by a self familiar with the actual. But to do this, to set about it without interposing our own 'set' both in thought and feeling, not falling back either to the cognitive or the emotional, is hard to attain, and perhaps can only be maintained by the constant rehearsal of the power to do it. Nothing is more remarkable in an artist than his uncanny sensitivity to lives that are not his, and the same can be said of the statesman and the historian in terms of imaginative power. But the artist can try out anything, he is not limited by circumstance like the others. From the training of this comes sympathetic insight, resource in thought and a favourable reception to a changing reality. The fine arts are perhaps unique in what they offer to education here.

II

We have seen something of the situation which is central to study of the fine arts, and the educational gains that the study of it offers. The most general phrase covering such educational gains in the fine arts would be that they are concerned with the cultivation of aesthetic judgment, whether this appears in the preoccupations of the creative artist or, in rather different meanings, in those of the appreciator, the art gallery goer, the art historian, occasionally the illustrator. Aesthetic judgment is clearly not exclusive to the artist, though its most typical or important form might appear in the artist's work. From that point, aesthetic judgment accretes intellectual and cognitive elements, and contains elements of knowledge about art as well as knowledge of art. The full capacity to make an aesthetic judgment, nonetheless, requires both the central making

experience and the knowledge about art, according to the view taken here. Yet others will urge that this so-called cultivation of the aesthetic judgment is a waste of time, for everyone knows that it is incurably subjective, agreement is not to be found anywhere, and in fact aesthetic judgment is not a judgment at all in a respectable sense, just some sensitive and controlled interplay of feelings.

Now the discussion of aesthetic judgment tends to cluster round cognitive material. The strongest claim to be *objective* is to be found in science. And here, as elsewhere, there is pressure to define aesthetic judgment in an intellectually cognitive manner, and to seek means of verification analogous to those obtaining in scientific judgments and logical propositions. There is, however, no more reason to suppose that judgments will be homogeneous in type than there is to expect homogeneity in types of knowledge. We ought first to consider briefly the character of aesthetic judgment before we go on to ask what is objective in this case. Discussion of what is objective has been mixed up with discussion of what is true and what is real, as if testifying successfully to the true and the real will bring us to objectiveness anyway. But the varieties of truth, and the descriptions of reality, are as striking in their differences as in their variety; indeed, there is no reason to suppose, for instance, that what is true in mathematics has even the remotest relation to what is true in aesthetics.

Still, it remains curious that words like truth and reality should turn up at all in such different contexts of inquiry. One description of these words clearly supports some feeling of confidence and assurance—what is true, for example, is that which is confidently asserted, or that which satisfies the demand for explanation (where satisfaction as a *feeling-state* is indicated). This has only to be mentioned to arouse distrust. The great value of scientific objectivity, we shall be told, is that it is independent of the state of feelings a person has. The feeling-state of persons is such a subjective aspect of personal life that no general characterization of objectivity is to be looked for there. Is not subjective the opposite (an attractive piece of rhetoric) of objective?

It is unwise to dismiss discussion of feeling-states so quickly. The intellectual approach to feelings, which looks to scientific objectivity as the type to which all others must conform, tends to rest upon some view of emotion and feeling as that to which no order may be brought, and which at worst is obstructive of intellectual operations.

Such a view is far too simple. It is clear that feelings are as often facilitative as obstructive of action and thought, and perhaps some feeling-state is a necessary condition for thought to proceed at all, as later developments of cognitive theory are beginning to hint. A more sophisticated and thought-out view of feelings is essential for the arts, as L. A. Reid has made clear. For the central situation in art study undoubtedly deals in feeling-states more prominently than it deals in intellectual ones. Whatever objective means in the fine arts, it certainly will be found to have reference to feeling-states. And if a closer look at these states reveals that some reliability of judgment is compatible with them, we may explore the view that they are more than bundles of emotions behaving unobstructively, but are built into the notion of objectivity as it obtains in the arts. If there is any certainty in aesthetic judgments, feeling-states are as likely to give a clue of its nature as intellectually cognitive aspects of the art process.

Certainty, it may be rejoined, is not a luxury to be afforded in our time. Dogma is discredited on many sides, and probing questions greet any fresh appearance of it. *Provisional* knowledge, subject to modification or destruction and exemplified in science, is the prized kind, leading to temperately held certainties. Seen in a *social* context, this rejoinder is no surprise. Certainty as a state of mind has wrought monuments of misery in human affairs, and from the depths of dogmatic sincerity and assurance has frequently arisen the destruction of the public peace. Our temperate certainty, developed in the social sciences under the aegis of the pure sciences, has earned respect, as Popper saw, because it appears as a benign influence in human problems. And it commands universal respect by the integrity of its search for what is objectively held.

This view from the social sciences exerts an influence in the fine arts, often the theatre of internecine wars between rival schools, and at present shimmering with a kaleidoscope of ephemeral opinions. Such temperate certainty, it is thought, must by one means or another be imported into the arts, to form the basis of an objective aesthetic judgment. This is the spearhead of the intellectual cognitive approach to the problem of objectivity in the arts, an approach which abjures and deplores powerful roles for feelings. Such an approach finds no barrier existing in the fine arts between persuasive slogans and sincere judgments, and often dismisses the whole area of study as incorrigibly opinionated.

It may be thought that temperate certainty is associated with calm feeling-states, as with the sages of old, or the man of common sense. Yet clearly, even the social and pure sciences afford no ground for supposing that strong feelings are incompatible with objective judgment, whether it be of science, history, or legal proceedings. The strength of the case for temperate certainty is not its association with any one state of feeling, even a calm one, but its independence of such states, or rather indifference to them. The predicament for the fine arts is thus acute, for highly active feeling is one of the most notable features of activity in this area, as has been said above. So if room is to be made for objective judgment, there the notion that objective judgments rest upon the cognitive aspect of mind only, with feeling as irrelevant, must give place to a situation in which objectivity only appears when feeling-states are found in the presence of cognitive activity as *essential* components of the objective judgment.

Up to now we have been sceptical about the possibility of inquiries into truth or reality leading us to objectivity in the fine arts, and we have likewise rebutted the notion of objectivity in pure science as a model for the fine arts. There remains another way of taking the subjective-objective distinction which may be relevant here (it will have been noticed that the scientific model in effect identifies the objective with the cognitive and the subjective with the feeling and emotion side of the mind).

Subjective *can* mean immersed in practical problems and daily concerns involving oneself and one's own advantage and disadvantage. In all such practical concerns, feeling-states are charged with interested aims—the person seeks what is good for him and his at the expense of others if necessary, and the intensity of his feeling-states, not to speak of much discussion about motivation, deal in the pursuit of these practical aims. We have already seen the difficulty of applying the language of motives to the art-making situation; here we are confronted with difficulties occasioned by the failure to distinguish between subjective states of feeling, arising naturally in the practical situation, and objective states. To these we now turn.

All kinds of objective judgment, aesthetic ones included, are marked, not by any withdrawal from feeling-states (it is here that the most important false step in the 'temperate certainty' argument occurs) but from matters of practical concern and self-interest. Now when this self-interest is in abeyance, one glimpses another

relation to awareness, thought and action, cognition, feeling, and other concepts. This other state of mind and its productions, whether they be pure research, expert and pure knowledge, or the achievements of the fine arts, enjoy universal respect both as a central cultural heritage and as a rich mine of ideas, valuable for practical application and concerns of personal advantage. This mine of ideas can be exploited, but is never added to, by those involved in their own concerns. The condition of pure knowledge, pure thought, making of art, is withdrawal from these concerns.

If this is true, then (thinking of the fine arts), when we stand back from practical concerns and accept the world, we make new things in that state, and our feeling-states are freed from that relation they bear to cognition when they are alongside it in the pursuit of practical policy. We can make what we will. The things we make register that completeness of our freedom from rules. The possibility of aesthetic preoccupation with what we make arises then, though this withdrawal from practical concerns is a prelude to a variety of mental concerns of which the aesthetic is only one. Moreover, there is nothing here offering a clue as to degrees of aesthetic insight, only a state which is a precondition of them. No doubt further inquiry into aesthetics would take up form, media, the embodiment of feeling in the object, and the like ideas. The present point is that such things cannot arise, and no objective judgment can appear, save in the mind detached as described. The freed feeling-states which, it seems, then arise, are worked with during the making of art objects, and the maintenance of those states is essential to the work.

One final word on this most difficult of matters. The names by which feelings and emotions are normally called, such as revenge, frustration, sorrow, jealousy, have reference to the practical situations of everyday life. People do not even learn to feel these things save in such a context. But the feeling-state to do with contemplation, art-making and objective aesthetic judgment has very little to do with these emotions. For it is not free floating, not available for many different situations as they arise. It occurs in a very tight union with the special cognitive quality of creative and objective situations in the fine arts, and whilst it is there, one's normal propensity to feel sadness, loneliness, exuberance, merriment, and so on, is in suspension, although states communicating objective feelings bearing the same names may be experienced by the maker

and evoked by what he makes. When this state of mind is present, objective judgment, aesthetic sensitivity, the making of things in fine art, are all possible. To call such a state of mind disinterested, is to define it negatively by indicating its divorce from practical concerns. But it is a positive state of mind supervening on practical concerns, not a matter of stern self-control and withdrawal from them.

All that has been attempted here is to vindicate the notion of another kind of objectivity than that prevailing in science. But since it is a prelude to what happens in science also, we must point to the guiding and ever-present role of the feeling-states in this art-making state as distinguishing fine arts from other objective states, yet *sharing the title* with them in virtue of the withdrawal from practical concerns that has occurred.

Finally, it will be readily seen that such a view of what is objective in the fine arts does nothing to distinguish between inferior and superior work, nor to suggest how one piece of work can be judged as aesthetic whilst another piece is rejected. The sole implication of the above bearing on this is that if an art object is made with practical concerns or for self-interest, to that extent it will not be an objective piece of work. Aesthetic is the name of what can flourish in the fine arts *when an objective making situation* is attained. But the objective does no more than set the scene for the aesthetic. This experience of objectivity, strikingly in contrast with that obtaining in science or history, and loaded with feeling-states widely different from those called up by practical life (for which the same word is often used), is one which study of the fine arts offers *par excellence*. If a man has not got it, no amount of scientific objectivity will rescue him from uncertainty of judgment in the fine arts. And since the objective state here discussed has much in common with that of science, and still others such as history, it can be claimed that the objective experience of art-making in the fine arts which explains the feeling-state as an indispensable part, has general educational value, well beyond its own borders.

12

It will have been noticed in this discussion that study of the fine arts has been contradistinguished from more cognitive areas of the curriculum in order to show more clearly the contribution of the fine arts to the education of persons and minds. Nothing written

here, however, is meant to decry the importance of cognitive studies. But if one accepted an exclusive emphasis in the curriculum on logical and rational thought and knowledge, with a leading emphasis on verbal communication as the means whereby a tradition is passed on, then the fine arts would be penumbral and dispensable—a minor feature of education.

The view of cognitive centre and non-cognitive penumbra has been rejected here. This distinction, deriving in part from epistemology and in part from philosophy of mind, is part of an abstract scheme which is the product of philosophical inquiry into the nature of mind and knowledge. It has no more immediate application to the education of persons and minds than has laboratory experiment in psychology. The distinction has a use and appropriateness as an instrument for understanding what a person and mind *is*, but is of no immediate applicability in the task of producing persons and minds by an educational system. For there we have the responsibility of attending to all sides of persons and minds, and the cognitive/non-cognitive distinction separates, for the curriculum, what it is more sound to view altogether. One of the most promising new theoretical trends in this connection is the cognitive-developmental theory of psychology, where the experimental study of learners has been fruitfully interpreted, more and more, by an enlarged view of cognition itself, one that connects it on all sides with feeling-states and judgment, and tries to show that any one of these aspects of the whole stands to be structurally damaged if the developmental situation does not simultaneously cater for the others. Thus, if this is true, damage to the cognitive side of education, using the common sense of the word, may well be sustained if the feeling and judgment sides are neglected. Such a view would clearly provide a much more intelligible underpinning of educational concerns. Study of the fine arts would then be clearly seen as playing an essential part in building and constituting the educated person's capacity to know and to understand, and feeling, instead of being thought of as being as much of a hindrance as a help, would receive the systematic treatment which can enable it to play a full part in the conduct of educated persons.

Further reading

These books have been generally useful to the author in writing this article and are recommended:

Furlong, E. G. (1961), *Imagination*, London: Allen & Unwin.

Gustafson, D. F. (1967), *Essays in Philosophical Psychology*, London: Macmillan.

Hospers, J. (1946), *Meaning and Truth in the Arts*, Hampden, Connecticut: Archon Books.

Koestler, A. (1964), *The Act of Creation*, London: Hutchinson; Pan Books (1969).

Kohlberg, L. (1968), 'Stage and Sequence: the Cognitive Developmental Approach to Socialization', ch. 6 in Goslin, D. (ed.), *Handbook of Socialization*, Chicago: Rand McNally.

Macmurray, J. (1935), *Reason and Emotion*, London: Faber.

Meyerhoff, H. (ed.) (1959), *The Philosophy of History in our Time*, New York: Doubleday.

Oakeshott, M. (1966), *Experience and its Modes*, London: Cambridge University Press.

Reid, L. A. (1969), *Meaning in the Arts*, London: Allen & Unwin; New York: Humanities Press.

Richards, I. A. (1936), *The Philosophy of Rhetoric*, London: Oxford University Press.

Strawson, P. F. (1968), *Studies in the Philosophy of Thought and Action*, London: Oxford University Press.

Wittgenstein, L. in Barrett, C. (ed.) (1967), *Lectures and Conversations on Aesthetics, Psychology, Religious Belief*, Oxford: Blackwell.

6 Art and art education

Dick Field

I

The question with which we are really concerned in this article is: what do we mean when we talk of art education? At first sight this appears a simple question to answer. 'Surely,' you might be tempted to reply, 'art education is teaching art?' A moment's reflection would, however, convince you that this was an inadequate answer. Does teaching art mean teaching about art? Or does it mean teaching how to make art? Teaching principles? Or teaching techniques? Or both? Behind these more obvious possibilities lurks the further question: can art be taught? Clearly our original question admits of no quick or uncomplicated answer.

Moreover, as we continue to consider the question, we see that it involves a decision as to what we mean by art in art education; and beyond this we are surely brought face to face with the question of relationship: in what sense is art education dependent upon art? or art upon art education?

Then there is the whole range of meanings embodied in the phrase Education through Art—from Herbert Read's conception of everyone an artist in his own craft to the notion of later art educators that the practice of art confers ancillary benefits. These raise difficulties about what is to be done in the art lesson. Read believed that doing something well—no matter what—made one an artist. Those who believe that the objective of the practice of art is the ancillary benefits which accrue must ask themselves: what kind of art? how much art? will anything else serve as a substitute?

In this article we shall look at the concepts of education through art and education in art. It seems clear that art education has passed through a lengthy period of concern with education through art, and that during this period art and art education drew further

apart as the concept became increasingly unrealistic. At our present point in time art education seems to be moving into a period of greater concern for art as offering its own singular contribution to human experience, rather than considering it merely in an instrumental way. In our pursuit of the relationship between art and art education in this article, we shall, therefore, move forward in time to a consideration of current ideas in art in education.

Both the concepts of education through art and education in art, however, would appear to start from the premise that art education in schools of general education is based firmly on the practice of art. We must look at this premise later; but in order to see how it arose we must first examine the concept of child art. It is interesting to note in passing that the term is not much used now. Perhaps we no longer respond to the work of young children as we used. Still, the term has had an undoubted currency; we must, therefore, accept its importance in the growth of ideas in art education and attempt to discover just what was meant by it and what ideas were embodied in it.

The term appears as the title of Viola's book (1942) (originally called *Child Art and Franz Cizek*). On the first page he writes: 'The term child art is itself very young. Two generations ago nobody dreamt that every child is a born artist. The discovery of child art is parallel with—or perhaps a consequence of—the discovery of the child as a human being.' A little further on he writes (1942, 8) of James Sully as being the first to use the term child art. Sully wrote (in 1895, quoted in Viola) of the art of children as being 'a thing by itself', and went on: 'the little artist is still much more of a symbolist than a naturalist.' Further on in the same chapter Viola (1942, 13) writes: 'Child Art is primarily Art.'

Here is a confused set of statements. Viola appears to suggest that when it was discovered that children could make art, their work was given a special name because of the importance of the discovery. Sully is saying something different: he clearly differentiates children's art from other art—it is a thing-by-itself—but the reason that he adduces—that the adult artist is a naturalist, whereas the child-artist is a symbolist—is no longer very meaningful to us. Viola's remark that 'Child Art is primarily Art' he qualifies by saying 'First came Cizek, then came the psychologists' (1942, 13). One must assume that he is drawing a line between art as the artist sees it and art as the psychologist sees it—about which distinction we cannot be quite so certain.

The term child art appears in the titles of three other books. *Child Art to Man Art* (Johnstone, 1940) was a very early attempt to tackle what was seen as the problem of the adolescent and art.

Child Art Grows Up (Collinson and Holmes, 1955) proposed ways of preserving the liveliness and colour of the work of young children into adolescence and beyond.

The Growth of Child Art (Tomlinson and Mills, 1966) was a collection of reproductions of children's work exhibited at the National Exhibition of Children's Art from 1955, with a brief text largely concerned with art teaching, and containing these words of Victor Pasmore: 'The term child art therefore ... cannot be applied to the adolescent. Nevertheless, it is evident from the unsatisfactory response of the adolescent to the new art teaching, that the imagery and technical limitations of the small child are being imposed on all children irrespective of their age and development. ...'

Apart from these three books I can discern only one further reference in the literature to child art. Neither Marion Richardson, whose pioneer work between 1912 and 1948 exerted such a deep influence on art education in England, nor Herbert Read used the term—nor (so far as I am aware) has any writer in the United States—with one interesting exception: Rhoda Kellogg (1969, 208, 209). In the introduction to her book she makes it clear that she is considering the work of children from as young as twenty-four months through eight years. She uses the term child art frequently; her principal thesis is that the aesthetic response of young children to the work that they do has been greatly underestimated. She seems to distinguish between basic art and child art, and clearly she can look at archaic art as if it were child art.

For example she writes (1969, 209):

> My aim in showing the similarity of child art and the art of
> ancient or remote adults is not merely to illumine the sources
> of mankind's artistic development, but also to raise the
> reader's estimation of child art. The illustrations in this
> chapter represent art that commands the respect of scholars,
> and child art should be accorded the same respect.

Later in his book *Child Art* (15) Viola makes it clear that in his view the battle for the recognition of child art had been won in 1937, because in that year children's pictures were sold for five and ten

guineas apiece. Yet in the same paragraph he refers to the lack of appreciation for 'pure infantile art'. Then at the beginning of his third chapter (25) he gives a chart showing that by this phrase he means the stages of

scribbling and smearing
rhythm of spirit and hand
abstract–symbolic stage (Egypt).

These, he writes, are the first three stages in the development of children's art discerned by Cizek. Clearly then he must be writing of the drawings and paintings of very young children—up to the age of eight or so. Francesca Wilson (1921) wrote of Cizek: 'the age he loved most was from one to seven'.

It seems clear, therefore, that when Cizek (and Viola) and Kellogg use the term child art they are referring to the work of children aged from one to seven or eight years; that is to say, to children who are below the age when they begin to analyse what they see according to adult notions of accuracy and detail.

We can now go on to look at the more difficult question of in what sense child art may be described as art. Viola (33) quotes from Cizek:

The child creates subconsciously. . . . Art more and more dries up because it is supplanted by the intellect, and from the subconscious only a few produce any more. The time for art is over perhaps. In its place probably technique will come. The latter can reach a very high level, of course, an immense accomplishment, but it will be something different from art or another kind of art.

Cizek said elsewhere (Wilson, 1921, quoted by Viola, 63):

People make a great mistake in thinking of child art merely as a step to adult art. It is a thing in itself, quite shut off and isolated, following its own laws and not the laws of the grown-up people. Once its blossoming-time is over it will never come again . . . the great break, the caesura, comes at this period (about fourteen) and after that you have either the art of the adult or no more creative epoch at all.

Perhaps the most important point to pick out here is not so much whether young children create consciously or subconsciously (it

would seem likely that they do both, as adults do) but how they see their world. Here we must turn to Ehrenzweig (1967, ch. 1) and the concept of syncretistic vision. He writes:

> The child's more primitive syncretistic vision does not, as the adult's does, differentiate abstract details. The child does not break down the shape of some concrete object into smaller abstract elements and then match the elements of his drawing one by one. His vision is still global, and takes in the entire whole which remains undifferentiated as to its component details. This gives the young child artist the freedom to distort colour and shapes in the most imaginative and, to us, unrealistic manner. But to him—owing to his global, unanalytic view—his work is realistic.

Later Ehrenzweig adds: 'Syncretistic vision is never entirely destroyed and can be shewn to be a potent tool in the hands of the adult artist.'

This does not quite answer the question of in what sense child art is art, but it does show the line of argument to take. It is the combination of syncretistic vision with the ability to respond to the work as it grows (Kellogg, ch. 1, 7) which gives to young children's work the quality which we now all recognize. We have to suggest that Cizek's dictum is only partly correct; and that child art is in a continuum with adult art. We might add, with Ehrenzweig (10), that if we can 'sustain (the child's) old syncretistic vision side by side with his new analytic awareness' then child art may properly be said to contain the seeds of adult art.

The mainstream of this article is concerned with the relationship between art and art education. Since all art in schools of general education starts from the child and his activity in art, we have been looking at the concept of child art and its relationship with adult art. It is appropriate next to inquire about the influences which may act upon the development of children's art activity from the moment when they make their first mark. No child is free from influence— even drawings done at home by children untaught and unadvised must still inevitably reflect differences in their environment. Even so, it is when we come to look at work done with a teacher—even by children of seven or eight years old—that startling differences emerge. If we look at the illustrations at the end of Viola's book the basic character of the drawings by children up to the age of five

is at once apparent; but the work of children over that age seems to show first a general influence of time and place, and second the specific influence of the teacher. If one looks at the reproductions of work by young children in *Children as Artists* (Tomlinson, 1944) and in *The Growth of Child Art* (Tomlinson and Mills, 1966) one sees at once that none could be supposed to be the work of Cizek's children; nor could they all be supposed to emanate from the same school. It would seem incontrovertible that many of these differences must be due to overt teaching; in fact, of course, we know from Viola's records that Cizek did a good deal of very precise instruction.

What, however, are much more interesting and much more difficult to assess are the ways in and degree to which the teacher's influence is unconscious. If we read some of Viola's records (1942, 112–93) of Cizek's lessons and compare them with Marion Richardson's own account (1948, 15–25) of some of the 'descriptions' she used to give as starting-points for lessons we can get some sense of how individual differences of character and temperament reveal themselves in the teacher so soon as he or she begins to teach.

We must assume that such influences were exerted largely unconsciously. We do not know if either Cizek or Marion Richardson recognized the effect of their teaching. Both emphasized the children's contribution, and we may suspect that both with all sincerity minimized their own.

The relationship of these two teachers with the world of the professional artist must not be overlooked. Cizek is recorded (Viola, 12) as having consulted friends among the Secession Group of Austrian artists before commencing his art class; Marion Richardson (14) communicates to us her delight as she realized, while looking round the first Post-Impressionist exhibition in London in 1912, the close affinity between the work which she saw there and the work done by her children from the Girls' Grammar School in Dudley.

One final point we must note about these two teachers: neither left children to work alone; each believed that children need help and guidance if they are to achieve any continuing success in expressive image-making. Their own writings put it differently. Cizek said (Viola, 44): 'I teach children art by not teaching at all in the accepted sense...', while Marion Richardson wrote (13): 'I began to see that this thing that we had stumbled upon, as it were by chance, was art, not drawing.... I could free it but I could not

teach it.' Evidently to teach meant something different to them from what it means to us—partly indeed because of their own work. And of course their words have been frequently misunderstood, from that day to this.

What of today's teachers of art? After all, their position is different from that of the pioneers; they are most likely to have taken some kind of course of a more or less sophisticated kind in preparation for teaching, and their ideas must spring partly at least from this background. Specifically, they are likely to have been expected to operate as artists. What sorts of influences are they likely to bring—wittingly or unwittingly—to the business of teaching art?

The first point that emerges is a particularly interesting one. Specialist art-students—while still students—both because of the form of their education and because of pressures within that education, may well have operated in their own work somewhere near the frontiers of contemporary art. So the influences exerted by art and the artist and by the artist-teacher are to all intents and purposes the same. The notion of problem-solving, the definition of completion as the point at which the problem is solved, the use of photographic images, the abandonment of boundaries between craft and craft—all these are characteristic alike of contemporary art in the galleries and of contemporary art in the schools. Gone is the attempt to preserve child art through adolescence; gone, too, is the notion that there are activities and media that will do very well for children though they are of no use to the professional.

But this brings us to a second point. For many years now, in Britain at least, teachers have been over-afraid of influencing their pupils. Many teachers abdicated—in a very real sense—from their duties in the sacred cause of freedom for the child. It is becoming clear to us now that teachers misunderstood what Cizek and Marion Richardson were saying about their own teaching; partly because they wanted to misunderstand, due to their beliefs about freedom; but also because of a failure to give a comprehensive meaning to the word 'teach'. It would seem that there was then a widespread supposition that 'to teach' meant 'to instruct' in a narrow sense—rather like 'to condition'. Accordingly, although teachers did a good deal of teaching in the sense of providing particular materials or setting up a particular situation, anything that savoured of instruction was taboo. Then in the early fifties in Britain Victor Pasmore began to develop the concept of the basic course, drawing ideas

from the Bauhaus; at about the same time the foundation of University Institutes of Education to take charge of the process of teacher-education in Britain led to a great expansion in and tightening up of courses in the philosophy and psychology of education in the teacher-training institutions. Gradually a truer sense of the significance of the verb 'to teach' began to spread among art teachers. It may be, therefore, that the pendulum has already begun to swing; that art teachers are beginning consciously to teach in the fullest meaning of the word. If this is so then the likelihood is that their influence upon their pupils will be a different one.

The third point which it is important to make is valid in spite of the new thinking which is going on both in the United States and here. It is that teachers still believe profoundly in the practice of art as a self-sufficient element in education. This is not surprising—after all, the whole structure of art education grew from the surprise and delight with which the pioneers realized that children could make art—and indeed most art educationists still hold that a central feature of art education must be the experience of art gained through making art. The difficulty has always been the tangle into which art teachers have got themselves over the relationship between the process and the thing made. If you regard the quality of the thing made as evidence of the quality of the experience of the maker, it becomes appallingly difficult to avoid teaching towards the quality of the thing—thus shortcircuiting the experience. In fact, of course, it does not seem that the relationship between the quality of the artefact and the experience can be so simple, so that the establishment of such a criterion must be suspect. But evidently we have to say that the influence of the teacher's beliefs about practical work must be felt in the art-room; and that there is a very real danger that the perversion of those beliefs may neutralize the whole learning process.

Our fourth point relates to the process of teaching practical art. Children are accustomed from the earliest age, when they have drawn something which the teacher thinks could be 'improved', to being told to look at the real thing. A child who has painted a blue strip at the top of the page for the sky is likely to be taken to the window and shown the sky, coming right down to the ground. The implication for the child is clear: art is to do with accurate observation and recording. The teacher may not intend this, and indeed at the right time the reference to nature is surely valid; but it must

be due to such incidents that many children owe their failure to realize that art is not merely imitation, but speaks in a language of its own.

We must examine the teacher's influence in one more area. Undoubtedly one of the most interesting developments in art for young children during the last twenty years or so has been the great increase in the range of materials used for practical work. Some of these will be materials for specific crafts, but a great deal will be scrap materials, success in whose use depends upon the skill and inventiveness of the children themselves. Such materials are admirable for use by mixed-ability groups, for there are few children who cannot achieve something with their use; art and craft is often valued in schools precisely for this reason. The influence of the teacher here may well be a negative one. Certainly many children, in whom one would expect a natural desire to do things well, seem to develop the attitude that verve and dash are more likely to be approved than care and accuracy. Undoubtedly many teachers do experience great difficulty in evaluating children's work of this kind: presumably because of the long-lasting confusion between the evaluation of the child's work as art, and its evaluation as a means of giving confidence and satisfaction to children. The recurring question, as we have seen, is whether the former evaluation is a guide to the latter.

The kinds of influence that act upon children when working with a teacher have been discussed here of necessity at some length. Because of the great similarities between the basic forms of very young children's work, the notion persists that if the teacher does the right things, then somehow the children will achieve a kind of ideal, 'natural', children's art. This cannot happen; no child is free from influence; as soon as a teacher enters the art room his influence is to be felt. Indeed, it could be argued that influence is inherent in the teaching/learning situation. Even the art teacher who is most convinced that he should not influence the children cannot avoid setting up certain expectations by his arrangement of the room, his choice of materials with which to stock his room, his expressed or unexpressed preferences. In this section, therefore, I have not attempted to argue that the existence of influence by the teacher is either good or bad; only that influences exist, and must therefore be understood.

But of course the influences generated by the teacher are by no

means the only ones to act upon children; their whole environment, with which as they grow they interact in developing ways, is constantly resisting and yielding in what constitute differing influences. To try to account for them all would involve writing a history of growing up. Here we shall simply consider briefly the influence of the potent photographic image.

Children are now accustomed, from very early days, to seeing the photographic illustration; even works of art are often only seen in reproduction, so that they take on some of the characteristics of the photograph. And the moving image—first in the cinema, now in television—presents to the eyes and imaginations of childhood a series of experiences which may rival the intensity of the experiences of everyday life. The material is presented in colour or black and white, using all the resources and skills developed over fifty years' experience to concentrate and intensify the message. The sequences of images thus formed are—perhaps literally, often metaphorically— larger than life; it is not surprising that when children are engaged in art work their imaginations often turn for source-material to the stuff of the cinema and the television. It seems probable that they do not always distinguish between what they have apprehended of their own experience, and what has been mediated to them by someone else. It would seem probable that one of the strongest influences of the moving picture on young people growing up is still further to blur this boundary.

It is surely no accident that one of the most popular techniques in schools today is collage—the assembly of cut-out photographic images to make a new image. Such cut-out images have become one of the most vital raw materials used by children, and no one who has seen the seriousness and concentration with which children work at making their selection and arrangement of them could doubt the meaningfulness of the activity to them.

It is interesting to set collage into the context of our discussion on child art. If we consider the transition from child art to what follows, a logical proposition might be: that even while the process of image-making is ceasing to be vital as a means of resolving relation- ships within the child's environment, it is gaining strength in its own right, as art. This change corresponds to the weakening of syncretistic vision as analytic vision gains in strength. It is possible that the nature of materials used by children during this transition period plays a serious part in the way in which development takes

place. For example, one might group together the great variety of materials used for assemblage as offering particularly speedy possibilities for the putting together of wholes. Thus for children whose syncretistic vision is weakening such materials might provide an effective vehicle for working both analytically and syncretistically.

Up to this point we have paid attention to (1) the art of children up to the age of eight years as a basis for practical work; (2) have considered such work as art; and (3) have given some space to an examination of the influences usually and automatically brought to bear when art is taught as a practical activity. We must now look at certain features of art itself as a preliminary to the consideration of two major concepts—first, education through art; and second— as the central element in this article—education in art.

Manuel Barkan (1970, 7) writes:

> Although there is no acceptable definition of aesthetic experience (in terms of its necessary and sufficient properties), there is enough consensus among theorists to propose a functional concept of its nature: aesthetic experience is an experience that is valued for its own sake, intrinsically. Whether it be listening, looking, performing or producing, involvement in an aesthetic experience carries the desire to sustain and feel the full import of the moment for its own sake. In an aesthetic experience one perceives the integral inter-relationships between the form and content of the experience. Such perception is what makes aesthetic experience different from other extrinsically valued experiences in everyday life.

In this passage there are a number of interesting points. First, we observe that Barkan writes of *aesthetic* experience. Dewey (1934, 46) points out that '"artistic" refers primarily to the act of production and "aesthetic" to that of perception and enjoyment', but he adds: 'there is no word in the English language that unambiguously includes what is signified' by them both. Consequently Barkan is compelled to use the term 'aesthetic' for both.

Second, Barkan does not write of art *per se*; instead he writes of aesthetic experience. In this he is clearly at one with contemporary thought. We have already referred to the difficulties experienced by the art teacher in establishing a sound working relationship between experience and object. Such difficulties arise because the first explanation of the whole curious activity that springs to one's mind

is that the artist is making an art-object—the thing made appears to be the end-result.

Third, Barkan writes of an aesthetic experience as arising from 'listening, looking, performing or producing'. He thus writes of making an art-object as providing the same experience as looking at and responding to an art-object. Dewey (1934, 47) writes: 'The distinction between aesthetic and artistic cannot be pressed so far as to become a separation.' He elaborates the point by a discussion of the artist working: the artist goes on adding to or altering the work until he is satisfied with what he sees—until the work speaks back to him as presumably it would speak to the spectator. There is of course a semantic problem here: art does not 'speak' to us in the same sense that words do. At a level where verbalization is possible there may well be misunderstandings between artist and spectator; it is at levels beyond words that communication in the arts takes place.

Fourth, we must note that he writes of the arts—not merely of visual art—and he writes as if the experience of the arts were one experience—no matter what the art, no matter how the experience is gained. There is here a fruitful area for discussion—the nature of experience in the arts compared, and the ways in which that experience is directed and organized—which is outside our present brief, but of which art educationists need to become increasingly aware.

The basic argument is clear: the experience of art is the same for artist and spectator alike—though of course the routes to that experience are different. The spectator has his role to play. He cannot be merely passive. He must be open to experience, prepared to accept what comes; but such openness may only be the result of much effort and of a considerable deployment of previously-gained experience and knowledge. Reid (1969, 303) writes of the spectator's experience: 'It is an intuition of wholeness which is in sharp contrast to the sometimes very long processes of art-making. . . . ' Certainly the total experience of art-making cannot be the same thing as the total process of being a spectator. Both, however, may be long: the spectator may need to return again and again before he achieves a full richness of response.

The interesting question here for the art educator is: just what for children should be the introductory experiences of art? It is a canon among art educators that they should be experiences of making art;

and indeed there can be very few children who do not draw, paint, model, from an early age. But generally speaking, the result of this has been that for children the role of spectator has been neglected. This whole matter is discussed in the article by Sonia Rouve, in this volume.

We must move on, and consider briefly the difficult question of content. Clive Bell argued (1914, 27 *et seq.*):

> To appreciate a work of art we need bring with us nothing
> but a sense of form and colour and a knowledge of three-
> dimensional space . . . people who can [feel pure aesthetic
> emotions] as often as not, have no idea what the subject of a
> picture is . . . they are concerned only with lines and colours,
> their relations and qualities and quantities. . . . To those who
> have and hold a sense of the significance of form what does it
> matter whether the forms that move them were created in
> Paris the day before yesterday or in Babylon fifty centuries ago?

In the history of the development of our ideas about art this is a key passage. True, we seldom speak of Clive Bell nowadays, or read his book, or use the term 'significant form'. Nevertheless, we still hold to something very like Bell's basic principle. Listen to Meyer Schapiro (1962, 282):

> What counts in all art are the elementary aesthetic components,
> the qualities and relationships of the fabricated lines, spots,
> colors and surfaces. These have two characteristics: they are
> intrinsically expressive, and they tend to constitute a coherent
> whole. The same tendencies to coherent and expressive structure
> are to be found in the arts of all cultures. . . . Such ideas are
> accepted by most students of art today, although not applied
> with uniform conviction.

The notion of history would seem to be irrelevant, subject-matter of minimal significance, according to this view.

Yet, even so, there is one important respect in which we have departed from this view. We recognize that a good deal of con-temporary work will not stand on its own, for several interrelated reasons, of which the most important is that art works which have a basis in other art works may be of such a kind that the barriers to response are too great. To this fact we owe many of the teaching exhibitions of which there have been so many in the last twenty

years—exhibitions which set an artist's work in a context, both aesthetic and social, and in the explanatory catalogues to which the words of the artist and of his critics often appear. In such exhibitions, subject-matter is likely to seem unimportant since, in the words of Meyer (1967, 152): 'Where representation is present it is assumed, by artists as well as critics, to be the vehicle for the presentation of the real stuff of painting—color, line, texture and their organization.' Meyer goes on to point out (153) that 'If art expresses nothing but itself, if it is self-contained with respect to meaning, then who made it or when it was created makes no difference.' Different styles will, he suggests, coexist together with past styles; and since the new is not 'better' than the old, 'stylistic change should not in itself be a desideratum'. His book, an analysis of the patterns of twentieth-century culture, should be on the reading list of every serious student of the arts.

Up to this point we have proceeded as if the only area we need consider is that of fine art. Yet many educationists would now claim that perhaps a more important area is that of design for life; more important, because such damage has been done to the environment that strong remedial action is necessary. At this time, therefore, a number of design courses are in operation in British schools; a certain literature has appeared; and principles have been enunciated. So far the idea has made little headway in teacher training institutions, which has meant that only a comparatively few teachers have so far been involved. I have elsewhere (Field, 1970, 55) discussed the remarkably ambiguous attitude of art teachers towards design education over the years. Ken Baynes (ed.) (1969, 5) suggests that perhaps now at last there is a breakthrough:

There are probably two main reasons why these events [developments in the teaching of design] are taking place in Britain at this particular moment. One is the complex change which is associated with the final destruction of aristocratic society and the dismantling of world responsibilities. It involves coming to terms with certain facts: that most people live in suburbia or in large industrial cities, that patronage is dispersed throughout the mass-market, that traditional social and moral codes are increasingly unworkable under contemporary conditions. An aspect of this is a tremendous desire to understand the mechanisms and possibilities of mass industrial culture.

Young people are less and less seduced by a vision of a lost rural or imperial past, more and more concerned to build out of the resources of the present . . . the interest in the practical possibilities offered by design education is based on its obvious relevance to the kind of society which is emerging.

It is clear from this interesting passage that what is envisaged is something very much wider and more comprehensive than could be dealt with by any single teacher or department. At least a course of some duration, involving a number of departments of a school or college, would be required. However desirable such a course might be, its very existence and worthwhileness as a 'design' course would surely depend upon other foundation studies; it would seem unlikely that active sensibility and awareness could be developed solely inside such a course. Reid (1969, 302) writes:

Art education must, as a first principle, initiate people into what it feels like to live in music, move over and about in a painting, travel round and in between the masses of a sculpture, dwell in a poem. . . . These paradigm experiences are the basis of an illumination of much that is beyond themselves. . . . Aesthetic insight, feeling from the inside what art is—this is the central starting and expanding point for everything else.

Barkan (1970, 9) proposes as the goal for aesthetic education 'to increase the student's capacities to experience aesthetic qualities (values) in man-made and natural objects and events in his environment . . . the general goal for aesthetic education can be achieved only through attention to the development of the student as a person'.

Art education has in the last seventy years or so been increasingly concerned with the development of the individual—though of course one would want to argue that the cultural education of the individual affects his behaviour as a member of society. Here is Baynes, however, to make the point that in art education we must begin to see that in order to educate the individual as an individual we must first see him clearly as a member of society.

The mainstream of this article will lead us to a consideration of the concept of education *in* art; but before we proceed to this the concept of education *through* art demands our attention. We must

6

look first at Herbert Read's version (1943) of this concept, as he developed it at length in his book *Education Through Art*.

On the first page of the book Read is quick to point out that the thesis on which the book is based is not his but Plato's—that art should be the basis of education. For a full study of the proposition the book itself is essential but difficult. Read develops the argument as follows (1943, 7): 'In a democratic society the purpose of education should be to foster individual growth.' Growth, he argues, is a much more complicated process than is generally supposed; the process of adjustment of the subjective feelings and emotions to the objective world would seem to have an immense influence upon the quality of an individual's thought and understanding. Read suggests (7) that 'the most important function of education is concerned with this psychological orientation, and for this reason the education of the aesthetic sensibility is of fundamental importance.' He stresses that he is not narrowly concerned with art education, but very broadly with (7): 'The education of those senses upon which consciousness and ultimately the whole intelligence and judgment of the human individual are based.' Aesthetic education, he says (8, 9), has for its scope:

I the preservation of the natural intensity of all modes of perception and sensation;
II co-ordination of various modes of perception and sensation with one another and in relation to the environment;
III the expression of feeling in communicable form;
IV the expression in communicable form of modes of mental experience which would otherwise remain partially or wholly unconscious;
V the expression of thought in required form.

He continues, in a famous passage (11):

Growth is only made apparent through expression—audible or visible signs or symbols. Education may therefore be defined as the cultivation of modes of expression—it is teaching children and adults how to make sounds, images, movements, tools and utensils. A man who can make such things well is a well-educated man. If he can make good sounds he is a good speaker, a good musician, a good poet; if he can make good images, he is a good painter or sculptor; if good movements, a good dancer or

labourer; if good tools or utensils, a good craftsman. All faculties, of thought, logic, memory, sensibility and intellect, are involved in such processes, and no aspect of education is excluded from such processes. And they are all processes which involve art, for art is nothing but the good making of sounds, images, etc. The aim of education is therefore the creation of artists—of people efficient in the various modes of expression.

This is not a difficult idea (though it could be argued that the logic is not impeccable); Read is saying that of course people have different trades or professions, but they are united in the sense that each can in the practice of his trade be an artist. In other words, art is not merely a separate activity, to be carried on by people whose trade is art. Since there is art in all activities, all who practise these activities can be artists. The task of education is to help people to grow, both as individuals and as members of society; the measure of its success is that its products are artists 'efficient in the various modes of expression'.

We must remind ourselves that by 'art' Read (35) means 'the arts'; we must further observe that he maintains that 'life itself, in its most secret and essential sources, is aesthetic—that it only IS in virtue of the embodiment of energy in a form which is not merely material, but aesthetic'. It is a little disconcerting to descend from these lofty heights to find that one is, in fact, talking about the visual arts in education. Nor is it altogether clear in what way the teaching of art links with the concept of education through art. Read cannot mean that if you educate a person to be a good visual artist then he will automatically be a good engineer; but if he is not saying that, what is he saying? It is not surprising that educationists—and particularly art teachers, since the book seemed to be especially addressed to them—shied off his interpretation of education through art to an easier notion, which has been current for almost thirty years, and which we must now consider.

Since the first fine flush of child art, art educationists have tended —especially perhaps in the area of secondary education—to be on the defensive, as the critics came back saying in effect: 'Splendid, so children can make art; but what is the educational point of doing so?' Art educationists accordingly set about finding intellectual justifications for what they were doing; and found a particularly fertile ground for argument in the notion that the practice of art

confers some extraneous benefits on the individual practising it. Thus to see properly, to express oneself, to develop confidence, to be persistent, to be honest, to develop sensibility, to become a whole man (and, in the United States, to become a good citizen)— all these and more have been urged as benefits which accrue 'on the side'.

This emphasis—not only in art education—on the development of the individual inevitably influenced the criteria applied to the activities in which those individuals engaged. In art education—as we have seen above—the criteria related more to the person than to the artefact. In fact the two persistent criteria of the last twenty years among art teachers have been: one, that the children enjoyed themselves; and two, that they were expressing themselves. It is pertinent here to quote Manzella (1963, 17):

> The educationist has students engage in art experiences having as their primary goal life adjustment and the integration of learning experiences. The educationist says that he is concerned with the student himself, not with what he produces. The old standby in the field is 'process rather than product', which is supposed to mean that what happens to youngsters in terms of their total growth while they are engaged in art activities is of critical concern, not their finished product. This is often expressed by art educators as an interest in people, not things.

We have touched earlier on the problem of the relation between activity and object; here we are merely concerned to point out that this successor to Read's doctrine in fact developed at a time when writers and teachers were becoming more concerned with general ideas of child development. Its practice put art educationists in the forefront of educational thought, yet laid the foundations for many of our present difficulties.

To create a situation in which children could express themselves with enjoyment, art teachers were driven progressively to abandon teaching positions. They hoped—and of course they had grounds for hope—that the internal disciplines developed during art activity would preserve a kind of status quo. That this has proved not to be the case for perhaps a majority of children in art lessons must be due to pressures felt throughout society. One result has been that many teachers who attempt to teach in a sense beyond simply creating situations find themselves in the position of the student

teacher who wrote in her notebook: 'The children were alarmed and annoyed at being asked to do something difficult.'

One more point about the concept of education through art needs to be brought out; and that is its connection with the idea of expression. Herbert Read built his book around expression—as is clear from the quotation on pages 22 and 23. Lowenfeld wrote explicitly (Lowenfeld and Brittain, 1964, 21): 'Art is not the same for the child as it is for the adult. Art for the child is merely a means of expression.' It would seem that both Read and Lowenfeld underestimated the organic nature of child art, and, with their eyes fixed upon the art of the first forty years of the century, chose to emphasize expression as a motivating force for all children and young people. In this they were certainly speaking for their age. Indeed children, and adults too, do express: in its simplest meaning to express is merely to make known, to communicate. The crucial question is: expression for what purpose? Lowenfeld seems to say: for its own sake; but it is difficult for us today any longer to suppose that the artist—child or adult—is simply motivated to externalize that which is within. Many artists have told us that not until they had begun to work did they discover what they were about (see Protter, 1963; Museum of Modern Art, 1959). Such statements, together with later observations of young children, suggest that the process is much more like a searching, an exploration—Picasso would say 'a discovery'. When Robert Motherwell writes (Protter, 250): 'I happen to think primarily in paint', he makes it clear that the action of painting has become organic for him. Children engaged in art may similarly be engaged in a life-giving activity.

One question remains to be considered: exploration of what? We have seen that young children seem both to explore their environment through art and to explore experience in art. The adult surely does the same; only whereas the child is mainly concerned with his immediate environment the adult thinks of art mainly as a vehicle for exploring a mode of experience accessible in no other way.

In looking at the concept of education through art we have been considering one possible working relationship between art and art education. We can see in retrospect that throughout the period since the war the professional artist too has been much concerned with process—so much so that, as we have seen, he has often found the need to explain the artefact when it is exhibited. Through the

artist-teacher there has been a constant cross-fertilization between art in society and art in education. Also the period has seen the emergence of the designer and his attempts to free himself from what he conceived to be the shackles of fine art; in the schools the study of design has made headway. Finally, we have to say that though the period has been characterized by uncertainty, one clear tendency seems to be evident: we are learning to be eclectic in the matter of styles (see Meyer, 1967) both in the galleries and in the schools; though we are still often bewildered by our inability to reconcile them.

It can be argued that, in reaction to the concept of 'education through art', the development of the concept of 'education in art' became inevitable. If the one focuses attention upon the pupil, the latter calls attention to the discipline of art; if the former involves minimal teaching, the latter proclaims that there is material that needs teaching; if for the former the practice of art is sufficient, the latter calls attention to the claims of aesthetics, criticism and art history. While we were giving full attention to the former we could hardly heed the latter: only in the last few years has opinion begun to shift around.

Nevertheless, education in art demands attention in its own right. The Rev. St John Tyrwhitt, M.A., writing in 1868 (17), defines the function of 'education by art' as being 'to create and gratify the desire of Beauty wherever it is needed'. In writing so he felt that he was viewing art as a means of general education for the upper working classes. He also thought (21) that there should be 'education for art'—the education of the artist, and provision for 'such an education in form and colour as shall enable any person to ascertain and develop whatever powers he may possess of Observation or Imitation, or of Pictorial Expression, direct or symbolic.' His objectives were to be achieved (17) through practical art—practised in 'cheap Art Schools, well supplied with natural models . . .' And it is the case that since his day, art education has always been primarily concerned with the activity of making art; in fact, it has been assumed that only through the practice of art could children experience art. In view of the discussion on pages 147 and 148 above, it is clear that such an assumption can no longer be made without qualification. One sees that to experience the creative steps— leading into the unknown—of making art is an educationally valid procedure; but then follows the further question: is practical

experience alone sufficient for young people who will not become professional artists? The answer must be that on the whole it seems probable that most contemporary art education does not provide sufficient real opportunities for children to develop the right kind of skills and to acquire the knowledge needed if they are to enjoy a continuing and fruitful contact with art. There must be a structure of knowledge and experience upon which the individual can build, so that his own responses can be enriched thereby. Such a structure must surely embody the individual's experiences in making art; and this in turn suggests that those experiences in themselves might be more structured.

The implication of what has just been said is that matters about art may usefully enhance experience. Discourse about art can be differentiated into aesthetics, criticism and history; but it must be emphasized at once that it is not suggested that art education should be fragmented. If these elements cannot be taught as parts of a larger whole they had better be forgotten. But talk about art there must be, both in relation to activity and in relation to appreciation.

The real point of all this is, of course, the proposition that education in art must equip the individual with the experience, the knowledge and the criteria necessary if art is to play a proper part in his world. This involves looking both inwards and outwards; both at the significance of art to oneself, and at its significance as an element of social communication. Above all, it involves the construction by the individual of an evolving set of values; criticism—in the constructive sense—is of the essence of response in art. The teacher, also, must be involved in an awareness of the structure of thought and feeling which he desires to encourage in others, but he must not attempt to supplant individual structures with one of his own.

It has been suggested here that the teaching of practical art may need to change. Wherever art teachers teach, some pupils and students are doing splendid work; yet the thinness of many current procedures has the effect for many other children and young people of gravely diminishing the range, variety and richness of what is experienced. This is often due to the fact that we fail to see art as a learning activity, and so often fail to help learning to take place. More discourse about art, both differentiated and undifferentiated, at all levels of art education, would seem to be necessary.

There is a further aspect of the concept of education in art which

must be emphasized. Art in general schools so often becomes an artificial school activity—a bit of drawing and painting and not much more; yet art manifests itself throughout human activity, and a principal function of education in art would be to gather together all the strands and consider relationships and common criteria. Thus activity in art might no longer consist almost entirely of individuals engaged in lonely activities looking inwards only. Activities such as collecting and collating, describing, criticizing, would result from the attempt to encounter art wherever it is to be found.

Such a view of education in art must not, even in this guise, be allowed to be too parochial. What we have described as education in art could without difficulty be expanded to become education in the arts. This area, so long neglected or merely paid lip-service to in British education, would afford a rich mine for study by all educationists in the arts. The first difficulty in all notions of integration is over-ambition. There is a great deal to be gained from simple comparisons, from explorations of what appears to be common ground—and certainly equally important, the study of differences. And of course teachers in the arts have much to learn from one another, and much to gain from working together. It may not be too wild a hope to visualize general schools of the future with departments of the arts, where programmes of education in the separate arts proceed, sometimes converging for common study, sometimes diverging to pursue individual lines of inquiry.

2

It has, I hope, become clear in the course of this article that in considering the relationship of art with art education we have been thinking of art in a dual role: first, as one of the modes by which the individual seeks to recognize and organize his relationship with his environment—considered in its widest sense; and second, as a means of communication in society. Evidently these roles are intimately connected, in places overlapping, in places complementary. In our society the operation of these roles changes as society becomes more conscious of its activities in one direction or another; it is possible to think of art education as one of these activities: as part of art in society. This makes more pointed the question that immediately becomes apparent—and that we have

been discussing in Section 1 above—what is the role of art education in relation to art in society, allowing for the moment that the latter term be used to describe both roles of art as proposed above?

Clearly, attempted answers to this question must fall into two groups—those that suggest a functional relationship, and those that suggest some other kind of relationship. If the relationship is a functional one, then it is imperative that the student of art education should form an opinion upon whether art in society shapes art education, or vice versa; or else, as perhaps seems more likely, in what ways the two interlock.

It is evident that it is not merely desirable but essential for the art teacher to have an understanding of the relationship; for upon such understanding depend the attitudes and beliefs which will so strongly influence the decisions that he will take as a teacher of art. Those decisions concern objectives and their implementation; they are not trivial but fundamental decisions. In many respects art education has become an accepted and set activity, desperately needing the new thinking that could result from a new look at the social aspects of art education.

There seems to be one more vigorous reason why the student should study this relationship: art education is a field of study which makes use of many disciplines. It is still not accurately delimited and is fragmented. For the student the study of the relationship between art and art education provides a means of integration. He must study art as an individual and social phenomenon together with art education, and must grasp the complexity of their relationships. He must use philosophy, psychology and sociology as tools. Moreover, this is not likely to be an area in which, as certain basic areas are studied, relationships necessarily become apparent; the student of art education may well discover that only through a study of relationships will the nature of the basics emerge.

3

Properly developed, we have seen that the study of art and art education could bring together in a simple framework those separate disciplines of which the material is composed. It is worth emphasizing that one object in this kind of study is precisely the fact that it provides a structure for organizing a complex body of material; also, about this structure one must say that it must be

6*

sufficiently flexible to allow of study in depth when and where necessary.

We are concerned here with ways of studying the relationship between art and art education; and the first point to be made to the student of art education is that he faces an inescapable dilemma. As a human being he must be involved in art—in the arts—must experience them from within; as a teacher he must be able to stand outside and observe the aesthetic experience in himself and others. The problem is tempered by the fact that, although nothing can ensure that you have aesthetic experiences, an examination of what is happening may help you next time. For example, you are placed before a work of art. You begin by opening yourself to whatever experience the work has to offer. You wait receptively. But gradually and inevitably your response changes; you begin to wonder, to question, to be critical. You talk to your companion about your feelings, about the felicities of the work, about the things that perplex you. All this is important—it is the total experience that is significant—not just the period at the beginning—and it gains in significance as the process is repeated before the same work. The period of analysis and discussion, interesting in itself, plays its part in enhancing later response.

We must not prejudice the issue: the fact is that the individual experiencing art as an individual merges into the teacher of art, and his experiences of art must serve as his primary vehicle for exploring the relationship between art and art education. For him as individual the objective must be the experience of art; as teacher he is concerned with the problem of the significance of the experience in relation to his procedures and goals.

But the student of the relationship we are discussing cannot rest upon his own personal experience: he needs discursive weapons with which to probe and analyse. Again we find him playing a dual role; for as individual he needs discourse about art to focus and intensify his experience, while as student he needs discourse to examine the relationship between art and art education. The two areas of discourse are not at all the same: for the study of art there are available the established disciplines of aesthetics, criticism and art history, and the student will, of course, need to move freely through these for the enhancement of his own experience. But to examine the problem of the relationship of art and art education involves him in seeing both psychologically and sociologically. The

salient point here is that these disciplines are to be used as tools. The relationship exists and is to be studied: formally, if need be, through the disciplines; informally, too, when this is appropriate.

Central to the study of this relationship is this historical element: the changes and developments in sequence seen as the relation between, on the one hand, art philosophies and movements and on the other, ideas in education and art education. In order to discern at all clearly the relationships here it will be absolutely necessary to see all in its context, both social and intellectual. It will also be desirable to try to see what artists and teachers actually did, as well as what they said they would do or were doing.

Ideally the study of the historical sequence should have as its apex (not necessarily last in time) the study of the contemporary scene: for clearly one important objective for the student must be to attempt to see himself and his work as artist and teacher in the light of his own time. Indeed, this may be the ultimate objective, for essential to one's understanding in the arts is some grasp of how far and in what ways one is conditioned not only by the past but by the present—'the intrusive present', as Whitehead called it. It is a truism to say that one is the child of one's time; it is nevertheless extremely difficult to be clearsighted about views and attitudes one feels committed to and convinced are one's own. It would seem at least possible that a course of study might start from the present and the immediate past, picking up sources of ideas and movements from appropriate points in time.

It is evident that on both sides this study is seated in sociological study: both art and education can be seen as tools used by society for shaping its succession. The serious student of art education must make a determined effort to grasp the forces influencing the forms of art and of education in the twentieth century, in order that he may begin to see in what senses art can be a living element in the lives of all men and women. At the heart of the student's effort must be an awareness of contemporary art-forms, wherever they may be found; and no doubt every student will wish to do his or her own research in order to see such forms in their current context, and to consider how they come to be as they are.

All this seems to sketch out a three-point programme for the student of art education: first, he must be involved in the study of art, through the experience of art (both through making and response) and discourse about art; second, he must work towards an

understanding of art (and not merely fine art) and its significance and place in the life of the individual and in the life of society; third, he must engage deeply in the linking study of art education as communication between the artist and art, the individual and society.

It would be a happy consummation if such a programme were carried out in conjunction with studies of the other arts, in order that the student might form some ideas of their similarities and differences, and might become more aware of their essential unity.

References

Barkan, Manuel, Chapman, Laura H. and Kern, J. (1970), *Guidelines: Curriculum Development for Aesthetic Education*, Ohio: Central Midwestern Regional Educational Laboratory Inc. (CEMREL).

Baynes, Ken (ed.) (1969), *Attitudes in Design Education*, London: Lund Humphries.

Bell, Clive (1914), *Art*, London: Chatto.

Collinson, Hugh and Holmes, Kenneth (1955), *Child Art Grows Up*, London: Studio Books.

Dewey, John (1934), *Art as Experience*, New York: Putnam.

Ehrenzweig, Anton (1967), *The Hidden Order of Art*, London: Weidenfeld & Nicolson.

Field, Dick (1970), *Change in Art Education*, London: Routledge & Kegan Paul.

Johnstone, William (1940), *Child Art to Man Art*, London: Macmillan (out of print).

Kellogg, Rhoda (1969), *The Analysis of Children's Art*, San Francisco: National Press.

Lowenfeld, Viktor and Brittain, W. Lambert (1964), *Creative and Mental Growth*, New York and London: Collier-Macmillan.

Manzella, David (1963), *Educationists and the Evisceration of the Visual Arts*, Scranton, Penn. and London: International Textbook Co.

Meyer, Leonard B. (1967), *Music, the Arts and Ideas: Patterns and Predictions in Twentieth Century Culture*, Chicago: University of Chicago Press.

Museum of Modern Art (1959), Catalogue of Exhibition *The New American Painting*, New York: Museum of Modern Art.

Protter, Eric (1963), *Painters on Painting*, New York: Grossett & Dunlap.

Read, Herbert (1943), *Education Through Art*, London: Faber.

Reid, Louis Arnaud (1969), *Meaning in the Arts*, London: Allen & Unwin and New York: Humanities Press.

Richardson, Marion (1948), *Art and the Child*, London: University of London Press.

Schapiro, Meyer (1962), 'Style' in *Anthropology*, Chicago: University of Chicago Press.

Tomlinson, R. R. (1944), *Children as Artists*, Harmondsworth: Penguin.

Tomlinson, R. R. and Mills, John F. (1966), *The Growth of Child Art*, London: University of London Press.

Tyrwhitt, Rev. R. St John (1868), *Pictorial Art*, Oxford: Clarendon Press.

Viola, Wilhelm (1942), *Child Art*, London: University of London Press.

Wilson, Francesca M. (1921), *A Lecture by Professor Cizek* (pamphlet), London: Children's Art Exhibition Fund.

Further reading

Arnheim, Rudolf (1970), *Visual Thinking*, London: Faber.

Eisner, Elliott and Ecker, David (eds) (1966), *Readings in Art Education*, Waltham, Mass.: Blaisdell.

Jones, Richard M. (1968), *Fantasy and Feeling in Education*, New York: New York University Press and London: University of London Press.

Langer, Susanne (1957), *Problems of Art*, London: Routledge & Kegan Paul.

Mattil, Edward J. (1966), *A Seminar in Art Education for Research and Curriculum Development*, Philadelphia: Pennsylvania State University Press.

Mcfee, June King (1961), *Preparation for Art*, Belmont, California: Wadsworth.

McKellar, Peter (1957), *Imagination and Thinking*, London: Cohen & West.

Pappas, George (ed.) (1970), *Concepts in Art and Education*, New York and London: Collier-Macmillan.

Smith, Ralph A. (ed.) (1966), *Aesthetics and Criticism in Art Education*, Chicago and London: Rand McNally.

7 Aesthetics and aesthetic education

Louis Arnaud Reid

1 Introduction: preliminary distinctions

In this article I shall discuss a number of related topics. I shall begin by saying what aesthetics is, its purpose and justification, and shall try to expound it by illustration and example rather than by formal analysis. I shall then go on to consider what is meant by aesthetic education, asking particularly whether aesthetics has any bearing upon it, directly or indirectly. I shall conclude with some observations upon the teaching of aesthetics, particularly to those who are either art teachers or who are engaged in the training and education of art teachers.

Before settling down to the main task, however, it will be necessary to make some preliminary terminological distinctions, distinctions between concepts which, though very closely related, must not be confused with one another, as they very easily are. They are: art, the aesthetic, aesthetics, the aesthetic object, criticism, aesthetic education.

To begin with aesthetics: the aesthetics which will be discussed here is *philosophical* in character. Philosophy is always importantly concerned with questions of *meaning*: philosophical aesthetics examines the meanings of the words and concepts which we use when we talk, for instance, about art. When we experience art or talk about it we make many assumptions of which we are not as a rule aware. Philosophical aesthetics digs these up, analyses them critically, and tries to clarify confusions of language and concepts. It does more than this, however: it attempts to think things together coherently. Thus, though it necessarily has a critical and analytic side, it aims to build up a positive structure of ideas which may enable us to see more clearly the different parts in perspective.

This is philosophical aesthetics. But there is another related

study, with an empirical or scientific emphasis—*psychological* aesthetics. In what is called 'aesthetic experience', it goes without saying that there are body-mind events, and certain responses and behaviour, which can be empirically examined; and some empirical knowledge is logically presupposed when we talk philosophy. A good collection of empirical material of different kinds is to be found in C. W. Valentine's *An Experimental Psychology of Beauty* (1962). There are also psychoanalytical studies, some of which are referred to in other articles in this volume. These cannot be discussed here. But it is quite in place to remark that the results of psychological investigations, the questions they investigate, the language and concepts of their reports, the assumptions which psychologists inevitably make in their questions and reports, are fair data for the philosophical examination and criticism of meanings.

I have used the words 'art', 'aesthetic', 'aesthetic experience' and it must be supposed that if there is aesthetic experience there must be *objects* of such experience: they may be called 'aesthetic objects'. I shall have a good deal to say about all these ideas in the course of this article. But now, and still at the descriptive stage, it must be pointed out that 'art' and the 'aesthetic' are different, though overlapping, concepts, with an area in common, the aesthetic in art. 'The arts' in the history of culture cover a much wider area than the aesthetic. They impinge and are impinged upon by the religious, the magical, the didactic, and so on. The aesthetic on the other hand has relevance in areas far outside the arts—the flight of a bird, the form of a shell or a piece of wood—these have aesthetic value. There is an obvious distinction between art, a human artefact, and natural objects and events, not man-made. Both have their aesthetic aspects, and it is with these that we are concerned here. Anything which is aesthetically 'enjoyed' is an 'aesthetic object'. An aesthetic object may be an art object, or it may not.

Another item in our preliminary agenda is the concept of *criticism*. I have said that philosophical aesthetics is a critical examination of our talk, assumptions, etc. Criticism is talk about art and the experience of it; so the talk of criticism is a proper part of the subject-matter of aesthetics. But it must be emphasized that although criticism and aesthetics are both 'talk', criticism is talk of a *first* order, about works of art themselves, schools, movements in art, etc., whilst aesthetics is talk of a *second* order (sometimes called 'meta-criticism'), talk not directly about works of art or of

movements like Impressionism or Cubism. This is not a water-tight division. The philosopher of aesthetics does often refer to particular works or schools, and the critic certainly at times talks 'philosophy', though not as an expert and often without knowing it. The difference lies in focal emphasis. The critic is concerned directly with, and is supposed to be an expert in, works of art themselves, seeing them (speaking ideally) discriminatingly, and helping others to do the same. (A good critic is often, in effect, a teacher of aesthetic appreciation.) A philosopher is, of course, very much concerned with all this, and must draw upon it. He could not talk any relevant sense without it, and without plenty of first-hand experience himself. The philosopher, as a condition of his relevant comment, must be as much of a critic as he can, though he may remain an amateur. More than this, it is almost a necessity that he have first-hand experience from the inside of at least one—pre-ferably more than one—of the arts, as a *maker* of art, although there, too, he may be but an amateur. Without inside acquaintance of the 'feel' of art fashioned in this medium or that, he is likely to be dry, unconvincing, possibly irrelevant. Philosophy may be a conceptual study, but the professional philosopher as such and without know-ledge of art is not qualified to pursue aesthetics, and harm can be done, and sometimes is done, when he tries to write aesthetics out of 'the top of his head'. On the other hand the critic, though he is not a philosopher, does at times need the help of the philosopher in examining the concepts and the assumptions, often unconscious, which he is bound to use when he talks about art. Philosophers of art and critics do, in different ways, need each other (see Reid, 1969).

Next, aesthetics must not be confused with the *aesthetic*. Aesthetics, as we have seen, is a conceptual philosophical study, and the general name for the *object* of its study is the 'aesthetic'. Aesthetics we come to understand better by thinking about the arts and other aesthetic objects and the language and concepts relevant to them. The aesthetic (in art or elsewhere) is what we come to know directly and at first hand in 'aesthetic experience'. No talk of aesthetics is ever a substitute for that, for it presupposes it.

One final preliminary remark. Aesthetic *education* must not be confused with, and particularly must not be identified with, aesthetics. Aesthetic education, I will say provisionally, is education for more discriminating appreciation, aesthetic understanding, of,

mainly, the arts. Aesthetics may have a bearing on aesthetic educa-
tion; I shall argue that it has, directly or indirectly, as has history
of art, or iconography. But aesthetics is a study in its own right.

2 Some questions in aesthetics

After these rough-and-ready preliminary distinctions, some of
them obvious but I think necessary, we may now go on to illustrate
what aesthetics *is* by looking at a number of problems basic to
aesthetics and chosen because they are particularly relevant to the
interests of teachers or intending teachers, and especially teachers of
art. But it must be emphasized that although aesthetics is being
introduced by examples and illustrations, this introduction can only
be an opening up. Philosophy (and aesthetics) is obstinate and
persistent questioning: there is no final full stop. For reasons of
space I shall not be able in this particular article to argue at length.
But I hope I can show the kind of questions and the manner of
questioning which is typical of philosophical aesthetics. They can
be applied to many more than the few problems I have selected.

I begin with the 'aesthetic object'. This has an abstract and formal
sound. But I think we are justified in beginning with it because
unclear assumptions here can cause much confusion in our talk of
other questions of aesthetics and can incidentally affect the clarity
of our teachings about art and education.

Ordinarily, when we make some pronouncement about, say, a
picture, such as that it is 'beautiful', or perhaps in some way
unsatisfactory, we seem to be referring to an object—in this case a
picture hanging on the wall. The picture hanging on the wall is a
physical object in the sense that it is supported by hooks, can be
carried about, etc. It is also a physical object in a scientific sense—
a complex of molecules, say. Because, or partly because when we
say 'that's good' (or 'not so good') we *point* to the picture, some
people have held that its aesthetic qualities literally belong to it,
literally when no one is there, when the gallery is empty and
perhaps in darkness. Leonardo's 'Madonna of the rocks' is 'beauti-
ful' even when in store; the flower literally 'wastes' its sweetness
(which it literally has) on the desert air. This view has a long history,
with arguments for and against, impossible to cite here. But one may
remark that, on the one hand, this view does seem to conserve the
common sense assumption that it is the *picture* we are talking about,

the picture on the wall, and not just our own feelings and experiences. On the other hand, it is very difficult to think of aesthetic qualities existing or subsisting without anyone experiencing them. It is not difficult to construct a scientific theory of the *physical* object existing apart from anyone perceiving it; it is much more difficult to conceive of an *aesthetic* object existing apart from anyone's presence or even thoughts or feelings about it. Partly because of this seeming dependence upon a perceiving subject, and partly because aesthetic judgments about the picture can vary so much between even discriminating experts, some philosophers (and again it has a long history) have argued for an exactly opposite position, that aesthetic judgments are purely subjective, that beauty is indeed (in some metaphorical sense) 'in the eye of the beholder'. You and I (even if 'experts'—whatever that might mean on this particular supposition) each have our own 'tastes', and 'there's no arguing about tastes'. Among many things that can be said about this view is that we do, in fact, argue very much about matters of taste in art (as we do not argue about having or not having a taste for olives). If aesthetic judgment is purely a matter of personal 'taste', is it really a judgment at all? And if one view is as good as another, would there be any point in aesthetic 'education'?

Personally I hold that either of the extreme views is untenable for many reasons which cannot be given here; and I now propose to suggest an alternative view (some form of which is pretty widely held), which includes the positive truth in each of the extremes.

Take the picture on the wall again. In an aesthetic situation there are a number of factors. There is the physical picture, the physical object occupying space in the gallery, going on existing (presumably) when the gallery is empty. One part of this physical object is its physical surface, of paint arranged at one time purposively by the painter. Now there are the spectators looking at the picture, you and I, looking at it in a very special way. It is not at all the way in which the employee of the gallery looks at it when he has to carry it off, or a tycoon thinking of its possible auction value, or a scientist examining the pigment, or even an art-historian thinking of how it came about or its place in history. We are looking at it 'aesthetically', at its forms, the way in which the relations of its parts, its colours and shapes, perhaps depicting a subject, are built up into a whole, and we are looking at it as a whole. But whether the picture is representative or not, the central part of aesthetic attention is its

concern with the forms presented to perception, so in a sense with the forms 'for their own sake', and for a peculiar and unique sort of meaningfulness which they seem to embody. To take up this position is to take up what is I think quite properly described as the 'aesthetic attitude'. This concept has been criticized; it seems to me indispensable—so long as it is recognized that although we *can* 'take up' this attitude by consciously giving it special attention, it need not come about in this way; aesthetic attention is often 'caught' as well as 'taken up', say by a bird's flight or a shell or a piece of knotted wood.

The description of the aesthetic situation so far has taken account of both factors, objective and subjective, too exclusively emphasized in the two extreme views mentioned. But it contains something more. On the one hand there is the physical picture with its physical surface which we attend to. We attend to it, and in the way which is called aesthetic, and the aesthetic quality of the picture would not exist except in relation to the body-and-mind of someone perceiving it, the original painter or the spectator. The physical picture is the physical basis without which there would not be this particular aesthetic experience. It is through the appearing-of-the-physical-object-to-a-spectator-looking-at-it-in-a-certain-way that the aesthetic quality comes into being. This, which may now be called 'the aesthetic object', is neither the physical object (though the physical object is a necessary condition) nor a merely subjective experience, but what may be called, in a technical term, a 'phenomenal' object of a certain kind, the aesthetic kind. The whole perceptual world is an appearing or phenomenal world—not electrons, atoms, molecules, but a shaped, coloured, sounding world apprehended in perspective. The aesthetic object is a selection from that phenomenal world, viewed in a certain way, the aesthetic. It is not something lying about like a stone or a picture in a pile, but a phenomenon related to a perceiving subject.

One's views, I said, about this very general question of the aesthetic object, affect a great many things one thinks in the field of aesthetics. There are several more particular questions which teachers of art and aesthetic education will certainly come across in their work, and particularly in their discussions about art. I shall try to indicate briefly what they are, subject to the inevitable oversimplifications which short statements must entail.

One question, which usually arises very early, is about the relation

of subject-matter to form. This is a traditional battleground, particularly when the visual arts are being discussed, though it arises too with other arts such as literature, drama, and some music. Let us take visual representative art as typical because it clearly has a subject-matter—painting and sculpture have, throughout the history of art, been greatly valued because of the subjects which they represented. Art critics and historians of the past have laid great stress on the stories which pictures tell, their moral and religious content, their didactic function and influence. The Christian painters of the past regarded themselves as craftsmen skilfully depicting the subjects of their commissions. (This idea of themselves is of course no reflection on their gifts as artists.) Harold Osborne (1970, 241–9) gives a number of examples of the writings of critics of the eighteenth and nineteenth centuries on the subjects of pictures—some so remote from our contemporary attitudes that they have to be read to be believed—Diderot on Greuze's 'Girl weeping for a dead bird', John Brown on Wilkie's 'Distraining for the Rent', Ruskin on Landseer's 'Old Shepherd's Chief-mourner'. A violent reaction from this was of course bound to come, and did. Beginning with 'Art for Art's sake' of the nineties, Whistler with his picture-titles—'Symphony', 'Nocturne' and so on—it came out most explicitly in the early nineteen-hundreds. The reaction of Bell and Fry was against 'literary' painting, the emphasis on *form* as against subject-matter—form containing in it nothing brought from 'life'—'no knowledge of its ideas and affairs, no familiarity with its emotions' (Bell). Nothing indeed was relevant except 'a sense of form and colour and knowledge of three-dimensional space'. Roger Fry, though holding the same sort of view, was much more guarded and sceptical. But the whole movement of abstract art, from Kandinsky on, emphasizes form as against subject-matter.

The different views of artists and critics here are, of course, a topic for aesthetics. There is, as usual, truth on both sides. In representative art, the subject-matter factor cannot be ignored; and it affects the very form itself. I shall return to this. On the other hand, the exclusive emphasis on subject-matter misses the whole point of its being art. Art is not just a mirror of anything. In representative art subject-matter is something apprehended by the artist from a point of view, in a perspective in which the artist, his body-and-mind active, with his background, temperament, interests,

outlook and tradition, works in a particular material medium which both has its limitations and offers its own special imaginative opportunities. Something new comes into being.

Representative art has subject-matter, certainly. But we must push further. What is *meant* by 'subject-matter'? We often assume this to be a simple question; in fact, it is very complex. 'Subject-matter' is highly ambiguous. What, for instance, is the subject-matter of Cézanne's 'Le Lac d'Annecy'? In one obvious sense, it is the lake itself, backed by mountains, with a castle in the distance. But, from another point of view, the subject of the *picture* cannot be the actual lake itself, the water with its molecular constitution which could drown a man. The existing lake which Cézanne saw may be the subject-matter which started him off (or one of the things which started him off), an important condition, but hardly much more. In one sense it is a lake that anyone can see if they go there. In another, more important, sense, it was the lake as *Cézanne* saw it. Even that is not simple; it could be the lake as he saw it first, or (getting more and more particular) as he looked at it again and again, selectively noticing its forms and colours, and further, as a painter, beginning to see it as a subject for painting, and seeing it in terms of his medium of oil paint. Then, when he began to paint—since painting for the artist is a journey with a starting point and an end perhaps only dimly seen—he began to 'see' different things, seeing more and more as the painting progressed, a seeing partly determined by the medium, partly by the forms on the canvas already there. And so on. The completion of the painting would be the end of a journey of discovery; something new in the world had been both discovered and genuinely created, a fresh concretion literally embodied in the phenomenal aesthetic object. So the 'subject-matter' is now transformed, transfigured into something which can fairly be called the *content* of the picture, which we, as individual spectators, have to try to see as well as we can and in our own ways through attention and direct study. We become, as we learn to see it with aesthetic discrimination, virtual-artists-after-the-artist. We see not *through* a 'transparent' picture to the Lake of Annecy; we look, as it were, *into* an image in a very peculiar sort of lens, or, in another metaphor, at a content—embodied in a medium which is opaque. Unless this is understood, we shall, when we have conversations about the picture's 'subject-matter', be talking at cross purposes. So, analysis in aesthetics can be of great importance

in art education. 'The "subject" of the painting? Well, what exactly do you *mean* by "subject"?' And this applies to different arts: where is the 'subject', where the 'content' of the 'Ode on Immortality', 'In Memoriam', *Hamlet*, 'Guernica' . . . ? How much, and how little, can the précis of a poem tell you of the full meaning of the poem itself? Is not the meaning only *in* the sounding poem, read with sensitive aesthetic understanding?

I have been saying in effect that in the *formed* medium, subject-matter is transmuted into embodied content. Form is an important determinant of content. This can be said as against those who overstress 'subject-matter'. But exactly the opposite can now be said as against extreme one-sided formalists like Clive Bell. In representative art you cannot even apprehend the *form* with aesthetic understanding if you rule out the influence of subject-matter. On Bell's theory, you would literally be unable to have proper aesthetic understanding of the form of nearly all traditional art. (This will be argued for in a moment.)

But first (and pushing again) what is 'form'? The word can mean a number of things. One is literal shape in space, for example the shape of a circle or a cube. Or it can be a 'shape' in time, for instance the swoop of a hawk or a passage in music. Again, in art there are standard traditional forms, such as the novel, the play, the poem or, more particularly, the sonnet or the triolet, the sonata, the fugue, the symphony. These are all generalized forms and not in themselves aesthetic: they might be called forms of art, but not the form of art. When we come to speak of the form of a work of art, although because in speaking we always have to use general words, we are in the end referring to something which is *individual*. Susanne Langer puts it well (1957, 15 and 25–6): the abstract sense of form is 'structure, articulation, a whole resulting from the relation of mutually dependent factors, or more precisely, the way in which the whole is put together'. But artistic forms 'are not abstractable from the works that exhibit them. . . . To the total effect that is an artistic form, the colour matters, the thickness of lines matters, and the appearance of texture and weight.' And now, we may add, the content matters: in art which is representative, and in all art, form is not separable from content.

Attention to form, the form of content, or content-as-formed, is vitally essential in any aesthetic apprehension of art. It is paramount in abstract art and in pure music, but it is essential in representative

art too. It may be remarked in passing that although abstract art, such as geometrical painting, or pure music, has no 'subject-matter' outside itself as we have seen representative art to have, it is not without *content*. (Pure music, for instance, however formal, is never 'pure mathematics'.) But what content is here, and how its nature is to be analysed, is a profoundly difficult question, too large to enter upon here (see Reid, 1969, especially chs VI–X).

Having said a word on form and the importance of attention to form both in representative and abstract art, let me return for a moment to the fallacy typified by Bell, that subject-matter, anything in life outside art, is of no importance even for representative art. What alone is necessary, he says, is attention to form. It is of some importance to look at this here, for the fallacy is apt to recur.

Subject-matter in painting (for example) has indeed an essential part to play in the sheer perception of form. Harold Osborne (1970, 139 *et seq.*) makes this very clear. He points out that if we look at a picture which depicts an object, the depicted object will manifest visual properties different from those of the physical picture and perhaps conflicting with them. He writes (1970, 145–6):

> The representational significance of the forms exerts a dual
> influence, both optical and psychological, on their character as
> forms and these various ways of seeing fuse and coexist.
> An oval has its own character as form. But an oval in a
> representational picture may represent a perspective view of a
> circular wheel and what we see is a circular wheel. Yet the
> oval does not wholly lose its intrinsic character in the abstract
> organisation of forms which is the picture. In ordinary real-
> life perception we see a world of things with more or less
> determinate shapes separated by indeterminate spaces (we see
> the things but don't see the spaces between them). In looking
> at a painting as an organisation of forms the spaces between
> the figures are as important as the shapes of the figures.
> Yet we none the less simultaneously (and even inconsistently)
> see the painting as a representation of things separated by
> indeterminate spaces. This is an optical influence of
> representational significance on form. There is also a psycho-
> logical influence deriving from the *interest* of the representa-
> tional significance. When any pictorial element—any shape,
> line or path of colour—has representational import, its

psychological impact is changed and therefore the prominence
and insistence it has on the whole system of formal relations
which build up the structural configuration which is the work
of art are different from what they would be if the same
elements carried no suggestion of representation. An oval
which represents a face or a breast makes a different impact
in the formal structure from an oval which is just an oval.
A circle which represents a runaway chariot wheel or one which
represents a mirror has a different dynamic force in the system
of abstract relations from a circle which is no more than a
casual space between figures. In these ways representation
has its influence on formal structure. Aesthetic appreciation
combines several levels and modes of looking which fuse and
interact, while each retains a relative independence. A person
who has not seen a picture as an abstract has not seen it as a
picture; but one who sees a representational picture only as
an abstract has missed much of its aesthetic content.

All this seems to me a very clear refutation of any one-sided
formalism. If I may put it in my own way: in representative art not
only is subject-matter transfigured in embodiment into a new
thing, but the opposite happens. Subject-matter has a literally *trans-
figuring* effect on the aesthetic apprehension of form. The content is
(in part) derived from the subject-matter, and it is both true that, in
embodiment, the content is the formed-content, and the form is the
form of the content.

We must now notice—and it cannot be more than that—a
whole cluster of related questions, questions which constantly
come up in the teaching/discussion of art. They concern 'pleasure',
'feeling', 'emotion', 'enjoyment', 'expression'. We all talk about
them, usually very loosely. Even serious philosophers sometimes
say that art is justified simply for the pleasure it gives us. We go to
the theatre or listen to music 'for pleasure'. We make, or attend, to
art 'because we like it'. We say that art is justified because 'it
satisfies feeling'. Or art 'expresses the artist's feelings and emotions'.
It releases his emotions and, through art's communication, ours.
And so on.

I can only comment briefly and dogmatically on these turns of
speech. The understanding of *feeling*, I think, is of the utmost
importance not only for aesthetics and psychology, but for wider

theory of knowledge. It is almost universally misunderstood. The lack of almost any systematic study of the nature of feeling has had lamentable effects on the study of the educational curriculum. The place of factual and conceptual knowledge is well recognized. But the function of feeling in the development of knowledge and understanding in a wide sense has been largely ignored. Feeling (and emotion, which is too often lumped together indiscriminatingly with feeling) is consigned to the private and subjective. Against this it can be argued effectively that feeling has a crucial function to perform in coming to know and understand: it has a *cognitive* function, and is not a mere subjective happening. This stands out very clearly in the development of *aesthetic* understanding, but it has a far wider application than this. But where can we find this acknowledged? With the notable exception of Susanne Langer's writings, hardly anywhere in psychology, philosophy of mind, or educational theory. Unfortunately I cannot develop this general theme here: I can only emphasize that in aesthetic percipience it has an indispensable place. The understanding that feeling has a cognitive function has great importance for aesthetic education. Because feeling has been relegated to the 'subjective' compartment, and art is supposed to be concerned with feelings and emotions, the arts have been hived off as subjective phenomena. Science, history and the rest have to do, it is thought, with the real world and are departments of serious knowledge. Not so the arts, it is implied. The arts satisfy feeling and emotion, but they are not serious academic disciplines, though perhaps desirable as a relaxation for off-periods—or for weaker 'non-academic' streams! I have attempted to open a discussion of feeling, and particularly of feeling as cognitive in 'Feeling and Understanding' (Smith (ed.), 1970, ch. 3). There is a shorter discussion, particularly applied to music and other arts, in *Meaning in the Arts* (Reid, 1969, ch. 8, 'Feeling, Emotion and Music').

To say that we pursue art 'for pleasure' is an oblique and highly misleading way of stating something which is true—that we do not do it for the sake of anything else, for practical purposes, for increase of knowledge in the ordinary sense, etc. But if it means that we simply do it in order to get 'pleasure', it is a pretentiously empty statement as all such pleasure-statements are. It sounds like an important affirmation, but it tells us almost less than nothing, and it puts the cart before the horse. It is true that as self-conscious

human beings able to form concepts, we can abstract from various experiences an idea of something which we call 'pleasure', and that we can pursue certain courses of action for the sake of the pleasure they bring; the idea of pleasure to be gained can be the 'teleological cause' of our actions as sophisticated humans. But the causes of pleasure are infinitely various. Eating, drinking (water or other liquids), sex, exercise, sunbathing, being entertained . . . enjoying nature or art aesthetically . . . —all these and many more things can bring 'pleasure'—but the concrete characters of these various activities and experiences are so varied, and the 'pleasures' concretely regarded as various as the activities, that to say that we seek them *because* of the pleasure they yield is the most vapid of all possible statements. To say it is to reify an abstraction. 'Pleasure' is not a *thing* to be sought after. Pleasantness when it happens in any particular case partakes of the individual character of the experience or activity. It is expressed better as an adjective (or maybe an adverb) than as a noun. Having the active experience of healthy exercise, or drinking, or sex, or art, is *pleasant* (or if, as with genuine love, or the aesthetic experience of a great work of art, the word 'pleasant' is too slight or too banal, we could use technical language and say 'it is positively toned on a hedonic scale!'), and the pleasantness in each case is not only logically posterior to the active experience, but is qualified by the *total* character of the particular experience, partaking of that character. So, when we are behaving healthily and naturally, and not as over-sophisticated hedonists or pleasure-seekers, we eat and drink to fulfil bodily needs, and though when these are being satisfied our normal experience is pleasant (if we are hungry or thirsty) it is quite artificial to say we eat and drink to 'get pleasure'. Again (taking one of the commonest 'for pleasure' examples), although sexual coition can be intensely pleasurable, it is the natural drive (operating in different ways) of male and female to be sexually joined together which is prior to, and the condition of, the pleasure. Moreover, the couple have to do *that* particular thing together to get *that* particular pleasure, and the pleasure is unique not only to that kind of activity, but to the persons concerned and to each occasion. The same general arguments can also be applied exactly to the arts and art experience. It is only through intensely active attention to the aesthetically meaningful forms of art that aesthetic 'pleasure' arises —though here and elsewhere the word 'pleasure' is far too general

and thin. What of *Lear* or 'Guernica' or *Death in Venice?* Indeed, the very poverty of any general language, even of robuster words like 'enjoyment', 'satisfaction', is a vindication of the main point that I am putting forward (but cannot develop) namely that the import of 'feeling' can only be given content by referring to the concrete and individual activities in which it occurs. To feel may, grammatically, be an intransitive verb. But epistemologically it is transitive. It always has a content, as for example, when we feel our own bodily and mental states, and often, through our bodies and minds, an object (as when we 'feel' the sunshine, or the suffering of another person, or the drift of an argument, or the rightness of a course of action or the pattern of a picture or a passage in music . . .). Always the character of a feeling when it actually happens is the feeling *of* the whole concreteness of the occasion which gives rise to it. This is so whether its tone be positive (vaguely named 'pleasant') or negative ('unpleasant', 'painful', etc.). All this, I hope, suggests the empty silliness of saying that art is just for 'pleasure' or because we 'like' it.

When I have been arguing is not a digression: it has momentous importance for aesthetics and aesthetic education. If art were just for 'pleasure', there could not only be no justification for art education; there would be no need for it. Anything would do. If pleasure is the aim, then, for some people, 'pushpin (or bingo) is as good as poetry', and poetry would have no stronger claim for a place in the curriculum than pushpin or bingo. But if it is the *quality of the pursuit*, its depth, its potential for human expansion and enrichment, the quality which, as we said, is logically prior to any 'pleasure' that may enter into it—then the question of justification (and, in particular, educational justification) does open up. A game of pure chance—which may not even require any study of 'form', as in horse-racing—begins and ends with the game; the pleasure it yields is an evanescent excitement, refreshing temporarily perhaps and then gone. But in fields which can make serious claims for exploration and study—science, history, philosophy, literature and the arts—it is the nature of the study itself, and its potentiality for the enlargement of understanding and experience which is the central question. These are all 'disciplines', and it is only through the attention to the demands of the discipline with all the hard work which any major discipline entails, that its real value is discovered. And art, and the aesthetic enjoyment of art, is a strenuous lifelong

pursuit of illimitable human importance. It is the learning through art, the increase and growth of a unique kind of understanding, that matters supremely. The joy it can bring is immense; but if we put the pursuit of the feeling of joy (or 'pleasure') into the central focus, we thereby cease to attend to the discipline of the enterprise itself, and the characteristic and special joy of art ceases to exist. If we begin to attend to our own pleasures and emotions in making or contemplating art, we cease to be serious and are substituting for art a sentimental cult of ourselves-as-enjoying art which quickly evaporates because it is no longer the art itself which brings enjoyment. Even on the hedonist platform there is the old paradox: 'to get pleasure, forget it'.

The same general considerations apply to the related clichés that 'art expresses (and communicates) the artist's emotions'. If emotional states are (as I would argue) high degrees of the excitement of concrete 'feelings-of', then, once again, it is the nature and intention and value of the concrete activity which counts, not the excitement of emotion in itself. Indeed the ordinary uses of 'emotion' and 'emotional' bring out more clearly the danger of focus upon subjectivity. Art sometimes—not always—evokes intense emotion. If it does, it is dangerously easy to be diverted from attention to the art to emotionality, the enjoyment of our own emotions: this is aesthetic suicide.

Again, our former arguments about subject-matter and content apply here. Perhaps an artist does have 'emotions' which set him off—as subject-matter, say a landscape or an idea, may set him off—and he may have emotions when he is, say, painting. Painting may, in some limited sense, 'express' them. But, if we remember the Cézanne example, it is not his raw emotions, any more than raw subject-matter, which is shown in the completed work. It is content, a new creation, discovered through disciplined working in the medium, which is offered to us. And if *that* awakens feeling, perhaps emotion, in us, it is the feeling or emotion which is logically dependent upon the active apprehension of the form of the finished picture (or other work of art). It is the studied picture that counts, not the artist's emotions. I am afraid I have no space here to enter into another connected question, almost certain to arise in discussion with students, of what we mean when we apply feeling-words to the work of art itself—for example, 'the *music* is sad . . . gay, rapturous, contemplative . . .'. It has often been considered, by various

philosophers. (See Osborne, 1970, 75–89 and 269–71 or Reid, 1969, 101–10 and ch. X.)

I have been stressing the logical dependence of feeling (in art and elsewhere) upon the aims and activities and experiences *of* which it is the feeling, and that, as having a content, feeling is cognitive of its content. But feeling has also an active part to play in the making and in the sensitive discrimination of art. Feeling is a pioneer in art-making (and indeed in thinking also); the artist feels his way, pioneer-like, before he sees clearly or fully understands what he is doing. Feeling, too, is a pioneer in coming to the quality of art that is given, in a finished work or a score. Musical performance is a clear example of this. The musical performer is an artist who has to understand aesthetically the given music which he is playing. This depends in part on technical understanding and competence, ability to read the score, to play it, to study it analytically with the use of words covert or overt. But playing musically is more than all this. The performing musician must, his body and mind working together, *feel* the music, feel it through the feeling of his body-and-mind for the music. The qualities of tone, the varying volume of sound, the phrasing, the dynamic direction to the end of a phrase, the dynamics of the phrasing in relation to other phrasing and to the whole—all these and much more have to be cognitively *felt* as well as intellectually known, and felt through the mind-body organism in a way which is unique to art. This is cognitive feeling directed to the music itself. It must be aesthetically relevant; it is not a mode of self-indulgence. Without this feeling (which is quite different from having emotions about it) the musician simply cannot *know* his music; his performance will be mechanical and dead.

3 Aesthetics and aesthetic education

A great deal of what I have to say about aesthetic education follows directly upon the cognitive-feeling emphasis. But it is now time to look more closely and more specifically at the nature of aesthetic education.

I said in my book *Meaning in the Arts* (301–4) that the function of art education in liberal education is 'to develop discriminating apprehension and understanding of the arts'. That will do for a start, though here it might be better to substitute the wider term

'aesthetic' for 'arts'. Because the best works of art are the product of human creativity at its highest and most complex, development of the discriminating apprehension of the arts will always be a major part of aesthetic education. But the aesthetic, as we have said, is wider than the arts; the world of nature offers unlimited potentialities for aesthetic attention. Aesthetic education should develop increased awareness of the aesthetic everywhere. One more brief preliminary comment: the words 'discriminating apprehension and understanding' suggest an emphasis on the *contemplation* of works of art already made and given. This, for most people, is the main thing that they will learn through aesthetic education. But it must never be forgotten that appreciation and understanding of the aesthetic in art are gained in a very special way, and from the inside, by the devoted artist working in his medium (this also applies to a 'performing' art like music). I am not here concerned directly with practical art education. But I hold without reservation that practical experimental experience in the various media of the arts is of the greatest help in coming to understand and appreciate them, even if this does not always lead to much in the way of 'artistry'.

'Aesthetic education . . .' develops 'discriminating apprehension . . . intuitive understanding of complex aesthetic objects.' How do we interpret all this? What do we mean by 'intuitive'? Why do we call its development 'educational'?

The word 'intuition' is so sentimentally, abusively, and loosely used that I must begin by saying that by 'intuition' here I mean simply immediate apprehension of a complex as a whole. Ordinary perception is a good example of intuition. I look straight ahead, perceiving a very complex pattern all at once and as a whole. Another sort of example is the 'seeing' of the validity of an axiom. The emphasis is on immediacy, directness, singleness, wholeness. There is no suggestion here of the sometimes supposed infallibility, or even validity, of intuition. Possibly the intuition of an axiom is 'infallible'; a perceptual intuition certainly is not. I can perceive in a vague and hazy way, or what I immediately see may be an illusion. But in all intuition there is a very direct apprehension of a complex whole which is given or presented.

That an intuition takes place in time, and takes time to register, that sometimes, perhaps in some degree always, it is *seriatim*, is not incompatible with its immediacy, singleness, wholeness. The striking of three on a clock, the pattern of a short musical phrase,

certainly takes time to occur, yet the three and the musical phrase are intuitively apprehended in immediate single compass. This, together with the vagueness, of various degree, which I have admitted, is of great importance in understanding aesthetic education. The very centre of the aesthetic is the immediate intuition of an aesthetic object; without this we do not know what we are talking about. But when we encounter, say, a complex work of art for the first time (a picture or a poem or a symphony), our intuition of it may be very vague. We do apprehend a whole, but many of its parts are only foggily discerned, and many are missed altogether. How do we improve on this? Partly by looking, reading, listening . . . again and again. It takes time. This is true for everyone, artistic ignoramus or expert (though of course the expert apprehends much more on the first occasion). But partly also, and very importantly, through aesthetic *education*, education which, though it must always in the end be made relevant to aesthetic intuition, is a time-taking process which may at times stray far from it, for example, to history, to comparison of techniques, to formal analysis. Studies of such matters, if sensibly conducted, both broaden the scope of interest in the art being studied, and contribute to the enrichment of the intuitive apprehension of the art in question. Intuition is capable of infinite degrees of illumination, from a nearly blank stare to a complex intuitive perception of extreme acuity.

All this is, in part, why we call discriminating understanding of the arts, focused always in intuition but not confined to it, by the name of 'education' and 'educative'. Education, or to be an educated person, may require a great deal of *training* of various sorts. The performing musician has to acquire many techniques of performance, analysis, etc. The learning to appreciate art requires skill, power of analysis, information. But educated understanding, though it requires these and much more, is not identical with any of them or all put together. It is something which happens to, and occurs in and through, a mind-organism, and is only experienced directly there. This is particularly notable in the case of intuitive aesthetic understanding, and it is, unfortunately, one of the things which makes such understanding so impossible to measure and so difficult to assess (which makes money-supplying authorities sceptical about non-vocational art education). It is easier to test in written or oral examinations (though it is not easy) whether a student is becoming 'educated' in history or science, partly because

information and ability to analyse and synthesize can be more explicitly shown. We can to some extent judge of a person's aesthetic insights by what he says and writes, but since aesthetic insight is more exclusively intuitive, and not factual or discursive, it is much harder to assess. Only in the aesthetic itself is the aesthetic most fully discerned. That is why it is easier for an expert critic to judge of the educated musicality of a *performing* musician. But since this performance is in turn itself an art, it is a special case.

None of these difficulties cast doubt on the fact that there is such a thing as becoming aesthetically educated, becoming an aesthetically educated person (or at any rate becoming more of one), a condition both of depth and breadth, breadth, as I shall now try to show, in turn contributing to depth. What, briefly, are some of the factors making for this education?

Two opposite truths must be held together. One is that the aesthetic is uniquely distinctive, autonomous, self-contained, unified, exclusive of the extraneous, complete in itself. Aesthetic education begins, and has its central focus, here. On the other hand the aesthetic occurs in the context of human life, material conditions, experience, culture, ideas, history, etc. What is *inside* art as aesthetic depends on what is *outside* it. The arts depend on different material media, require different kinds of techniques, are influenced by what has happened historically both inside art and outside it—art movements, archaeological and other discoveries, religion, ideologies, social changes and influences, politics . . . And there are the assumptions of working artists, critics and ordinary people, which, as I have tried to show, are material for aesthetics. Aesthetic education entails some cognizance of these things. In the historical visual arts or in literature it is pretty obvious that one could not grasp intelligently what is 'inside' these arts without possession of some of the heritage of what is 'outside'; and this is true, though not quite so obviously, of the more abstract arts. On the other hand, unless the awareness of the many factors outside the aesthetic in art is properly assimilated and made relevant to the development of direct aesthetic insight, it can be so much dead wood. How does this aesthetic relevance come to be achieved?

Into all our awareness—perceptual, imaginative, conceptual, aesthetic—there enter countless influences, influences of what may (but need not) have been once fully conscious, but are now consciously forgotten, taken for granted, having become part of our

dispositions to attend and apprehend. We 'see' the world in per-spective as a coloured, resonant, three-dimensional continuum, a world of nameable things and relations—the ordinary world of adult perception and conception. We see it as such because of countless explorings, learnings, teachings, education—from babyhood on-wards. This common basis, *plus* much more, is presupposed in any aesthetic apprehension.

Everyone comes to the arts with all this ordinary equipment. We come, too, as individual persons—with certain temperaments, dispositions, gifts, with special personal associations which affect what is seen, with a particular cultural background in which the arts and the aesthetic may, or may not, have played a part, and perhaps with some, or little, experience of trying to work in some medium. On this basis, for organized aesthetic education to proceed there will have to be, on the one hand, open exposure to works of art of various kinds, and on the other, some initiation into their place in the historical cultural context, some learning about tech-niques, manners, styles. A certain attention will have to be given to what the critics have said, and at times, perhaps, to the analysis of concepts involved in the arts and in talk about them, i.e. aesthetics.

All these can be of importance, and at times each may be attended to focally. But none of them (except the direct exposure to the aesthetic) is in itself strictly aesthetic; or at least all of them include much which is not. Suppose, for instance, a pupil is learning about techniques in various media—tempera, transparent water colour, oil, collage; and about different artists' use of them—Giotto, Cotman, Cox, Van Gogh, Turner, Braque, Max Ernst. Or suppose he is studying style, or the history of art. He may acquire a great deal of information, and it may contribute to his education. But having information is not in itself aesthetic percipience. In order that these things shall become truly a part of aesthetic education, they must, as we have said, become assimilated so that the pupil comes to perceive, to see differently and with new understanding what was before seen vaguely and half blindly.

Michael Polanyi (1967, *passim*) has developed, in many of his writings, what he has called 'the tacit dimension of knowing'. All thought, he holds, 'contains components of which we are sub-sidiarily aware in the focal content of our thinking, and thought dwells in its subsidiaries, as if they were parts of our body'. 'Thinking . . . invariably contains its subsidiary roots.' I have

7

borrowed from Polanyi in various writings. The best application of his ideas to aesthetic understanding which I know is Harry S. Broudy's paper 'Tacit Knowledge and Aesthetic Education' (in Smith (ed.), 1970, 77–106). He points out that the learnings (some of which I have mentioned) that constitute aesthetic education can be construed as the subsidiary elements which bear on the focal experience of the work of art. To replicate, reproduce such learnings (e.g. information about history of art, or about techniques) is of minor importance. What we have to do is to interpret them. We do not want recapitulation but to use what we have learned to see differently. What Polanyi teaches is that there are two kinds of knowing which enter jointly into any act of knowing: (a) by attending to it in the way in which we attend to an entity as a whole; and (b) knowing a thing by relying on our awareness of it for the purpose of attending to an entity to which it contributes. This is 'tacit' knowledge. For example, in looking into a stereoscope, we see a single three-dimensional image. We have to *rely* on the two-dimensional images to see the three-dimensional stereoscopic one. We have to rely on them; we must not attend to them. Focal attention to both sets at the same time is impossible. A blind man (or anyone in the dark), feeling his way along by the point of a stick, is aware of the point of the stick as though it were an extension of his body. If he were aware of all the subsidiary awarenesses which are the condition of his being able to feel his way, he could not get along. Or if a piano player became aware of his subsidiary knowledge in playing, he could not play. He would be like the centipede, 'considering how to run'. All this applies directly to the various things, relevant but not in themselves aesthetic, which we have to learn in the complex, 'aesthetic education'. Some of them, as I said, we have learned as part of our common growing up; we could not perceive at all without them. Assuming only these to be there, we may certainly get *some* impression of, say, a picture or a piece of music. If we have natural aesthetic sensitiveness the impression may be very important for us. But we have to learn a great many other things too. Unless we learn these other things, or some of them, and unless we learn to *dwell* in them (an important word for Polanyi), to rely on them, our aesthetic understanding will remain rudimentary. Becoming aesthetically educated is learning to use our tacit knowledge by dwelling in it in our focal attention.

In all this, aesthetics, at the right season and moment, can play a

part. Aesthetics, we know, is a conceptual study, a discipline on its own, and as a second (or even third) order activity its direct aim is intellectual clarification and understanding, not subsidiary to education of aesthetic percipience. At the wrong time it could get in the way and be a distraction from what is central, attention to the aesthetic object itself. It might even, if misused, be destructive. On the other hand, since aesthetics, in the way we described, unearths assumptions often false, and subjects them to criticism and clarification, its effects, become tacit, can certainly be importantly influential in the approach to the arts, and at different stages of discriminative learning. Perhaps it is particularly needed in reflecting on contemporary arts, where all sorts of interesting experiments are going on (some, as is the way with experiment, successful, others failures), and where we are being bombarded, almost weekly, from critics and artists, by all sorts of theories expressing often unexamined assumptions. As with art experiments, some of these theories are interesting and important, others very crude and muddled. At the right time, as I have said, there is a great need for the aesthetically sensitive philosopher's criticism and clarification.

But above all, there is needed, for a balanced view of liberal education, a far better understanding of the kinds of *insight* which artistic creation and aesthetic understanding can bring. It is an ongoing exploration into meaning which is unique and very different from the explorations into other kinds of knowledge clearly recognized in the curriculum. In the aesthetic symbol the meaning is drawn from the breadth, depth and height of human experience, is gathered into the aesthetic object and transformed through its dialogue with the medium into new significance, encountered face to face. It is not an insight of the 'head' or intellect only, but of the total feeling mind-body organism in a direct imaginative adventure into meaning which can be encountered in no other way. We become aware as never before, and once we have become aware, new worlds begin to open out. This vital aspect of any full human culture needs to be far more seriously studied than it has been, and its recognition could do much to rescue aesthetic education from the ignominy from which it far too often suffers even in some of the 'best' of our academies of learning.

References

Langer, Susanne K. (1957), *Problems of Art*, London: Routledge & Kegan Paul.
Osborne, Harold (1970), *The Art of Appreciation*, London: Oxford University Press.
Polanyi, Michael (1967), *The Tacit Dimension*, London: Routledge & Kegan Paul.
Reid, Louis Arnaud (1969), *Meaning in the Arts*, London: Allen & Unwin and New York: Humanities Press.
Smith, Ralph A. (ed.) (1970), *Aesthetic Concepts and Education*, Urbana, Ill.: University of Illinois Press.
Valentine, C. W. (1962), *An Experimental Psychology of Beauty*, London: Methuen.

Further reading

Beardsley, Monroe C. (1958), *Aesthetics: Problems in the Philosophy of Criticism*, New York: Harcourt Brace.
Collingwood, R. G. (1938), *Principles of Art*, London: Oxford University Press.
Elton, W. (ed.) (1959), *Essays in Aesthetics and Language*, Oxford: Blackwell.
Hook, S. (ed.) (1964), *Art and Philosophy*, New York: New York University Press.
Hospers, John (ed.) (1969), *Introductory Readings in Aesthetics*, London: Collier–Macmillan and New York: Free Press.
Margolis, J. (ed.) (1962), *Philosophy looks at the Arts*, New York: Scribner.
Margolis, J. (1965), *The Language of Art and Art Criticism*, Detroit: Wayne State University for University of Cincinnati.
Osborne, Harold (ed.) (1968), *Aesthetics in the Modern World*, London: Thames & Hudson.
Osborne, Harold (1970), *The Art of Appreciation*, London: Oxford University Press.
Reid, Louis Arnaud (1969), *Meaning in the Arts*, London: Allen & Unwin and New York: Humanities Press.
Righter, W. (1963), *Logic and Criticism*, London: Routledge & Kegan Paul.
Smith, Ralph A. (ed.) (1966), *Aesthetics and Criticism in Art Education*, Chicago and London: Rand McNally.
Smith, Ralph A. (ed.) (1970), *Aesthetic Concepts and Education*, Urbana, Ill.: University of Illinois Press.
Sparshott, F. E. (1963), *The Structure of Aesthetics*, London: Routledge & Kegan Paul and Toronto: Toronto University Press.
Stolnitz, Jerome (1960), *Aesthetics and the Philosophy of Art Criticism*, Boston: Houghton Mifflin.
The following journals contain articles on aesthetics:
British Journal of Aesthetics
Journal of Aesthetics and Art Criticism
Journal of Aesthetic Education
Leonardo

8 Teaching art history: a methodological reappraisal

Sonia Rouve

I

We live in history-haunted days. The mass media daily hurl at us the small change of history. Ideologies entice us to interpret this gale of sensational information as litanies for the past, hymns of the present or marching songs towards the future. But, for all this infatuation with history, we ignore history. Is it really a dispassionate record of 'what really happened' or is it a torrent of accidental events, which only the observer can canalize into meaningful sequels? Carried along by the imperious stream of history, the flotsam called mankind seldom questions the nature or the direction of the current. But, whatever the answer, grave doubts gather over the tacit implications and overt procedures of traditional history. And, inevitably, they cast their shadow on art history, which is but a chip off the old historical block. In the eyes of many, art history is discredited. The dissatisfaction in schools and colleges, and the cries for the exclusion of art historical studies from their curricula may well have been unduly vociferous and insufficiently substantiated. They are nonetheless symptoms of an educational malaise calling for an accurate diagnosis and, if possible, a prompt cure. But no pertinent diagnosis and no practical cure are conceivable without a preliminary theoretical re-examination of some problems directly or indirectly affecting the state of art history in educational establishments.

Outbreaks of protest against art history are not altogether incomprehensible in our era of vertiginous consumption and frantic obsolescence of the work of art. It seems impossible to insert a sense of permanence in a world yielding to the cult of the ephemeral. If nothing is meant to last, history itself cannot survive. It is clear that teachers professing pious respect for time-honoured values

founded on aesthetic stability will be easily silenced by any panegyric of built-in redundancy. Yet, if differently brought up, they should nevertheless be capable not only of facing, but also of using this nihilistic upsurge to add new vigour to the methodological approach to art history. Neither nerve-rending happenings nor destructive fancies should raise unsurmountable obstacles along the trail blazed by such educational dialecticians. If their judgments rest on a dynamic fluidity of evaluation, they should be able to make positive currency out of negative-seeming situations. In due course, I shall put forward the idea that it is advisable to bring together in a unified pedagogical procedure such apparently incompatible extremes as art and anti-art and, therefore, art history and anti-art history. At this stage, however, I would like to point out that the aversion to conventional art history may also stem not from a worship of transience but from a deep belief in the universal validity of art: hence from an unreplenished desire for rigorous scientific precision, akin to that aimed at in the natural sciences. Such believers in verifiable objectivity are by no means less depressed by the present state of affairs in art history. But unlike the partisans of impermanence for whom art history is out of the question, objectivists anxiously question it. Is scientific rigour incompatible with art history? Can we accept the tenets of the 'science of art', born in Germany around the turn of the century and belatedly naturalized in the United States where, we are told (Kleinbauer, 1971, 3), 'art history is non-philosophical'? But is not even such allegedly impersonal *Kunstwissenschaft* the outcome of a set of personally-held philosophical views? If this should be so, must we not deduce that any attempt to diagnose the ailing art history must unfold concurrently with a closer scrutiny of the philosophical foundations on which it is erected? And would not methods of tuition bear the stamp of this philosophical motivation? Scientific objectivity recedes further and further, shrouded in philosophical subjectivity.

And indeed, concepts central to the substance of art history and to the methods regulating its exposition in the classroom differ considerably when teachers (consciously or not) construct their courses according to the aim-orientated prescripts of Hegel or of 'that heretic Hegelian, Marx the materialist', or structure them around Popper's assertion (1957, 449–63) that 'each generation has the right to look upon and interpret history in its own way', thus

'giving a meaning to history which, in itself, has no meaning'. It will not do to object that art historians are not philosophers and should be left outside such philosophical quarrels: whether they realize it or not, they are in the position of Molière's character who spoke prose all his life—and never knew it. All teachers of art history are crypto-philosophers of history. It could hardly be otherwise: contrasting philosophical views inevitably crystallize in contradictory methods of teaching art history. The aim of this article is simply to discover which one of them is best suited to the present-day situation. But such selection cannot be made without an initial glance, however cursory, at the philosophy of history in connection with the theoretical approach to the teaching of art history and its practical consequences.

2

We are all prone to proclaim that art history is part and parcel of a cultural legacy into which teachers are supposed to initiate their pupils. But the rites of this initiation seem to have got out of hand—hence the constant contradictions which disturb the student and undermine the subject matter. This is nowhere more evident than in the unfulfilled promises of the so-called 'objective' art history. Pupils expect factual knowledge—true, dispassionate, unsoiled by personal whims. They receive value judgments, disguised as universal scientific truths. What is worse, such value judgments are often contiguous but contradictory: thus the same manual considers the 'altering of normal proportions' both negatively as 'an error in realism' and positively as 'a vehicle for expression' (Upjohn *et al.*, 1949, 54 and 204). The authors have crossed two, or more, philosophical lines. This is the most common shortcoming of supposedly 'objective' courses of art history. Descriptive endeavours are constantly sapped by prescriptive evaluations. Subjective value judgments and philosophical terms used out of context are abundantly scattered—by ignorance or inadvertence—across the pages of books and even dictionaries, said to be the acme of scientific objectivity. Of course, such recourse to aesthetic value judgments is, in itself, unimpeachable. I shall submit later on that the abolition of the demarcation line between some sort of aesthetic appreciation and the cognitive corpus of art history is to be recommended—but only in a completely different epistemological and pedagogical

ambit. But under no circumstances must such individual apprecia-
tive propositions be smuggled into expositions alleged to revere
objectivity and to demonstrate that art history 'is a science, no less
and no more'.

The appetite for an art history that would be a thoroughbred
science seems more likely to be satisfied by another class of erudites
who consciously restrict their studies to narrowly framed subjects.
These are indeed so limited and so emotively sterilized that they
afford a glimmer of hope that they will stifle all fancies and keep
alive only the 'facts'. Such conscious refuge in small tracts of the
vast domain of art often tempts teachers, unhappy with the clashing
opinions found in confused compilations, and still looking for guid-
ing lights to illuminate their tutorial practice—for, in an educational
situation, we are duty bound to consider history above all as
'practical history' (Perry, 1966, 35). Once again, they will be
disappointed—if not by the tenor, then by the span of the inquiries
and the outlook revealed in that span. Even when purporting to
embrace broader themes with profitable educational reverberations,
such monographs and micro-studies prove deceptive in a tutorial
climate. For instance Blunt's *Artistic Theory in Italy 1450–1600*
(1940) does not even attempt to recall the theories of the Middle
Ages and hardly even mentions the 'first writers of the Early
Renaissance, though in some ways they foreshadow theories which
later become of importance'. This typical act of faith in strict
specialization is reinforced by Blunt's declaration added to the
second edition of his successful book (1956):

> Now I should not dare to write such a book at all. The
> capacity to make broad generalizations, to concentrate a number
> of ideas into a small compass in the hope that they will
> convey more of truth than of falsehood, is the result either of
> the rashness of youth or the wisdom of age. In the intervening
> period caution takes control.

To such caution (or to the unspoken reverence for Warburg's
dictum that 'God hides in details') we owe a number of self-
contained exhaustive explorations of micro-subjects. However
erudite, such detail-centred art history offers scant help to educa-
tionists, particularly if they work in secondary schools or lead non-
specialist studies in colleges and universities. Such minutely
apportioned interests are widely revered: even a relatively recent

anthology of *Modern Perspectives in Western Art History* (Klein-bauer, 1971, 37–105) reprints but similarly restricted and at times esoteric papers—in spite of the editor's impressive knowledge of the intricate ramifications of truly modern art historical methods and their respective philosophical ancestries. The reasons for this prevailing cult of some unattainable objectivity are to be found in the persistent echo of the last century's scientific creeds and in the ensuing methodological confusion between the aims of the art historian as a researcher and the aims of the art historian as a teacher. I shall therefore examine this equivocation in the light of the specific teacher-pupil relationship.

3

Unchallenged tradition compels teachers of art history to transplant research-favouring procedures on to classroom situations. Small wonder if rejections are frequent and final. Researchers concentrate greater and greater attention on smaller and smaller fields of investi-gation. Of course, such minutious explorations of recondite subjects are not to be brushed aside out of hand. Far from it: they usually harbour a wealth of intrinsic information. Though not exactly cornerstones, they can be the brick and mortar of art history. But what the practising teacher needs as reliable bearings is a survey of the whole building. Better still, an aerial view. Teachers crave for general ideas; researchers shun them.

In any but the highest and most elitist circumstances, the teacher may ignore the contractual covenants between Benozzo Gozzoli or Gentile da Fabriano and the Medicis, but he must have a precise idea of the Florentine hue in the Renaissance rainbow. He may be unaware of the managerial gifts of Abbot Suger of St Denis, but not of the salient features of Gothic architecture. In this quest for illuminating overall views, researchers and teachers part company.

Blunt has clearly stated the methodological creed of the re-searcher: rejection of broad generalizations and refusal to concen-trate a number of ideas into a small compass. The creed of the teacher is diametrically opposed: he thrives on broad generalizations and strives to distill a number of ideas into a small compass, in the hope that they will convey more of truth than of falsehood. This contrast is best accounted for by the differing manners in which researchers and teachers relate to art history. The former establish a

7 *

direct bipartite relation between the researching individual and the object of his research. Art history becomes thus the shortest line linking these two points. But teachers are necessarily involved in a tripartite relation: the teaching individual (1) and the object which is examined (2) are now connected with the pupil (3) at whom the teaching is directed. *Tête-à-tête* confrontations with art historical items, characteristic of the researcher operating in splendid isolation, give way in the classroom to a structured process of mediation. Researchers intending to teach must cease to be self-exiled hermits and become 'educational middlemen'. The straight line of research must break into the triangle of education.

The introduction of this third party—the pupil—in art historical considerations will henceforth colour our disquisitions. But already at this stage I must stress that traditional art historical methodology proves insufficient precisely in the context of such pedagogical mediation. Often disconcerting because of its philosophical incoherence, disturbing because of its questionable objectivity, distressing because of its excessive fragmentation, art history is obviously in a critical state, at least in the eyes of the educationist.

With this statement we seem to have reached rock bottom. Therefore we have no alternative but to brace ourselves for a new ascent. To do so, we must first recall the close connection between history and art history and remember that the unsatisfactory state of art historical methodology is a marginal result of the clashing cross-currents in present-day historiography. But while unperturbed art historians, with a few notable exceptions, still seem to be drawing on some inexhaustible fund of methodological certainties, historians are becoming aware of the dilemma bedevilling their methods.

4

Meyerhoff writes (1959, 16):

> One horn of the dilemma reminded the historian that he must tell the truth and nothing but the truth, that personal integrity, impartiality and objectivity are the marks of dignity and the standards of ethics in any intellectual discipline. . . . The other horn of the dilemma reminded the historian of what he would rather forget: namely, that this ideal may be unattainable; that, upon close inspection, history sets definite limits to

any claims of truth and objectivity; that it is affected by subjective, emotional or irrational factors in its subject matter and in the mind of the historian himself, and that a historical work seems to be constructed according to a peculiar logic of its own.

All this may come as a revelation to the art teacher chained to the common trust in 'scientific objectivity' but intellectually struggling to free himself from its yoke. He will gratefully realize that value judgments, up to now surreptitiously concealed within allegedly impersonal contexts, can at last flourish in the open, without endangering the ethical status of his method and the cognitive content of the subject-matter. He will understand that, if he is to present art history 'according to a logic of its own', he must accept that this logic (in the words of Aron, quoted by Meyerhoff, 1959) 'amounts to a simple proposition: the reconstruction of the past is not an end in itself. Just because it is inspired by a present interest, it has a present purpose.'

The reiteration of the term 'present' indicates that the historian is free to move away not only from the 'verifiable' past pursued by Positivists, but also from a foreseeable future guaranteed by Christians, Hegelians and Marxists. The present, as present, raises its unruly but fascinating head: the impermanent becomes a gateway to the permanent. This was felt not only by poets, like Yeats, who wrote of 'the past, the passing and the future'; philosophers, like Croce (1921, 12), carefully scrutinized this seemingly paradoxical presence of the past in the passing:

If contemporary history springs from life, so does that
history which is called non-contemporary, for only an interest
in the life of the present can move one to investigate past
fact. Therefore, this past fact does not answer to a past
interest, but to a present interest, in so far as it is linked with
an interest stemming from present life.

So Croce reached his fundamental proposition that 'all true history is contemporary history', which means that the past is dead except in so far as it is linked with an interest stemming from present life. And Ortega y Gasset (1941, 223) went on to proclaim that 'the past is not yonder, but here, in me. The past is I.'

Such views may be at odds with the convictions of the

historian relishing the past for the past's sake—a latter-day Pygmalion in love with his *kunstwissenschaftliche* Galathea. They are, however, of paramount importance for the educationist whose activity unfolds in the present, among pupils involved in the present.

5

At this point, the art historian is not only entitled, he is forced to ask: if art history is to stem from a present interest, whose interest should it be? Or, echoing Panofsky's precept (1955, 25) that all art history should deal with 'reality'—whose reality should this be? If 'the past is I', whose is this 'I'? The answer is, however icono-clastic it may sound: the pupil's interest, the pupil's reality, the pupil's I.

This assertion may be immediately counter-attacked. If the learning individual, with all his unpredictable whims, dominates the educational foreground, will not the facts to be learned sink in a turmoil of unstructured lessons, even more atomized than anything hitherto considered art history? Will not the interested present expel the disinterested past? Are we not returning to a crass utilitarian attitude at loggerheads with all true cultural values? Such alternatives seem to me to be incorrectly formulated. To put the matter in its proper educational perspective, we must first of all grasp the difference between the 'raw materials' of the historian and those of the art historian. History is built of data about events— which means it is *not* built on direct experiences of these events. Art history, on the contrary, rests on direct communion with objects or classes of objects always sensorially experienced and mostly materially present in the original or in trustworthy reproductions. In art history, the relevant fact of art is the experienced artefact. It does not make sense to maintain that this experience of the artefact can be relegated to the past.

History, however imaginatively reconstructed, can evoke only ineffable events forever past. Art history emerges from concrete objects in front of our eyes. Events vanish, artefacts persist. Consequently, for history, events can be at best intelligibilia—things that can be understood. Works of art are visibilia—things that can be seen. Historians have no choice but to proceed along rational paths, deprived as they are of immediate intuitive experiences of

their subject-matter. Art historians are in the privileged position of having at hand such immediate experiences, which enable them to start their investigations from an unmitigated existential involvement with an artefact. This artefact is clearly defined in time but potentially capable of unlimited yet organized backward reverberation. But, in any case, their activity is conceivable, as Collingwood (1946, 233) says, only as 'a transaction or a relation between a subject and an object both actually existing and confronting, or compresent to, each other'.

This essential 'com-presence' once again puts in evidence the important part to be played by the subject, experiencing intuitively or cognitively the art historical object in the precinct of his individual existence. Such relativity is even more plausible if we accept that (Abell, 1957, 250):

> to assert the permanence of human constitution, if assumed
> to imply a permanence of aesthetic reactions, involves an
> illusion. We might call it the 'illusion of aesthetic fixity' and
> compare it to the illusion of cosmic fixity which makes us feel
> that the earth is standing still.

The introduction of such Copernican dynamics into the teaching of art history by infusing into it some moderate Relativism, tilts the methodological balance towards the view that direct intuitive experience of the work of art related to the pupil's psycho-social situation ought to be the springboard towards a subsequent imparting of a body of art historical cognitions. Such a project is not exactly novel. Almost two centuries ago, over the period 1769–91, Reynolds (1966, 202) taught that there is a 'sagacity which . . . does not wait for the slow progress of deduction but goes at once, by what appears to be a kind of intuition, to the conclusion'. Such sagacity was 'far from being contradictory to reason'. What I am endeavouring to clarify is the place of such intuitive sagacity which 'goes at once' in our approach to art history—particularly in this age of easily accessible mechanical reproductions of works of art stored in innumerable 'imaginary musea'. It seems to me that this accent on the subjective and the relative (not to be confused with the anarchical and the incoherent) is not merely a matter of pragmatic classroom expediency. It is a question of theoretical clarity: an attempt to chart an insufficiently explored way of formulating a viable educational method as well as of working out a curriculum

that would bring art history to life and transfigure the tiresome imposition of 'facts and figures', theoretical cousins of the practical 'grapes and drapes'.

But such reform needs a new starting point for the restructuring of a prospective mode of art historical exposition. We may, however, find such a start without much difficulty if we are unprejudiced enough to reconsider the function of unpremeditated taste manifestations volunteered by the pupils, and of discriminating evaluative judgments fostered by the teacher. This mixture, usually subsumed under the blanket term of 'art appreciation', may well be over-flowing with individual idiosyncrasies. And yet it may prove to be the key to the closed and not always welcoming gates of factual art history.

6

To teach art history does not mean to impose a body of information to which the pupil is emotively neutral. In consists rather in the educational structuring of cognitions emerging from the total existential involvement of this pupil. Such involvement presupposes a communion with works of art in general as there always is a direct 'relationship' between them and our ways of life and thought. This points to yet another oversight in the conventional concept of art history and, consequently, in its tuitional methods: one of the terms of this relationship, namely the beholder or the 'consumer' of the work of art is stubbornly overlooked in favour of its 'author' or 'producer'. It is high time to redress this injustice and to render, as with Caesar, unto the beholder what is due to the beholder and to the author what is due to the author. And this can best be achieved by breaking down the barriers between art history and art appreciation.

They are usually considered as antagonistic: to 'appreciate' is taken as the utterance of value propositions embedded in personal experience, while to acquire art historical 'knowledge' is construed as a rote memorizing of a set of extra-individual cognitions. Cézanne and Klee are thus equated with algebraic signs or scientific formulae. But no educationist can accept that. Constant mediator in the triangular art history teaching situation, he knows from his work how greatly facilitated he is when evoking artists, styles or ideas to which his pupils are existentially attuned in 1973: the black

'rooms' of Goya 'go down' much more easily than Raffaello's 'Stanze' in the Vatican. This empirical observation may well be a truism: it is, however, rich in methodological implications. It proves that it is much easier for pupils to learn rationally what they already feel intuitively. In Osborne's view (1970, 5), the more active the 'unreflective performance which can be relied upon to come into operation without conscious effort and attention', the easier the path to the wilfully induced 'tautening of attention, concentration of control, heightening and enhancement of consciousness'. Now these are precisely the conditions required for any verbal formulation of the relationship with the work of art not too aptly, but commonly, called 'appreciation'. But 'appreciation' is a cumulative term embracing emotive, descriptive and evaluative attitudes to the work of art. And, therefore, it turns out to be the natural and inseparable introduction to that body of intertwined descriptive and evaluative propositions dealing with the same subject matter which we call 'art history'. As 'the past is I', any time that I utter an appreciative sentence, I implicitly make an art historical pronouncement, which may be faulty or inconsistent but is none the less rational, conceptual and, in varying degrees, cognitive.

But such conceptual cognition does not emerge complete with full verbal armour from the immediate contact with the work of art. Even when we 'recognize and appraise complex qualities' neither of their 'constituent elements nor clues are consciously known'. Verbal utterances are prepared by pre-verbal incubation, non-volitional and non-analytical. Such pre-organization of aesthetically tinged linguistic statements, necessary conditions for all subsequent art historical evaluations, is not inevitably hidden by impenetrable private darkness. It manifests itself publicly in similar non-verbal, non-volitional and non-analytical taste utterances. Such taste utterances lead to verbal art appreciative sentences which in turn lead to art historical descriptive and/or evaluative pronouncements. Taste forges the first inaudible ring in the chain linking practice to theory, life to method, now to yesteryear.

But, in this context, 'taste' is not to be taken at its conventional face value. In fact, taste always seems to have been something of a skeleton in the cupboard of aesthetics: even Hume writing in 1757, for all his analytical acumen, failed to outline what 'taste' really is. In fact, he systematically equated it to aesthetic (art appreciative)

judgment (Hume, 1964, 231–55). And yet he set out on the right road when he explicitly stated that taste communion is neither caused nor helped by any rational procedures: 'taste does not convey any knowledge of truth and falsehood, but gives us a sentiment of beauty'. Taste 'stains all natural objects with the colours borrowed from internal sentiment' as 'beauty lies not in the poem but in the sentiments or taste of the reader'. Had he continued in the same vein, Hume would have become something of a forerunner of the depth psychology discoveries of time to come. But he changed course in mid-stream of his investigations: having proclaimed taste a matter of sentiment, he returned to the fold of his epoch and endeavoured to reduce it under the common denominator of discursive appreciations with all their logic-coerced deductions. Still, if he failed to tell us what taste is, he showed us how to use it in an educational situation. He drew our attention to the initial unreasoned states of aesthetic affairs existentially related to the acquisition of ulterior art historical cognitions. In the beginning was Taste.

Of course, individual taste is not impervious to societal fashions. But this interpenetration, confusing though it may be for the psychologist intent on unravelling distinctive identities, greatly favours the teacher of art history. It gives him the guarantee of a group taste on which he can base his pedagogical activity. Thus, he can use fashionable boutique windows, harsh discothèque decorations or violence of sound volume as the opening gambit in the progression towards specific art historical topics, counting on evident expressive affinities between the proposed tuitional core extracted from past days and the pupil's 'scene', steeped in present-day preferences. Botticelli may well interest young people because they are attracted by the wavy outlines of trendy dress shops. The teacher's task would be to organize such disconcertingly distant manifestations into units that would be historically valid, logically coherent and methodologically effective.

The search for such coherent relationships cuts across traditional 'periods' or 'movements' in art history and therefore calls for a critical re-examination of certain key concepts constituting their methodological justification, in order to see whether they may or may not be affecting the reformed tutorial procedures which I am endeavouring to outline. Such concepts under discussion are 'causality' and 'chronology'.

7

The proposed model for teaching art history starts from present taste manifestations and verbal utterances of art appreciations, and proceeds backwards to past artistic events and theories illuminating these events. This deliberate regression in time is justified both on historiographical and methodological grounds. Not only can history be interpreted in general as contemporary history, but the stress on such contemporaneity in art historical expositions takes into account the pupil's spontaneous interest in events related to his own existential predicament. It has been objected that such a crab-like crawl is doomed to educational failure because it disregards the causal link between art events and fractures the chronological pattern of art evolution. But its fate is hardly that bleak.

In fact, to look in art for cast-iron sequels of causes and effects is to strive after an imaginary order alien to reality: art historical explanation is not, putting in slightly paraphrased Wittgensteinian terms, a causal explanation. Uttered in such a drastic way, this statement may be construed as a confession of the impossibility of introducing any kind of structural cohesion into the disparate mass of art historical phenomena. That this is not the case becomes self-evident in the light of the dual connotation of the Aristotelian 'law of causality'.

One way of understanding this word is to consider it as a possible, but by no means sufficient and/or necessary condition for a generative connection between two phenomena. But the same term may be given its full strength and intended as a sign of necessary and sufficient conditioning—as in the notion of 'causal determinism': in this case strictly defined causes give rise to equally defined consequences. It is precisely this dictatorial causal determinism that, according to Wittgenstein's views taken as a whole, has no place in art history.

An example will perhaps cast some light on this important point. Enumerating the after effects of the Counter Reformation, Hauser (1959, 116) states that artists

> were torn by force, on the one hand, and by freedom, on the other. . . . We encounter for the first time the modern artist. . . . The number of cranks, eccentrics and psychopaths among artists increases from day to day. Parmigianino becomes

melancholy and entirely neglects his appearance. Pontormo
suffers from serious fits of depression. Greco sits behind
curtained windows in broad daylight.

This typical instance of strong causal determinism, allegedly
stern and scientific, misfires all along the line. The Council of
Trent is presented as the direct cause, necessary and sufficient, of
sartorial negligence and maniacal depression which, in their turn,
are supposed to enlighten us on the art of Parmigianino and El
Greco. Modern artists are well-nigh equated with cranks and
psychopaths—all because of a dreadful turn of ecclesiastical events
spurred by the spread of Protestantism! Probability has been
mistaken for inevitability.

Causal determinism, in its scientific rigidity, proves to be incom-
patible with the complex nature of art history. Art historical
phenomena reveal themselves co-ordinated only on the basis of a
broadly understood 'soft' causality—so broad, in fact, that one may
even invoke, as a regulating parameter, a new principle of 'causal
*in*determinism' in art history, akin to Heisenberg's concept derived
from nuclear physics. He insists (1959, 19) that while 'every
deterministic system is causal, not every causal system is deter-
ministic'. In art history, small islands of causally conditioned data
are surrounded by vast expanses of undefinable developments and
unostensive filiations.

Einstein is reported to have said that 'God does not play dice'.
But in the realm of artistic creation he appears as an inveterate
gambler: in art history no encounter between the creative impulses
of the artist and the situation in which he is placed necessarily
results in a pre-determined and predictable performance. Nothing
in Fauvism makes Cubism necessary. Nothing in Expressionism
makes Abstractionism inevitable. Read (1964, 17) has warned us
'against the folly of trying to fix a specific beginning to anything as
underground as the first growth of an artistic style'. There is
always something imponderable in the sudden outburst or slow
mutation of art forms—just as at the root of matter in physics there
is something ineffable and undescribable which Heisenberg cannot
but call 'strangeness'.

It is essential to be aware of this restricted, probabilistic meaning
of 'causality' in art history. Only then can we feel entitled to con-
struct a new model of art historical studies, aspiring to a structural

cohesion 'according to its own logic', freed from compulsory deterministic regimentation. What then would be the methodological status of chronology in this prospective unit of art historical studies?

8

Without causality, chronology hangs in mid-air. If art events are not necessarily stuck together by omnipresent and almighty causal laws, it is logically untenable to consider that their respective manifestations should be conceivable only in a preordained chronological order. Therefore a mechanistic succession of events in art history cannot be the only way of presenting them in a coherent whole. We can choose our structuring principle and, in this way, 'confer a meaning to history'. Contiguous periods in art history must not be treated only as stepping stones in time, generated by whatever precedes and generating whatever follows them. Romanic architecture is not the cause of Gothic cathedrals, nor is the Renaissance a consequence of the Gothic upsurge. The linear stretching of chronology in what has been called 'historical time', does not correspond to the infinitely more flexible, though much less precise, causation in art history. According to Read (1964, 17), we 'should think rather of the complex movement of a chronometer—for historical time seems to reduce, on analysis, to such interlocking of gears and ratchets'.

Ideological motives for an exclusive rule of chronology over art history are equally untenable. Interest in temporal sequels is a derivative of the worship of Progress as the bloodstream of history. Both Idealists and Materialists join in this idolatry. The former may be Christians inspired by Augustine or, for that matter, Teilhard de Chardin. They can also be agnostic followers of Hegel, believing in his three-phased speculations on the Grand Idea as final goal. Materialists turn to Darwin and Marx for a map of roads progressively winding through the hills and deserts of history to a *Civitas Homini* whose theoretical blueprint has been available to the faithful for over a century. But is any progression necessarily Progress? Is all motion necessarily advancement? Is Progress the one and only law of history set by Divine Providence or Marxist Dialectics? These are questions which tradition takes for answered, erroneously attributing to human acts ontological

features and practical achievements extrapolated from the natural sciences or borrowed from theology. Because of this intellectual laxity, when 'God is dead', Progress becomes God and chronology remains his prophet.

Art queries this certainty. Because Michelangelo is anterior to Canova, is he his inferior? Is Kandinsky greater than Rembrandt simply because he was born centuries later? Such patent absurdities indicate that ideological beliefs are even less likely than logical constructs to impose chronology as the only methodological scaffolding suited to the teaching of art history.

It is therefore right and proper to look for an alternative to a chronological alignment of artists, filing off like soldiers on parade. Education stands only to gain from a different methodological manner of canalizing and directing the stream of art history. But the discarding of chronological discipline should in no circumstances lead us to adopt a curriculum constituted of unconnected items chosen completely at random—particularly favoured in so-called non-structured educational situations. Rejection of chronology does not imply exoneration from the necessity of a structure; it calls only for a more fruitful one. No single sector of art history can be a truly intelligible field of study when taken in isolation. To brush aside unproven causality and constricting chronology does not free the teacher from the obligation to provide a choate framework capable of embracing a temporal (as well as a spatial) cross-section that would be a backward echo in time and space of the pupil's present existential situation. To achieve this, the new units of art historical studies must rest on a clear notion of the role played by time in this methodological transfiguration.

9

Linguistics provides us with a paradigm of the temporal axis along which the objects of our concern should be placed. It draws (Saussure, 1962, 115) a clear distinction between (a) the axis of simultaneity, concerning the relations between coexisting data, irrespective of the intervention of temporal factors, and (b) the axis of succession, along which one can never examine more than one thing at a time, but along which are placed all the data set on the former axis, together with their respective changes. The terms coined to define these two approaches are 'synchronic' and 'dia-

chronic'. Conventional art history is pre-eminently 'diachronic', i.e. it deals with the chronological succession of events. But I have argued that such diachrony is not imposed by the nature of art history. Hence the plea for a methodological reversal: the introduction of a synchronic outlook, if possible, in the writing and, certainly, in the teaching of art history.

This synchronic approach must be taken into account by the unit of art historical studies on which we are to base our teaching. But—and this is important—while giving precedence to the simultaneous communion with the works of art irrespective of the temporal sequence in which they have been recorded, we must not altogether lose sight of the successive appearance of these works. However, in relation to prevailing methods, the routine balance will be reversed: succession will step into the background, simultaneity will spring to the foreground. Temporal sequels will be additional co-ordinates helping us to find our way in the labyrinth of art activities through the ages, not—as is so often the case—the unique factor determining the order in art history and, consequently, its curriculum and its methods of classroom presentation. Larger or smaller temporal compounds will have to be organized around a new cohesive kernel and distributed in new types of units whose structure and content are yet to be fully worked out. Be they what they may, they will not be pre-ordained by strict determinist laws, nor will they submit to unproductive chronological compulsion. Built 'according to a logic of their own', they will also embrace those extraordinary personalities that are a thorn in the flesh of traditional art history, dominated by causal laws, intolerant of any exception. Originality—so long an ill-fitting outsider—will find its rightful place within the less dogmatically organized ranks of art historical phenomena. And so it must be, for originality is the distinctive mark of the true artist, however irreducible to laws and regimentation he may be. But if such creative dispositions are unique, surely they cannot be sensed and classified. What then is a true artist? Here is Malraux's answer (1949, 79):

> I call artist the man who *creates* forms—be he an ambassador like Rubens, an image maker like Gilbert d'Autun, an illuminator of manuscripts like Limbourg, a courtier like Velazquez, a man of private means like Cézanne, a madman like Van Gogh or a vagabond like Gauguin.

Two basic ideas run parallel in Malraux's statement and we ought to take a closer look at them because they will help us towards the final step forward in our investigation. The first is the all-important concept of *analogy* which empowers Malraux to bridge the distances between such disparate personalities as Rubens and Cézanne. The second no less relevant point is the stress laid on the notion of *forms*. I propose to postpone for a while the scrutiny of analogy in order to concentrate on the place of forms in the unit of art historical studies.

10

'Form in art is the shape imparted to an artefact by human intention and action'—this is the definition given by Read (1965, 66). Forms in art are expressive, evocative, eloquent. Squares and rectangles affect us quite differently in an ordnance survey map and in a canvas by Mondrian. Cubes and spheres lead quite a different life in the manuals of geometry and in a painting by Cézanne. Divested of their pseudo-scientific robes, art historians appear as they really are: biographers retracing the life of these forms. Focillon (1947, 3) writes:

> Life is form, and form is the mode of being of life. The relations linking the forms in nature are not mere contingencies and what we call natural life is in fact a necessary interlocking of these forms without which it would be impossible. All this applies also to art. Formal relations within a work of art and between works of art constitute a definite order, a metaphor of the universe.

Obviously there could be no talk of such 'metaphors of the universe' if we had eyes only for relations between abstract forms independently of their content or their representational value. Nor could such evaluative limitation fit the intention to relate art history to the pupil's psycho-social involvement, hardly restricted to 'disinterested pleasure' in shapes and patterns devoid of any meaning. If forms are to be meaningful, such meaning must be found within the forms themselves and not grafted from without on to these forms. But abstract or representational, forms are never visually self-sufficient. They always refer to meanings which remain

beyond all optical images and yet are embodied in them. Forms signify meanings: they are both emotive and cognitive.

This Janus-like essence of forms is to be clearly understood if the teaching of art history is to be rooted in 'reality', interminable turmoil of form-embodied meanings. If teachers are to explore both the emotive and cognitive potential of art in time, they must be aware that all forms encountered in art history are both direct emotive spurs and indirect signs of meaning. They are not mere sounds of fury and their historical evocation is certainly not a tale told by an idiot.

But these forms are beyond count. What is more, they are unevenly scattered in time and in space. Our pedagogical task, on the other hand, is to present them in a coherent whole. To achieve this objective, we must choose an effective *principium divisionis*—a norm of congruent selection that would offer all the advantages of a synchronic approach to art events without the distorting impact of chronological causality. Such a cohesive feature, capable of structuring new units of art historical studies, respecting both the temporal consecution and the experiential immediacy of the works of art, can be provided by the concept of *analogy*. To grasp the sense and the implications of this term is to complete the elaboration of a revised unit of analogically structured art historical study, aimed at in this paper.

II

A brief analysis of 'analogy' will demonstrate its validity as a structuring principle in art history. Analogy indicates, in Aristotelian terms, 'the similarity between distant things', that is to say an affinity in form, function or finality between differing entities. Such affinities extend to logical relations, historical or biological qualifications and even to convergences between entities that may appear incommensurables. Thus, for instance, Leibniz proposes to explore spiritual entities '*ex analogia nostri*'—by analogy with ourselves. To reason by analogy is therefore to unravel affinities between detached and even dissembling entities. Such related analogical classes will, however, remain generic: they will point to the concord of only one or of several features, but never of the whole object. Otherwise our reasoning would be circular: we should move pointlessly from one identity to its identical double.

But correct progression by analogical reasoning seems to me of undeniable benefit for the specific educational situation with which we are dealing.

What matters for the teacher of art history is the revealing of analogies between works of art, envisaged as single entities or as compounds of such entities, conventionally called periods, styles or movements. Therefore units of art historical studies will consist of meaningful forms, simultaneous or successive, structured and classified according to their inherent analogy, irrespective of temporal contiguity and deterministic continuity. The example which I shall give is bound, by force of necessity, to be summary and, by design, elementary: it is impossible to compress within a few lines, the whole span of a discussion, subject to any number of educationally valid digressions.

Let us start with the assumption that pupils and students are, at this point in time, intuitively at home with the linear undulation of the Art Nouveau: their understandable interest in juvenile 'gear' and their unself-conscious daily experiences guarantee that we shall be setting foot on familiar ground, apt to catch the pupil's interest and to lower any defensive barriers erected against the much-decried art history. We therefore stand a good chance of slipping unobtrusively into the hedonistic, linear art of the turn of the century—that of Beardsley, for instance. He is certainly not a prominent figure in world art, but a most convenient stepping stone towards more relevant points to be made concerning those who are.

And, indeed, we may find it comparatively easy to make students see, by analogy, that such pleasure-craving attitudes to life and art are shared by some earlier artists, the Impressionists. But different means are adopted by them: forms emerge from the manipulation of colours and not through the definition of outlines. Thus we will begin tracing a methodological guiding line from the centre of the students' present-day un-reasoned taste commitment; we shall then continue by associating artefacts by virtue of a definite aesthetic criterion while distributing them along a temporal axis.

Having thus brought together the present interest of pupils and students with past achievements of artists, in a natural intersubjective whole, we have the choice of many a road, according to the age and culture of the students. One direction may point to modes of pictorial representation of space by chromatic juxtapositions or linear perspective, thus effortlessly reverting to the Renaissance and

beyond it. Another choice may be the contrasting of 'pleasure giving' paintings with primarily 'ideas fostering' works of art— again down to the religious or ideologically conditioned relics from the past. It would be equally possible (and, perhaps, advisable at a lower educational level) to explore the linear elongation of the human body, from Botticelli to the Egyptian frescoes. The number of such tuitional avenues open to the imaginative teacher is vast. But, whatever the turn he takes, his analogically structured unit of art historical studies will have put him in a position to pursue two concurrent pedagogical lines. On the one hand, rudimentary explanations of aesthetic theories, not sprung on the pupil in a disconnected and alienating manner, but used as a cohesive substance between the artistic personalities and styles mentioned in the course of the exposition. On the other hand, acquaintance with works of art, artists and movements, dealt with in any amount of detail which the teacher may deem profitable.

Finally, teachers may find it advantageous to sum up by rearranging their associative selections of art historical cognitions in chronological order against a wider cultural background; they will thus maintain, by variation, the interest of the pupils in the perhaps dying minutes of a lesson period. But this temporal reminder will be totally cleansed of its mechanistic supremacy persisting in the conventional methods of teaching art history. Much in the same vein, the detrimental part played in such methods by the arbitrary overrating of causal connections will be attenuated by the recourse to analogies and associations, set in motion by taste utterances and discursive evaluations indicative of the pupils' existential involvement.

Such involvement cannot but be confusion. The aim of educationists is to put some order into this chaos while maintaining its living pulse. Teachers of art history face the same problem, however unrelated to the daily vicissitudes of teenagers' lives their subject-matter may appear at a superficial glance. Perhaps their task will be facilitated by the use of the flexible units of art historical studies blending immediate aesthetic experiences with mediated historical cognition, linking past with present and learning to life.

References

Abell, Walter (1957), *Collective Dream in Art*, Cambridge, Mass.: Harvard University Press.

Blunt, Anthony (1940), *Artistic Theory in Italy 1450–1600* (2nd ed. 1956), London: Oxford University Press.

Collingwood, R. (1946), *The Idea of History*, London: Oxford University Press.

Croce, Benedetto (1921), *Theory and History of Historiography*, New York: Harcourt, Brace.

Focillon, Henri (1947), *Vie des formes*, Paris: Presses Universitaires de France (English translation: *The Life of Forms in Art*, London: Hogan & Kubler, 1948).

Hauser, Arnold (1959), *The Social History of Art*, London: Routledge & Kegan Paul.

Heisenberg, Werner (1959), *Physics and Philosophy*, London: Allen & Unwin.

Hume, David (1964), 'Of the Standard of Taste' in *Essays: Moral, Political and Literary*, London: Oxford University Press.

Kleinbauer, W. Eugene (ed.) (1971), Introduction to *Modern Perspectives in Western Art History*, London: Holt, Rinehart & Winston.

Malraux, André (1949), *Psychology of Art*, London: Zwemmer.

Meyerhoff, Hans (ed.) (1959), Introduction to *The Philosophy of History in our Time*, New York: Doubleday.

Ortega y Gasset, José (1941), *Towards a Philosophy of History*, New York: Norton.

Osborne, Harold (1970), *The Art of Appreciation*, London: Oxford University Press.

Panofsky, Erwin (1955), *Meaning in the Visual Arts*, New York: Doubleday.

Perry, Leslie R. (1966), 'Objective and Practical History' in *Proceedings of the Philosophy of Education Society*, 1, 35–48.

Popper, Karl (1957), *The Open Society and its Enemies* (vol. 1), London: Routledge & Kegan Paul.

Read, Herbert (1964), *Philosophy of Modern Art*, London: Routledge & Kegan Paul.

Read, Herbert (1965), *The Origins of Form in Art*, London: Thames & Hudson.

Reynolds, Joshua (1966), *Discourses on Art*, London: Collier-Macmillan.

Saussure, Ferdinand de (1962), *Cours de Linguistique Générale*, Paris: Payot.

Upjohn, Everard M., Wingert, Paul S. and Mahler, Jane Gaston (1949), *History of World Art*, London: Oxford University Press.

Further reading

On history

Meyerhoff, H. (ed.) (1959), *The Philosophy of History in our Time*, New York: Doubleday.

On art history

Gombrich, E. H. (1969), *In Search of Cultural History*, Oxford: Clarendon Press.

Kleinbauer, W. Eugene (ed.) (1971), *Modern Perspectives in Western Art History*, London: Holt, Rinehart & Winston.
Panofsky, E. (1955), *Meaning in the Visual Arts*, New York: Doubleday and Harmondsworth: Penguin (1970).

On appreciation

The Appreciation of the Arts series edited by Osborne, Harold, London: Oxford University Press:
Gaudie, S., *Architecture* (1971).
Osborne, H., *The Art of Appreciation* (1970).
Owen, P., *Painting* (1970)
Rawson, P., *Drawing* (1969).
Rogers, L. R., *Sculpture* (1969).

On galleries

Marcousé, R. (1961), *The Listening Eye—Teaching in an Art Museum*, London: HMSO.

9 Is it necessary to make art in order to teach art?

A Symposium

Those taking part

Tony Burgess William Newland
Olive Gabriel Ann Spencer
Dennis Griffiths Keith Swanwick
Alfred Harris John White (Chairman)
David McKittrick

The proposition that the practice of the arts by the teacher may be a source of insight into the teaching of the arts is not specifically considered in any of the articles in this book. In consequence the editors decided to initiate this discussion, the members of which were chosen to provide a spectrum of opinion from several of the arts.

The initial question: Is it necessary to make art in order to teach art? appeared to give rise to a number of further questions:

1 Is it necessary to have made art in order to teach art?
2 Is it necessary to continue to make art in order to teach art?
3 Does the answer to either (1) or (2) vary according to one's objectives?

If the answer to either (1) or (2) is 'yes':

4 What specific kinds of insight can the teacher derive from making art?
5 Must the art which one practises be the same art as one teaches?

Readers will notice the Chairman's efforts to encourage the discussion members to focus on these differentiated questions, but it is evident that they are interrelated and cannot be answered in

isolation. No member of the discussion would feel that these questions have been fully or even adequately answered; the questions themselves may seem simple but the answers cannot be. In consequence the discussion may be regarded as a preliminary airing of some of the issues involved.

What you will read here is an edited version of a longer discussion. As is typical of the discussion method of inquiry, ideas are sometimes revealed or explored at an intuitive, spontaneous level; sometimes there is an attempt at a more formal analysis. Consequently readers may find themselves reacting to a complex range of opinion and style which could usefully lead to continuing debate.

Since all members of the discussion group are actively engaged in the education of teachers of one of the arts—mainly in secondary education—it is perhaps not surprising that the discussion often turned towards the teaching of the arts to children. This emphasis in itself immediately raises further issues which every reader will doubtless wish to consider from within the context of his or her own inclination and concern.

The discussion

Chairman Is it necessary to make art in order to teach art?

TB The hang-up I have here is to know whether I am trying to look for a logical answer.

Chairman I don't think it was intended that the 'necessary' here is to be taken only in a strictly logical sense. Another point about the wording: 'to make art' was chosen as a deliberately imprecise phrase. 'Making music', for instance, often means performing, but we don't want to restrict the discussion in the musical area to this.

KS I think we'll have to differentiate sooner or later between what we might call the performing skills (and sensibility to the performing skills) and the actual making of an artefact, but I think it is possible to extend this slightly in relation to teaching, because it is here we get into difficulties. For example, it is possible to conceive of a person who could teach a group of children or adults to get inside a work, to get them inside the artefact—it may be a recording of music, a picture or whatever—and this would be arousing the sensitivity, or what in old-fashioned terms

would be appreciation, I suppose. But it is inconceivable that a person could teach another to play the clarinet unless he played one himself—absolutely inconceivable. So we have, on the one hand, what you could call the *making skills* (I mean—the techniques of pottery need to be known) and the sensitivity to use these skills to artistic or aesthetic effect; and on the other hand, you have the *performing skills* which could include things like acting, movement, use of voice and playing instruments. And then we also have what you might call *appreciating or responding*—aesthetic response—which probably could be initiated by someone who was keen enough but hadn't performed himself.

Chairman In other words the answer seems, then, to depend on one's objectives.

KS They're tied in. I can't separate them.

McK Teachers who are conducting making music sessions are quite often getting the children to play drums, beat cymbals, play xylophones, when they themselves may not be very adept at playing these things, but, in fact, they do sometimes make music with children and they are helping children to make better sounds on the instruments they play.

KS But they're very limited.

WN It is possible for little children just to take a piece of clay and make a figure, without any instruction, without any teaching.

AH Of course, people can be creative without being taught, but here we're referring to a teaching situation.

KS It's precisely what I'm getting at because in the case of your child making a clay figure you haven't taught him anything. He's learnt. So if you're going to use the word 'teaching', this must involve some activity on behalf of the teacher.

WN In the case of the little child with the piece of clay, the teacher provides the conditions for the thing to take place.

KS He could well have been dispensed with.

TB Not necessarily. You could unpick 'teaching' as between what you may say and show in a specific situation on the one hand, and teaching as providing situations on the other. That's one

point. I think it is related to a dimension between a very full-blown case of an art product, and a less full-blown case which is *continuous* with normal daily activity. This I think is obvious in the case of words—that you could see poetry as a long way from everyday language and from the kinds of things we do in every-day language, and which arguably is what the professional poet arrives at. But for young children it is probably much closer and more continuous with everyday language and what they are doing. And I should imagine it is the same for the visual arts too.

McK I would feel that the child can arrive at an artefact using words which is quite *discontinuous* with everyday experience. He might make a poem in which he successfully uses words to create a moment of virtual experience, which is quite distinct from everyday, actual experience—something separate and distinct from an everyday activity like baking a pie in the oven.

AS There are pies in art too. I think there is a confusion about artefact and art: everything one makes when one is doing an activity which one might call 'art' is not necessarily art. You make something. Where do you draw the line? What is the thing which makes it art? You see, I think there is an art of cooking; the pie is one of the products.

McK I think that you've got to recognize that the art of cooking is a very different process from the art of making poems.

OG It could be different, but a great chef might impart something of his personality—giving form to an idea. I can imagine a great banquet—a progression of dishes, setting one another off in almost a symphonic way. Perhaps this is flying a bit high, but something is contained and is conveyed through the thing that is made, in whatever form, whatever material it may be.

McK I would agree and describe it as the personal in the object— I wouldn't deny that at all—but I think there is quite a distinction between the poem and the pie. I think I am here going to make a definition. My definition would be that art is an illusory creation. It creates an illusion, and for every art there's a specific illusion, and maybe subsidiary illusions. But there's no illusion for the pie.

OG Oh there is!

DG It's a symbolization of something that's real in exactly the same way as the poem is. This seems to me to be what art is all about. Whereas our education tends to categorize and make distinctions and draw apart, one of the things that the arts do is to make sense of a whole—to draw things together in a way that perhaps they haven't been drawn together before, and this may be in images or dance or anything; a lot of this goes on inside the head. This is one of the difficulties in drama: that it's never complete sense—it's never really finished. Paul Valéry says, 'You never finish your poem—you abandon it.' There's never any complete statement. It's the exploration, the making sense, the drawing together . . .

Chairman So we have two sorts of issues: one is whether or not a work of art is delimited round things like poems rather than pies, and the other is whether or not a work of art is in the public world at all or more in the mind of the artist.

DG It isn't something in the mind. It is something that is physically produced, but the very process of art is what happens in the production of it.

KS I think there is a distinct difference which can be drawn between art and other experiences—which is why I have a different label for it. I don't regard invention, skill and art as synonymous. I wouldn't have three words in my vocabulary if I did. And I'll give you an example from music which is very clear and striking. This is a distinction made by Langer between materials and elements. If you go to a concert you will hear the note A in the interval. It is a signal for people to return to their seats and very rarely is it treated as a work of art—it is just responded to. Now, if you hear Wagner's Overture to *Rienzi* which opens with the same note A, not repeated but played on a single trumpet, people have, as it were, switched into a different mental 'set'; they are prepared to treat note A, not as a piece of musical material, but as a musical element which is going to go into combination with other things, and is obviously intended to be heard as music, both by the composer and performer, and is going to be treated in an imaginative way. Now I regard this as a distinction.

Chairman Are you saying, then, that what picks out the art object

is that one's attitude towards it is not a practical attitude? One is not going to return to one's seat, or eat a pie, but one is going to contemplate it for its own sake; it is a thing in itself; we wish to dwell on it with all our perception, our imagination, our intellect . . .

WN I would not go along with this. If you take a Sung bowl, which is perhaps one of the finest pieces of art ever produced, it is both a beautiful and a functional thing. You've combined both.

TB Aren't we treating two polarities here as one? There is the polarity between usefulness and the aesthetic object—between the bowl and the symphony, let's say; but I think there is a second polarity here, which Bill originally gave us, between the clay figure made by the child—in other words, a fairly modest, personal thing—and the finished article which is intended to stand as a public, finished article, and to go out into the world. On the second polarity—that is, the range between the modest, personal, occasional thing and the finished, public thing—on that dimension we are on something relevant, because it is the consciousness of the processes which enter into the act which becomes important for teaching, rather than a necessary knowledge of the full-blown, public symbol. I think my point about poetry is the same here: that if you see poetry as continuous with more modest kinds of usage of language, this is what the teacher *has* to know—*has* to have that sense of the processes—rather than of the full-blown, public artefact.

Chairman If we accept that point, then how far is it necessary or helpful to have engaged in creative experience oneself? How far has one had to create artefacts oneself, either in the full-blown sense or in a less full-blown sense, in order to teach?

TB Can I say something about the sense of the processes? I have read accounts of teachers teaching children to write poetry, when the kid writes a poem and the response to this is along one line—'this is a first draft' kind of thing. And then tremendous activity gets concentrated on this one poor little poem to improve it—to improve its metre, to get more powerful images into it, to control its language and so on—and the poem is drawn away from the original kind of place it operated in the child's life into some kind of finished kind of masterpiece which could be held

8

on a wall. Now this seems to me, in a sense, to be a misunder-
standing of the artistic processes. It's not to my mind that in a
teaching situation you really have to experience the full-blown
thing. I can imagine that importing notions of quality into a
teaching situation may inhibit teaching.

Chairman I suppose a question worth asking is: is it possible to
understand the process without having gone through this
oneself? Could we elaborate on this?

AH Each individual doesn't start at a particular point in the
process. Individuals are experiencing things all the time, and
start from the point at which they are at the moment—there may
be a different point for other individuals.

DG One of the difficulties about language is that it leaves huge
gaps. We can codify and categorize, and there are lots of categories
close together, but there are huge gaps where traditional thinking
and rational articulation don't reach. One of the many functions
of the arts is to explore, not altogether consciously, these gaps in
human experience not covered by language. The difficulty comes
in if you're going to teach this consciously (as Tony says—if
you're going to apply this to a poem) and if you start articulating
about what *should* be done, you're making the whole process so
conscious. You're inhibiting it and spoiling it—as Wordsworth's
later poetry was spoiled by his looking it over, and seeing where
the philosophy was wrong; whereas his initial insight into
experience, and capturing that, was not so bound, was freer, as it
were, and more true.

Chairman How far would people generally agree with Tony's
earlier point that in order to teach children to make art, you
don't have to have made art in any high or full-blown sense?

AH I suppose what we're asking is: is it necessary to have worked
oneself in order to be able to create the conditions for other
people?

TB I think it depends on what force to give to 'necessary'. If
we give it a logical force, I think it's hard to see how one can
make it stand as 'necessary'. On the other hand, when the child is
moving from ordinary speech, in talk, into a written poem, or
moving from clay which exists in the ordinary world into some

sort of shape or whatever, he's performing an activity, part of which he senses the direction of from inside himself, and part of which he sees legitimated in the world going on around him.

McK I feel a moment will arise when the child will become dissatisfied with the modesty of his products, and will want to articulate them more clearly. Now then, I think we need a teacher who has made art to be able to help the child to do that.

TB Now that I don't see.

DG No one can learn *totally* the language of speech, or painting, or music, or anything; so that what the child or the artist is doing when painting is to *explore* the language—and this is where the teacher can come in, I think, because if he accompanies him on the exploration and responds to what's being done, and has a sympathetic understanding of this, I would almost say this is more important than having produced something of his own.

Chairman Let us take up movement, for instance. How far do you think it necessary for the teacher to have created movement? What does one create—dance?

McK Yes, but I wouldn't like to be absolutely dogmatic. I would say it is helpful if the teacher has made dances in order to teach dance. It's helpful. And I would also say that it is important for the teacher to continue making dances in order to teach this particular art well, but I think the answer is different according to your objective. I cannot conceive teaching dance without children interacting for a large part of the time, and when my objective very strongly emphasizes the opportunity for children to interact and make meaningful relationships with each other, then, I would say, I don't have to be an expert dance maker in order to teach it. If my aim was to help children to appreciate dance as a composition or artefact, my first objective then would be to build a movement vocabulary—and that's a very particular objective: to help children to have a quick access to the vocabulary of dance which would be jumping, turning, travelling, leaping and so on; and to build then a vocabulary of *qualities* of movement: to build their vocabulary of rhythms, so that they had a large store of rhythms to call upon; to build their vocabulary of shape and their vocabulary of relationships. The second objective would

be then to give children the opportunity of using this vocabulary to make compositions. One could name, for instance, the form— whether it was to do with climax and resolutions; whether it was to do with transitions between one movement and another.

Chairman But what about the teacher's involvement in relation to those objectives?

McK If the teacher had made dances, then he would more readily understand these laws of composition. I think the teacher would have a vocabulary of movement; I think the teacher would have gained some of this knowledge and be aware of its nature. I think that would help in teaching.

Chairman Help, but not be absolutely essential?

McK Well, I would say yes. If one was going to have children articulate more skilfully, it would be absolutely essential to have done it. I don't think it could be acquired by just reading about how to make dances.

Chairman Is this true of the other arts? What about music? Do you agree?

KS Yes, with a lot of that, but it's different again in some ways. As far as objectives of making music in the early stages in the classroom with simple instruments which David mentioned earlier and which do not require a great deal of technique, a lot of work goes in this respect to try to get them build up a vocabulary of sound relations. This is very hard for two reasons: one, it's not a private thing like writing a poem—you collide with other people's noises. And two, it doesn't have the advantage of movement in that it's not a natural thing; that is to say, it is not using things you use every day. It's hard to get analogies going. But at some point, sooner or later, we nearly always find learners, pupils, whose ideas, imagination outstrip their techniques. They cannot formulate what they want to do because they cannot control the instrument or their voice in the way they want to, ought to, if they're going to get their idea across—and they get very frustrated. And at this point it seems essential to answer this question with a definite 'yes'. So that's really two things: one is the first stage—yes, we want the process to go on without a great deal of technique. But sooner or later the technique, or lack of it,

becomes a hindrance to expression. Now this doesn't involve the teacher only in knowing about it; it involves him in knowing *how*. I have to know how it feels. It's this second point—I must get the feeling—a kind of aesthetic awareness.

Chairman But how far in relation to the understanding of music— when we want children to *understand* it rather than make it— must the teacher have made music, I suppose as composition or as performance? How far is this essential to teach children to understand it?

KS The crucial thing is that children best get to grips with music by making it. If the teacher hasn't made music himself he hasn't got a thermometer with which he can gauge what is going on in the classroom. If he can't get the heat of it, he can't know whether they are getting to grips with really musical things or not. But it has nothing to do with age range.

Chairman He can't do this unless he's had some experience?

KS I would say not, no.

Chairman Of playing music or . . . ?

KS Of understanding—certainly handling musical sounds.

Chairman But couldn't he know this without having actually having played?

KS No, because it's not knowing *about*. It's knowing.

Chairman That is an important distinction. It looks as though in music and dance we've had the same sorts of answers, haven't we?

McK I would want to say, like Keith, that there are times in dance when the pupils' ideas are outstripping their ability to formulate them; and it's there when they want to have the means to formulate something but they haven't the vocabulary or the experience—it's then that the teacher needs to have done it and to have discovered some of the problems involved, and to have known what it is like to be doing these kinds of movements. Experience in dance is necessary when it comes to helping the child to formulate his ideas or his urges in movement.

AH I think we should question fundamentally the idea that there are people who have not experienced movement, who have not

experienced sound. The question we are all concerned with is: how can one help people to relate to, understand and build up these things which they have already done? The question the teacher should ask himself is: how can I help children to make contact with these experiences?

DG I was wondering whether I could say a word about drama because this is a special case, and it might throw light on the others. I come back to this thing of what's going on in life, and exploration of that because obviously there's a close relationship between the teacher and the pupil he's working with. It seems to me that the child has been making drama for a long time, for one thing. Right from early childhood he's been playing, acting roles and adjusting to life—and again making sense of experience. I would think that progress in drama would be rather more in the kind of complexity, or subtlety, or insights into how they saw relationships; how they explored the roles they could act in life; how they could explore their relationships with other people; how they went into stereotype situations and then into an unknown situation, and explored their reactions here.

AH For me the value of doing it, both for the teacher and for the child is that we tend to deny our own experience, and we are less likely to do this when we're involved in drama, or dancing, or painting, or whatever it is. Therefore I believe that it is necessary to have made art, and also at times to continue to do so.

Chairman What do you think of the great difference in the training of art teachers, music teachers and so on, versus the training of teachers of literature, the emphasis being in literature much more on reading and criticizing, and in the others much more on creating and performing? Is there something odd about this, or is it something you would expect?

AS There is something odd about it, but doesn't one have to bear in mind that we all speak the language? We were talking before about the idea of technique not being up to the ideas. Well, I always think this is rather a good thing because when the techniques have got beyond the ideas, that's when you fall down, and perhaps that's where you fall down with 'literary art' (if I may call it so) because one is so used to using words. But in other arts you are starting. You have a different grammar to

contend with. It seems important to me to make a difference between the two.

TB Can I make another point? It's about what is involved in writing a poem, but I think it is general in its application. It seems to me that what we need here is not a notion of what art is, so much as a notion of what *an activity* is, and writing a poem I take to be an activity. And if you think about what is involved in an activity, then you see the question of teaching in a slightly different way. The question becomes not what do you aim to teach, but what you can teach; that is to say, at what point can you impinge on the activity? Writing a poem, which is using language, involves two different sorts of elements. There is involved a focus which is finally not immediately concerned with language: it is a search for meaning which operates at the centre of the activity. Language itself is peripheral in the sense that as you search for the meaning, drawing on the sort of language which is coming up in the borders of your awareness, you test it against what you intuit about meaning. But the crucial thing is a commitment to the search for meaning; that's to say it's a commitment in the sense that you won't stop or walk out of the activity. Now this is something, it seems to me, you cannot teach in the sense that you can make it available by uttering it or by instruction or by showing. Therefore this gives a slant to how I would answer the question: 'do you have to have experienced an art in order to teach it?' I think what you have to experience is that sense of search, but you don't have to have experienced, for poetry at any rate, the production of a full-blown work. You have to have experienced the search enough to be able to understand it in the children you are teaching.

DG So you could define one of the objectives, in English teaching anyway, as the search for meaning and significance . . .

TB But I think there's a danger in thinking of teaching to concentrate on the repertoire, because the repertoire is the point where the adult or the practitioner is in advance of the pupil, so that when we set up the question of 'can you teach it?' you immediately focus on points where you have something to pass on, and you see teaching as pinpointed in those terms. But the really central activity in teaching is not passing on a range of

techniques, but somehow allowing this kind of commitment to develop.

McK The description of the activity as the 'search for meaning' I would wholeheartedly support as applying to movement. But to take you up on your final reference to 'this is where the teacher gets ahead of the pupil', I think the know-how is one of the ways we stimulate search and through playing with movements we stimulate and encourage the child to search for meaning. I don't think you can say it's a search for meaning to start with. In movement we start from: 'let's jump; let's leap and roll on the floor'. It is through fascination and enjoyment of the activity that one begins to recognize that by putting certain movements together, you reach something which you know to be meaningful, and which you know to be meaningful in no other way—quite specifically in that combination of movements. Therefore it is necessary to have art because it is the only way of saying this thing, of meaning this thing, making this kind of knowledge accessible and available.

DG One of the dangers, surely, in teaching is an over-anxiety by the teacher to programme things—to make the programme too tight. There is so much we want to teach that in fact we don't allow children to develop and to explore for themselves. And in any programme there must be room for that.

OG Can I come back to something Alfred said about experience? Being human we are all in different ways subject to common human experience. To my mind it's the heightening and deepening of experience which is of importance, instead of leaving people unaware of encounters which might become experience. I think that an experience is not complete until a response has been made to it, and in my approach to the teaching of art I have sought to consider manageable bits of common experience. Then, as other speakers have described, children begin in various ways to work on it for themselves, and if one has had the experience of working this way, if one knows what it is in one's mind and one's body, one knows the generation of an idea, its gestation, its carrying and bring it to the light of day, and clothing it in its own appropriate body—words, vision, drama, sound—then one can be at hand to facilitate. But there must be a progress towards the

shaped thing in order that the experience may be made whole. There must be a finished thing.

Chairman We've mentioned the search for meaning—that this is the essential thing that one can get from writing poetry, from learning to write poetry—but does one transmit this to the child?

TB Well, I don't think one transmits it to the child. No, my point was that you probably can't. The essence of the thing is for the teacher to be involved as a person, because then, if the child develops his own involvement, the teacher's got something as a person which is worth learning for the child.

Chairman This is only for the child who is already interested and committed, but for the child who isn't, what can the teacher do then?

TB You can't teach him. You may create the situation.... I mean, to take on the idea of teaching, you would need to take on the idea of being able to create a person.

Chairman I wonder how this would relate to an art like music. What specific insights are there here in, say, the playing of an instrument?

KS I think the problem is, it's not a natural thing . . .
AS Please, can I put in surely the human voice is natural? There is an instrument built into the human which is a voice.

KS Yes, but a fair amount of patterning has to go on—this is the trouble—to actually hear things and to respond and to imitate. And a good deal of imitation goes on at rock bottom.

AS But this is a natural thing too—imitation.

KS But the process is not, as it were, so much a drawing out of the children. It's a little more directed, because it is not in a sense natural, but transmitted in the terms of specialized sounds, not everyday ones.

Chairman Then what sorts of things is the teacher of music transmitting? Is it the same as in teaching writing? I take it that we understand we are not here concerned with teaching children to compose music? What sorts of things does a child who is

8*

learning to play an instrument pick up (or learning to sing, I don't mind) from the teacher over and above the mechanics, the techniques and so on? Are there more intangible things here?

KS You can put them in touch with sound materials very easily—you can have a room full of sound. Activity—*an* activity—can go on. But I want to ask another question: is it a musical activity? At what level, when could I say there is an aesthetic response of contemplating the sound for its own sake, rather than perhaps just exploring?

DG Isn't one obvious thing (no one has mentioned it before perhaps because it's so obvious . . .). When Tony talked about the search for meaning in the child, he didn't say 'out of the air' or something. It isn't out of the air. It's out of all the sense impressions he's had and what he's abstracted from these, but it's also from other works of art that he's been subjected to, as it were; and he's picked up, partly unconsciously, the forms of this way of creating, *recreating* experience. One of the things which has always hit me about art—a sort of germinal quality—when you've read a book, or heard some music that affects you, immediately there's a sort of release in yourself of what *you* might be doing.

KS Well this is exactly . . . many musicians have relied on the music of other people to stimulate them, to actually start them working (in some extreme cases always having to hear the same piece before they set down to work—Wagner was an example, Elgar too). At that level of operation it certainly helps. And it brings us back full circle: we have been looking at the process and at taking in and exploring one's own experience, yet now we find we are being offered, on one view, a *model*, as it were, or the stimulation of other artefacts. Actual works are being introduced.

Chairman Yes, but it still leaves open the question: what is the kind of involvement the teacher must have now?

McK I think the insights that someone gets from making art are not translatable into words, and by asking us to tell you what they are, you're really asking us to do that. The meaning exists only between the perceiver and the work, and there is an insight which is got in that relationship; and it's the relationship the child will get with somebody else's poem if it excites him, or if he is able

to recognize the meaning—which is ineffable, I think, and not put easily into words.

Chairman But again, this doesn't necessarily involve any practical involvement, does it? There is ineffable insight from appreciating works which is difficult to explain . . .

McK It's the same insight that you get in making it as in contemplating it.

Chairman This is the insight the child gets? What about the teacher?

DG It is partly providing an audience, isn't it? There's some token of sympathy between something the child has created and some other audience. This is one of the teacher's roles, I'm sure. By providing this token of sympathy a kind of sharing has gone on, and this encourages the child to go further.

KS Yes, the teacher's attitude, and indeed, the attitudes of other children are conducive, one would hope, to someone actually *trying* to formulate something. It has meaning if the person who does it finds it meaningful, but in another sense if only *one* person finds it meaningful . . .

AH Once we get on to the idea of things being meaningless, this seems to imply that the aim is to give meaning to something that had no meaning. And I think this makes nonsense of the whole idea of education.

TB By meaning I simply meant making articulate what is otherwise tacit. I believe that poetry, at any rate, is continuous with gossip; that is to say, that the search for meaning is something which is finally located, not in the activity of art, but in the person. Art represents a more developed form of something which is continuous with life, and is going on all the time. So that what insight the teacher draws from appreciation of works of art seems to me an appreciation that something which is a part of ordinary daily discourse can be developed in a more sophisticated and complex kind of way. So that, in effect, it's a pursuit of implications which are already there.

Chairman So the search for meaning is presumably not just a search for words as when one is trying to formulate what one is

going to say in ordinary discourse. It is something a bit more than this?

TB You don't search for words. To speak one is doing two things: you're intuiting towards something which you can't say until you've said it—that's the central thing; and at the same time as intuiting, you're calling up from your resources of medium—in language, or paint, or whatever—the thing which will convey that meaning and you're balancing it against your intuition.

Chairman Has one got to say something more specific about aesthetic meanings? I suppose in philosophical discourse one is trying to be precise, trying to clarify and formulate what one means, whereas presumably in the search for meaning in art, one is not?

AH It's just an extension of philosophic discourse; when you dig deep enough you go into poetry.

Chairman Is it that? I wonder.

DG It is partly that the meaning of life to the individual, or to the community sharing it, cannot be expressed in philosophical terms, philosophical language. I would have thought that when somebody in a school makes an effort to arrive at meaning, in such a way that it can be captured—maybe in dance or a picture or a piece of music—and contemplated, even if only for a moment or in reverie, then he's arrived at some sort of tacit knowledge. It's something he knows in his bones; it's his formulation for that moment, and presumably if this can be shared with the teacher and other people, this makes it more valid for him.

Chairman How far is continuity important? Is it important for the teacher of art to continue producing art?

OG One feels that it's needful and yet one knows that one's got to compromise with the demands of the teaching job in terms of time and energy—mental energy as well as physical energy. I feel, somehow, that something creative should go on—and this is just speaking again from personal experience—but throughout my teaching life I have been very reinforced by engaging at an amateur level in other arts. This has been possible rather more readily than engaging in my own.

Chairman Well this, if I may interrupt, hooks on to a question which we shall come to later, but is it an obvious point that one has to practise one's own craft in order to teach it?

AH I think the work one does is, in a way, communication. It's to do with a dialogue, and mainly a dialogue with oneself, though it can be helped by others. But this dialogue with the work is important.

TB I think for this to be a real question, you've to relate it back to the activity and what the teacher can do. There is a limited number of ways in which the teacher can impinge on this. He can be an audience for it—the point Dennis made—in which case he does not need to practise, but he does need to show sympathetic understanding; or he can be a fellow craftsman in it (which is arguably the best thing he can do, but it's not open to everybody) when presumably the child will derive immense value from his continuing to struggle with it, or search with it; or he can be an organizer and adviser—which is probably all that most teachers can do in the situation—in which case the quality of his advice may be affected by his continuing with the arts. But the really imperative thing in this case is that he keeps in touch with children, and with the way they learn—with the learning processes rather than with art necessarily. So, I think it depends on what kind of way it is in which you see the teacher contributing to the activity which is already going on in the child.

WN I think we've got to keep in touch with technological advances. I mean you get the Royal College of Art holding an exhibition of art and the computer; Paolozzi's influenced by computer work. . . . There are all these things, you know—keeping in touch. You stop the moment you leave art school; the moment you begin to teach, you'll certainly be out of touch.

Chairman Yes, but one could know these without actually practising?

WN I don't think so.

AS I think perhaps it's more than something technological. I think it is very necessary to keep in touch with changes in ideas, and, in a way, possibly one can broaden out on this so that one

is keeping one's awareness of how ideas work and in which direction things are moving.

TB You see, where children probably learn most about the practice of a craft (this is certainly true of poetry and English, and I hazard drama, but I don't know about dance) is from their contemporaries—from other children. They're the people who are involved in the activity. And I think at present, probably the situation is that the teacher doesn't contribute very much from his involvement in art, and yet children are learning art.

KS In music it's probably different in many ways because it's not an individual thing—not in the way it's organized in school. It's a group activity and the teacher is somehow involved in it— not sitting outside it. He's actually part of the thing, often contributing something to the sound; so, in a sense, he's practising, and one hopes in a widening range so that he's extending his own notion of what music might be, and one would hope for an increase in sensitivity.

DG The essential requisite for the teacher is to be continuing the dialogue with himself, to which Alfred referred, in some open way, and to be able to interpret this dialogue about what life's all about and so on, in terms of art—and this could be in one art or a mixture of arts.

Chairman Assuming that involvement in the arts is essential in teaching, either before one begins teaching or as a teacher, how far is it essential that it be the same art? I suppose there are two questions here. One is: how far could one practise one art and teach another? Another question would be: how far is involvement in a number of different arts helpful to one's teaching?

AS I would think that one does broaden out one's horizons of understanding in the arts as much as one can, but as for teaching another art, this is quite another question.

DG Well, you know, a primary school teacher in training has very little time allocated to any separate art—fantastically small really. It boils down in a three-year course to a matter of weeks, and yet he deals with teaching several arts, not just adequately but superbly in so many cases.

Chairman When his training's been in a different art?

DG Yes, he may have specialized in one art.

Chairman Even so, there does seem something that's incredible about a person who has been training, say, as an artist in the visual arts sense, and who then teaches even primary school children to sing or to write poems.

OG I'm trying to think very hard about this because particularly when I was teaching in a school, the visual arts were my main commitment. But I've always had, I would say, an almost equally strong commitment, first of all to music and on occasions to drama—and I have taught music in fact. I wouldn't say that I was even untrained because I'd been fortunate in belonging to a big choir under a very eminent conductor, and that was a training in itself. I know that I found great inspiration in the imagery that this conductor used to get qualities of tone; I was able to translate this in almost direct terms, into getting qualities in painting. You see, this is not a formal thing; and it may be just the use that I made of the general interest that I had.

AH We can assume that in order to really help children to gain something from a medium, we've got to be able to introduce them to the medium. If we've no knowledge of this medium, how can we possibly help them? This seems to be a very obvious point. And the other point—about training—I think is a bit of a red herring; we don't believe that anybody who has understanding of anything has necessarily been trained in a formal sense.

TB But in a sense the more interesting question is this one at the level of assumptions about training: that the assumption here is that one teaches only one art. I can't formulate this very well, but it seems to me that there are cultural assumptions bound up with this. I went for a weekend for English teachers, where forty of us gathered to experiment with different art forms. It was absolutely tremendous—different people doing all sorts of different activities—making music or drama or painting or photomontage or photoplays and things like that. All that was going on. This looks towards a different kind of way of teaching art.

Chairman In other words, you teach *art*, and not literature, music, drama. . . . You bring them all together.

AS I would think that in this sort of teaching of *the arts* it

would be helpful to have a team working on this, rather than one person.

DG　Begging the question a bit, isn't it, because it's back to a team of specialists. I think teachers of the arts can get together because in fact they've got basically the same way of presenting knowledge —the presentational form, rather than the discursive form.

Chairman　Do you think it would be too confusing to the learners to have all these arts intermingled as it were? Or would it be better for reasons of learning to have them all separate?

DG　One of the reasons why kids have rejected school—there are many—but one reason is because in real life, in the kind of presentation they have, mainly television, they're treated as human beings who can accept this bombardment of impressions of all kinds and make sense of it.

Chairman　Personally I feel sympathetically inclined to this idea of breaking down barriers within the arts, but I'm not sure how practically it could be done.

OG　The demand for the bringing together must surely come from a great and universal theme that demands expression in more than one way. It must be from a genuine requirement of the thing that people are trying to express—otherwise the results become contrived incongruities.

AH　I certainly shouldn't think they have to be put together of necessity. What we're looking for is how much insight one can gain from combining or separating them.

KS　I don't see that. I'm more inclined to think that one art form doesn't shed any light on another, but by combining them you produce a new form. And I don't see that necessarily one's learning more about either of the two.

Chairman　I think there's a difference between combining arts and teaching them together. Tony's case of a weekend when you're all engaged on different arts in the same place might be an alternative way of teaching integrated art courses—rather than having children all engaged in a project like creating opera where they bring the arts together.

TB I think you could turn Alfred's point on its head and say: show me the virtue of splitting everything apart. In primary school this sort of conjunction of different forms is something which is taken for granted.

AH Yes, still, you know, one's got to have evidence that putting together may be valuable. The feeling I have is that it may apply to some individuals and not to others, and I mention this because I believe children should be allowed to devote more or less attention to one rather than another.

KS I suppose the key thing that's been said about this question is perhaps the point that what the arts have in common is that they're all presentational forms rather than discursive.

TB If you think it desirable that they shouldn't be prevented from being put together, then probably this does change the notion of the kind of training which teachers of art should have. It's a cultural question—a value question. There are two moves you can make to answer it. You can say that it's so important to have one window on the world that you must pursue that; or you can say that there is a range of windows all of which have something in common and related to this central drive for meaning. I think what will finally determine your choice is the degree to which you accept the way art as an activity and its teaching are institutionalized. And if you want to envisage a new kind of institutionalization of a democratic kind, then I think you're going to draw nearer to the idea of a range of activities, and vice versa.

KS But, if it's going to be democratic, it must presumably be optional for the student in training—as one hopes it might be in school . . .

AS I would think that it's quite important to suggest that one has to take into consideration different personalities and different ways of approach, and that one should be very careful not to suggest that one of these two ways is the only way. There might be different kinds of training available for different people, so that you had some people who were looking through one window and some with opportunities to look through many.

TB I agree with that, but I think that what this comes down

to is de-institutionalizing the qualifications to embark on an activity.

Chairman Is there something lacking in the training of the teacher of art if he's trained in *one* art? Ought students to have an overall conception of ART? Do you think that the answer is for the teacher of the arts to see himself as specifically concerned with developing the aesthetic side of a child's nature, rather than teaching one particular art?

Contributors

Dick Field is Head of the Art Department of the University of London Institute of Education. He has had a wide experience of teaching in secondary schools, colleges of art, colleges of education and university; was at one time an art adviser to the West Riding of Yorkshire; and has examined for a number of Institutes of Education for the Certificate in Education, for B.Ed. and for ATC. His real interest lies in the relationship between theory and practice in art education, and his recent book *Change in Art Education* (London: Routledge & Kegan Paul, 1970) is much concerned with this interest.

Rosemary Gordon, after receiving her doctorate at the University of London (L.S.E.) spent some time in research at the Sorbonne, and later worked for several years at Napsbury Hospital as the Senior Clinical Psychologist, with particular interest in the development of research techniques for the diagnosis and treatment of schizophrenics and their families. A Jungian analyst and professional member of the Society of Analytical Psychology, she divides her time among private practice as an analyst, writing and lecturing on the psychology of art for the Art Department of the University of London Institute of Education. Her major field of interest is in relating the conceptual models of the ethologists, the anthropologists and the analytical psychologists and applying them to the study of attitudes to death, to religious belief, to art and to the creative process.

She is married to Peter Montagnon, BBC Television producer, now Head of BBC Open University Productions.

Mel Marshak, born in the U.S.A., qualified originally as a biologist and researched biochemistry at Berkeley. She later

trained as a teacher in primary and secondary education; became in succession head of a child care centre and teacher in a secondary school; and worked with maladjusted and handicapped children. She came to England in 1952, qualified in psychology at University College, received her doctorate, and later trained as an analytical psychologist. As a professional member of the Society of Analytical Psychology she now lectures in psychology at the University of London Institute of Education and practises as a psychiatrist. Among her writings, her three articles in *Didaskalos* on mythology have attracted considerable attention from students of the arts.

She has played the viola in several symphony orchestras.

John Newick is interested primarily in ethnic and cultural factors in education in the arts. He has travelled widely in Africa and has visited Mexico. Since 1962 he has taught in four overseas universities: as Reader in Art Education in the University of Science and Technology, Ghana; as Lecturer in Education in Makerere University College, Uganda; for a short period (on exchange) as Supervisor of the Secondary Teaching Credential programme in art in the University of California, Berkeley; at summer session, University of British Columbia, Vancouver. At present he is Lecturer in Education with special reference to the Teaching of Art at the University of London Institute of Education where he is tutor-organizer for the Diploma in Art Education for experienced teachers.

Leslie R. Perry is Professor of Education at King's College, London. Prior to this appointment he was the first holder of the Chair of Education at the University of Warwick. While Senior Lecturer in the Philosophy of Education at the University of London Institute of Education he was very involved in courses for students preparing to teach the visual arts. He played an important part in laying the foundations of the University of London Diploma in Art Education.

He has been for many years a practising painter.

Louis Arnaud Reid, Professor Emeritus in the University of London, has taught in four British universities, and in several other countries. He is author of some eight books and innumerable articles on philosophy. He began writing on aesthetics in the twenties: his book *A Study of Aesthetics* (1931) was influential,

particularly in America. In 1936 he published *Ways of Knowledge and Experience*. His most recent work, *Meaning in the Arts* (1969), explores the basic problems in art in terms of a theory of aesthetic 'embodiment'. Professor Reid is still writing and teaching aesthetics and is keenly concerned with its place, both in the education of art students and in general in liberal education.

Sonia Rouve studied in France and Italy and received her M.A. (Education) from London. She has taught in comprehensive schools and colleges of education and now lectures in theory of education for the Art Department of the University of London Institute of Education. Her particular fields of interest are philosophy and aesthetics, and she is now working on a study of the visual structures inherent in Wittgenstein's philosophy. She became interested in the question of an approach to the teaching of the history of art at the time of the Hornsey inquiry and researched into the conceptual nature of the subject and the methodology of its teaching in schools and colleges. This led to the area of current consideration: the teaching of the history and appreciation of art.

She is married to the art critic Pierre Rouve.

Symposium

Tony Burgess, who at this time was Research Officer, Schools Council Writing Research Unit, is now Lecturer in Education with Special Reference to the Teaching of English at the University of London Institute of Education.

Olive Gabriel, who is Lecturer in Education with Special Reference to the Teaching of Art at the University of London Institute of Education, is a worker in indigo and other dyes and an amateur in other arts, with an active participatory interest in music.

Dennis Griffiths, Lecturer in Education with Special Reference to the Teaching of English at the University of London Institute of Education, has an interest in writing research and in student drama.

Alfred Harris, Lecturer in Education with Special Reference to the Teaching of Art at the University of London Institute of Education, studied at the Royal College of Art and is currently teacher, painter, print-maker and photographer.

David McKittrick, who is Senior Lecturer in Movement at Goldsmiths' College, University of London, taught art in primary school before training as a dancer at the Sigurd Leeder School of Dance. He is author of *Dance in the Middle Years of School* (1972).

William Newland, who is Lecturer in Education with Special Reference to the Teaching of Art at the University of London Institute of Education, is currently teacher, sculptor and ceramist.

Ann Spencer, who is Lecturer in Education with Special Reference to the Teaching of Art at the University of London Institute of Education, has a special interest in historical, literary and musical London.

Keith Swanwick, whose Doctorate is in the aesthetics of music, is conductor, author of *Popular Music and the Teacher* and currently Lecturer in Education with Special Reference to the Teaching of Music at the University of London Institute of Education.

John White, who was Chairman of the Symposium, is Lecturer in the Philosophy of Education at the University of London Institute of Education.

Author index

(Italicized figures indicate References)

Subject index